THE
ROAD
FROM
ORION

ALSO BY JUDY KAY KING

The Isis Thesis: a study decoding 870 Ancient Egyptian Signs (2004)

Balls of Fire: a Science of Life and Death (2015)

PEER-REVIEWED ARTICLES

King, Judy Kay. **2019.** "A Trace of Emergence: Human Social Behavior as a Sign of Microbial Metabolism." *The International Journal of Interdisciplinary Cultural Studies* 14 (1): 57-79. doi:10.18848/2327-008X/CGP/v14i01/57-79 OPEN ACCESS

------ **2014.** "Death or the Powers: The Future of the Human Experience." The International Journal of Humanities Education 11 (3): 1-17. doi:10.18848/2327-0063/CGP/v11i03/43802

------ **2011.** "Unraveling Mountainway Ceremonials: Is Navajo Eschatological Ritual Another Semiotic Pattern of Ancient Invisible Magic Veiling a Complex Information System?." The International Journal of the Humanities: Annual Review 8 (12): 45-80. doi:10.18848/1447-9508/CGP/v08i12/43078

------ **2009.** "Cosmological Patterns in Ancient Egypt and China: The Way to Unify the Universe through Knowledge, Mind, Energy, and the Beneficence of the Elements." The International Journal of the Humanities: Annual Review 7 (2): 151-166. doi:10.18848/1447-9508/CGP/v07i02/42637

------ **2008.** "Cosmic Semiophysics in Ancient Architectual Vision: The Mountain Temples at Deir el Bahari, the Dead Sea Temple Scroll, and the Hagia Sophia." The International Journal of the Humanities: Annual Review 6 (4): 17-26. doi:10.18848/1447-9508/CGP/v06i04/42413

------ **2007.** "From History's Dustbin: A Semiotics of Evolvability Discovered within Man and his Mountain of Transformation." The International Journal of the Humanities: Annual Review 5 (5): 113-126. doi:10.18848/1447-9508/CGP/v05i05/42103

------ **2007.** "Man the MisInterpretant: Will He Discover the Universal Secret of Sexuality Encoded Within Him?." The International Journal of the Humanities: Annual Review 4 (9): 1-16. doi:10.18848/1447-9508/CGP/v04i09/43436

------ **2006.** "Biosemiotics in Ancient Egyptian Texts: The Key to Long-Lost Signs Found in Myth, Religion, Psychology, Art and Literature." *The International Journal of the Humanities*: Annual Review 3 (7): 189-204. doi:10.18848/1447-9508/CGP/v03i07/41722

For more information see:
https://cgscholar.com/community/profiles/judyking/publications
https://cgscholar.com/community/profiles/judyking
Also see: Proceedings of Semiotic Society of America for 2006/2007, 2008, 2009, and 2011 for four published articles presented at Annual Meetings

THE ROAD FROM ORION

A SURREAL STORY SUPPORTING THE ISIS THESIS

JUDY KAY KING

ENVISION EDITIONS LTD.

THE ROAD FROM ORION
IS PUBLISHED BY
ENVISION EDITIONS LTD.

Copyright © 2004 by Judy Kay King

All rights reserved under International and Pan-American
Copyright Conventions. Published in the United States
by Envision Editions Ltd., Gaylord, Michigan
First edition published 2004
Printed in the United States of America

ISBN: 0-9762814-1-4
13 Digit ISBN: 978-0-9762814-1-2

Library of Congress Control Number: 2004099667

Cover design is by Shannon M. King
using NASA Image PR93-01 dated 1/01/1993
of the Cygnus Loop Supernova Blast Wave
and E. A. W. Budge's representation of
the Creation from the sarcophagus of Seti I.

Envision Editions Ltd.

Thoth
Copyright © 2003 by Eric Szymanski

It says: "In the beginning was the *Word*."
Already I am stopped. It seems absurd.
I must translate it otherwise
If I am well inspired and not blind.
It says: In the beginning was the *Mind*.
Ponder that first line, wait and see,
Lest you should write too hastily.
Is mind the all-creating source?
It ought to say: In the beginning there was *Force*.
Yet something warns me as I grasp the pen,
That my translation must be changed again.
The spirit helps me. Now it is exact.
I write: In the beginning was the *Act*.

 Goethe's *Faust*

Preface

Contents

Bibliography

Preface

The corpus of Egyptian funerary texts demonstrate an advanced Twenty-first Century knowledge of space physics, quantum physics, molecular biology, supramolecular chemistry and bacterial genetics. Using this expansive knowledge base, the ancient Egyptians carved a sophisticated symbolic system of art and hieroglyphs into the tombs of the Pharaohs and nobility to disguise their Science. The Isis Thesis (Volume 1) posits that the primary objective of their hidden scientific knowledge was to map the chemical path by which the genetic heritage of the Deceased was preserved and vectored into a bioluminescent species that was not recycled back to earth and the world of photosynthesis. Decoding an elaborate network of over 870 signs in eight different texts spanning 2000 years, the thesis explains how the Pharaohs' Science of Death made humans into gods by cloning a new species. With this knowledge, the Pharaohs insist humanity can re-invent itself at Death. For humans today this knowledge may be an alternative to species suicide due to overpopulation, nuclear war, global warming and mass extinction.

The Story – a surreal plot of works of art, fact and fiction

To convey this scientific knowledge to readers and students that are not scientists or Egyptology scholars, The Road from Orion (Volume 2) is a story supporting and relating to the study, based on a surreal plot of fictional characters, historical facts and great works of art. Using the Egyptian method of providing drawings to aid understanding, the Table of Contents for the story is modeled on the Egyptian Senet game and depicts 30 chapter drawings related to events in the story. Within the text of the story, direct quotations of creative artists from renowned works of literature, art, music and philosophy are designated by italics with the work itself referenced in a short bibliography at the conclusion. These great works of art point to scientific concepts referenced in the thesis and add support to the interpretation, but not valid scientific evidence. Other themes woven within the story's plot address several controversial questions: Is schizophrenia a direct mental experience of the quantum world of atoms? Do hallucinogens allow humans access to the quantum world? Do

each of us have an invisible double? Did royal incest enhance the Pharaohs' spiritual consciousness? Has our idea of God prevented us from accessing comprehensive wisdom?

The Thesis – a study of Egyptian ideas and signs

The Isis Thesis begins with an Abstract of the study as an advance organizer. After this, we begin our quest to restore the effaced Egyptian sign, so that the Pharaohs' lost knowledge is restored to history. Part One of the thesis reviews method, sources, and the major ideas in the *Pyramid Texts* and the *Coffin Texts*. Analyzing textual advice, we map the Pharaohs' path to Eternity, discovering space physics evidence for actual energy landscapes that match Egyptian descriptions. Part Two examines the quantum world of the cell, for the Egyptian signs are dual-signified. We discover that the macroscopic earth system operates like a tiny bacterium. As the legendary alchemist Hermes Trismegistus said, "What is below is like that which is above." Part Three deconstructs the *Amduat*, a book often called the Egyptian Heaven and Hell, describing a journey through a black-hole protein funnel. Next, we analyze *The Book of Gates*, another Middle Kingdom text found in the great tombs of the Pharaohs. Briefly, we peer into *The Book of Caverns*. In Part Four, we explore the mystifying Book of Two Ways that still intrigues religious scholars, the New Kingdom *Edifice of Taharqa*, and the popular New Kingdom *Book of the Dead*, including the *Theban Recension*. As a corpus, these texts are unified in their presentation of Egyptian Science that centers around predicted chemical events in the afterlife of the Deceased. We close our investigation in Part Five with an evaluation of the Egyptian legacy and its links to String Theory, black hole theory, inflationary cosmology, and world religious perspectives.

Covering eight funerary texts within one book was a massive task that presented several difficulties. The first problem was how to address the large range of interconnected and dual-signified signs that have confused scholars for centuries. In an attempt to understand these signs with no intrusions, I became a full-time independent researcher for three years, leaving my college teaching and grant-writing career in 2001. This allowed me the opportunity to carefully decode the meaning of the signs and catalogue them in matrices with modern science parallels.

The second problem was the depth of cutting-edge scientific knowledge embedded in the Egyptian texts. Fortunately, nonstop satellite Internet access allowed research opportunities any time of the day or night. Also, excellent online university tutorials and courses in biology, chemistry, physics and genetics deepened my knowledge. Thanks to the efforts of the Otsego County Library

and their interlibrary loans, I was able to obtain unusual texts such as The *Edifice of Taharqa* by Richard A. Parker, Jean LeClant and Jean-Claude Goyon. Other texts such as Alexandre Piankoff's impressive Portfolio of Plates photographed from the Tomb of Ramesses VI were invaluable.

The third problem centered on the complexity of the funerary texts, which required numerous reviews of each text. To resolve the complexity issue and aid research and understanding, I compared the Old Kingdom *Pyramid Texts* and Middle Kingdom *Coffin Texts*, listing the major Egyptian themes or Idea Strands in an Appendix for the reader. This should also be helpful to critics who have not read the funerary texts. However, an ideal critique of *The Isis Thesis* rests on the critic having read all the funerary texts addressed. Constructive criticism can only result when Egyptologists, scientists and professionals in related disciplines work together to expand or modify the ideas within this work.

Although the thesis addresses more than one scientific discipline, students of general-level science, teachers and professionals should find it interesting. I have provided diagrams and matrices, along with definitions of scientific terms within the text, online resources in the References denoted by an asterisk, and a glossary of Egyptian deities and terms to aid understanding. The argument addresses ten objectives in Part One through Part Four that guide the reader to conclusions and possibilities in Part Five. Some of the issues noted in the thesis are more controversial than those of the story. Was the birth of science in Egypt? Can human consciousness exist after Death? Can we take control of our afterlife? Is God a quantum life-form modeling complex viral behavior?

Although the textual references and signs taken individually may be vague, the 870 decoded signs as a whole exhibit a unified matrix of Egyptian Science that mirrors and surpasses the knowledge of modern scientists. Is the scientific afterlife knowledge of the Pharaohs useful to living human beings? That is for you to decide.

I began this exploration of the Egyptian afterlife because I believed that the ancient Pharaohs possessed knowledge that would shed light on life and death, thereby eliminating the fear of the unknown for humans. My work rewarded me with the knowledge of why the ancient Kings did not fear Death, why they looked upon the world with a cool equanimity that was omniscient and eternal. Although no theory is an absolute theory, this thesis provides a scientific rationale for an afterlife existence that helps one to understand who we are, how our universe works, and what we can become.

1

Revision—the act of looking back,
of seeing with fresh eyes,
of entering an old text from a new critical direction—is for us
more than a chapter in cultural history:
it is an act of survival.
Until we can understand the assumptions in which we are drenched
we cannot know ourselves.

When We Dead Awaken: Writing as Re-Vision
Adrienne Rich

A starry black night is broken by a cold eye forever watching over the human sea of life. In relentless pursuit, the Sun guards the hazy horizon like an island of fire heating the earth, although this is not its real intention. The glittering eye from the horizon knows about the theft of fire and is angry because we steal its energy. We capture its fire to live, and that is why the crimson ring is a noose around our necks, or better yet, a raw tattoo of smoldering iron carved in our hearts. If a watcher stares long enough at that unblinking hydrogen eye, he will understand as I do that it is a living organism out for revenge. Plagued by ideas such as these, my estranged state of mind forced me to quest for the eternal Death of the Sun.

Thoughts of this nature do not shape the destinies of the general rabble who question their existence, but such considerations have styled the lives of two individuals that I respect, a madman who despaired and a sadist who lived

crazed by the belief that the universe is a purposeless, monotonous machine cycling round and round like the earth about the Sun. Certainly, the sadist's idea of a purposeless world is disturbing, but more disquieting is the madman's warning, which haunts my mind like a thief stealing the remains of my sanity. He said that when a person gazes too long into the abyss, the abyss begins to gaze back. The horror hidden in this idea forced me to quit staring at the Sun.

Unlike the sadist, I could not believe that human existence had no purpose, and I doubt that Friedrich the madman believed this either, for he told me a story, a parable about a shepherd who was sleeping when a black snake crawled into his mouth and bit him. The snake was lodged in the shepherd's throat, and Friedrich had tried in vain to rip it out. Finally, my friend screamed to the choking shepherd that he should bite the snake's head off. Desperate, the shepherd brought his jaws down hard on the snake, bit off its ugly head and spat it out. Jumping up laughing, he was no longer a shepherd, no longer human, but changed and radiant, which plunged Friedrich into deeper despair and madness because Friedrich wanted the shepherd's transformation. He wanted to be the Overman, a being beyond human, but he did not know how to make the change.

Before going completely mad, he told me more about his Overman, and I could see reason in his madness. Friedrich explained his makeover idea by saying that a human being was like a rope, with one end held by a beast and the other by the Overman. If a person could walk the tightrope from the beast to the Overman without falling, he would become the Overman.

"The object," Friedrich said, "is not to let the jester pass you on the rope."

When he first said jester, I imagined some fool balancing on the same rope and tripping me. But Friedrich explained that the rope stretched between two towers, and that I would come out of the small tower door on the left, followed by an excited jester, who would taunt me as I walked the rope. Friedrich agreed that the erotic clown would be hard to beat because he was behind me, and from this vantage point, he could easily threaten me with abusive shouting that I was lame, slow and should be locked back up in my tower.

Friedrich then said that when I least expected it, the hyper-freak would jump over me, throwing me off balance to crash to my Death. The situation seemed irreversible, but I could not give up Hope that there was a solution to outwit the jester.

"Is there any way I can trick the jester"—I said cleverly—"into coming out first so I won't fall off the rope?"

Visibly shaken by my remark, Friedrich said, "I have never been able to overcome the jester. All that I can do for you is to pick up your corpse after you fall."

Looking at Friedrich's heartbreaking eyes, I could see his despair, and I sensed the beginning of my own. The tragedy of always trying and forever falling was disturbing, but an idea came to me.

What if Friedrich did not have all the information? Maybe he had overlooked some valuable piece of knowledge related to the jester, a mystery about the jester that if known would make it possible to walk the tightrope to the Overman. It then occurred to me that only a fool would choose to walk the tightrope with the joker behind him.

"You have no choice," said Friedrich, "you are born to walk the rope and fall off."

I insisted that there must be a solution, that he had overlooked something, but he sadly shook his head no. That was my last memory of the madman, for he had a complete emotional breakdown. In 1889, Friedrich witnessed a sadistic cab driver brutally whipping his carriage horse. Sobbing, Friedrich ran to the suffering animal, throwing his arms around its bloody neck to protect the horse from the merciless whip of its master.

Friedrich collapsed completely in the Turin street next to the horse. Even though he underwent psychiatric treatment, he never recovered, dying almost two years later on October 25, ten days after his fifty-sixth birthday. I was still carrying the corpse of Friedrich Nietzsche's thought with me, still thinking of a way to outwit the jester, when I read the works of the sadist, who was also missing valuable information.

According to the American Psychiatric Association's Diagnostic Manual of Mental Disorders, a sadist is a person who inflicts physical or psychological suffering on another to achieve sexual excitement. The earliest age of onset is childhood and three criteria determine this disorder. For the purpose of sexual excitement, if one repeatedly and intentionally abuses a nonconsenting partner, or mildly or mortally abuses a consenting partner, then that person is a sexual sadist. The disorder can become severe, for some sadists rape, torture and kill their victims.

My friend Donatien was a self-professed sadist who only abused consenting partners. Yet, he was branded a demon, an alchemist, a Casanova, and a Bluebeard, who cut up his wives. Born into aristocracy, he was naturally arrogant, coming from a family well-known for their activities in civil and church affairs. Although neglected by his parents, household servants indulged him, and by age six, Donatien was tutored by his uncle, a friend of Voltaire's. In time, Donatien understood that Nature was totally indifferent to the experiences in a man's life. It did not matter whether one was dead or alive, imprisoned or free. Donatien understood this well, for he had spent twenty-eight years of his life in prison for charges such as not paying debts, excessive behavior in a brothel,

and for writing and publishing his stories. One wonders what was true about his life and what was contrived to prevent Truth seekers from reading his writings.

One story has it that when he was thirty-two, he and his manservant Armand engaged four prostitutes to satisfy his flogging fantasies. All enjoyed the episode until Donatien offered the girls aniseed sweets laced with Spanish Fly. This resulted in the girls becoming very sick and Donatien on trial for poisoning and sodomy. Escaping to Italy with his wife's younger sister whom he passed off as his wife, he was soon imprisoned by the King of Sardinia in a cell called the Great Hope, after his mother-in-law requested the King to arrest him.

Nonetheless, these reports of Donatien's antics did not stop me from reading his writings. I considered him my mentor as I did Friedrich, even though Donatien sometimes acted like the cruel cab driver that tortured the horse. Like Friedrich after his breakdown, Donatien believed in nothing at all, except perhaps for a good flogging to relax oneself. To me, he was a free spirit, a rebel against the absurd as Camus perceived him, a revolutionary force for a change in thinking.

One day he told me that his storyline *modus operandi* of maiming, raping and humiliating women for male pleasure was just a literary technique to emphasize a point.

Wondering whether his misogynous method was that effective, I said, "Well, Donatien, it better be a good point because posterity has you labeled as a sexual deviate. They have taken your last name and made it a psychiatric disorder."

The Marquis Donatien de Sade laughed and motioned me forward as if to tell me a secret that would change my life.

He said, "In the real world, virtue serves no useful purpose. Even a woman uses her virtue as a mask to disguise her physical weakness, while showing off her sexuality."

The Marquis de Sade had little compassion for the weak or any guilt for his actions, and he believed sexual gratification was rooted in power over the weak, a power similar to Nature's ability to forever rearrange indestructible molecules for its creations. Whether God is dead or alive did not matter to Donatien. What mattered to him was that knowledge and vice had rewards.

Emboldened, he continued, "The idea of heaven having power over us was designed by hypocrites and charlatans to deceive and suppress the strong."

I listened to him curiously, wondering if war, murder and cruelty were really necessary, so I asked him the purpose of these crimes of strength.

"War and murder release atoms of matter for Nature to recycle," he said. "It follows that mercy, Charity and virtue in general only help the weak to survive longer than necessary."

Somewhat shocked, I sensed that he was telling me the Truth because he didn't care whether I respected him or not. His libertine logic reminded me of the Irish poet Yeats who professed that the best means of achieving freedom was through battle, rage, drunkenness, sex and art. Like Friedrich, who believed that man could be described as a herd animal, Donatien compared the virtuous weak to lambs among the ruthless wolves that Nature favored. No wonder he aspired to be a wolf, for based on the limited Truth he understood from experience, he had lost Hope. The jester had beaten the Marquis de Sade.

The idea that the tragic visions of Donatien and Friedrich resulted from their being deprived of Hope by the jester haunted me. The jester understood the gag; he knew how to get the snake out of the shepherd's throat, he knew how to stop the fall. If Nature were unstoppable, ruthless, uncaring and ruled by the urge to create and rearrange molecules, then it would seem that Nature could also reorganize a person into a being that did not root sexual gratification in power.

To me it seemed that the problem was the jester, who was hiding the answer to some simple mystery that could restore the Death of Hope. There had to be a way to force the jester to walk the tightrope first, tempting the stormy freak to reveal what he knew about becoming the Overman.

Tormented by these ideas, my entire existence has revolved around solving this riddle, especially since I met John Friedman, Irish by blood, impulsive by nature. This is as much a story about John and me as it is about the pursuit of Truth. As for my identity, I must remain anonymous due to the events that transpire, yet I can tell you that this story is about the power of the Imagination to discover a New World, one that we can live in with Hope, not despair. It is about giving up the ordinary life for the sake of a spiritual quest that discovers and unmasks the lost meaning of an ancient Egyptian legacy.

Irish Curse:
Woe to you, you dirty fellow.
You've filthied me!

2

My quest to understand the mystery of the jester led John and me from Dublin west to Tucson, where we were seniors at the University of Arizona. Friends and scholars in pursuit of Truth, we were on our way to a professor's home for a cloning experiment. I knew nothing about genetics and John was an English major, who would sacrifice anything for knowledge about Death and the dream of immortality, even though he feared Death, the dead and their domain. Stretching his slim arms uncomfortably in the driver's seat, John lit a cigarette as the Catalina highway uncoiled before us like a serpent, unwinding to our destination, a mountaintop tourist town called Summerhaven.

Profiled against the golden haze of the passing horizon, John had the brooding look of a philosopher, preoccupied, distant, a darkness about him that gripped his high cheekbones and deepset eyes. Wavy black hair and a sharp nose added to his Faustian image, disguising his Irish heritage without erasing the one birthright he valued most, his limitless Imagination.

"The study of literature has taught me more about life than experience," John said, as we drove past a lookout with a breathtaking view of the 356-acre University of Arizona campus in the heart of Tucson.

Surrounded by the Santa Catalina mountains and the high Sonora desert of Saguaro cactuses and palm trees, the campus is bathed in sweltering sunshine 300 days a year. Here John studied classics ranging from Bram Stoker's *Dracula* to Joseph Conrad's *Heart of Darkness*. His taste for the surreal introduced him to the genius and schizophrenia of Antonin Artaud's poems, plays and films, along with the writings of Gerard de Nerval, who penned down his personal descent into madness moments before he suicided. Yes, literature had taught John a lot, but not enough because he still did not have an answer to the mystery of Death.

My gaze wandered to the burnt umber desert of hazy light, space, stone and earth, where violet mountain peaks emerged from the luminous turquoise mist like ancient pyramids, pregnant with timeless legacies forever lost to humanity. John believed that ancient Egypt had the answer to Death, and it was for this reason that he signed up for the cloning experiment. I was just along for the ride.

The instructor conducting the experiment was Dr. Lucia Farrell, the only granddaughter of Sir Flinders Petrie, who excavated the Great Pyramid. In Tucson, she was our closest link to the mysteries of a lost civilization, so we gave up three days of partying to be guinea pigs at the doctor's Summerhaven laboratory. Still, I had certain knowledge of events and special circumstances that I could not mention to John, even though I was his friend.

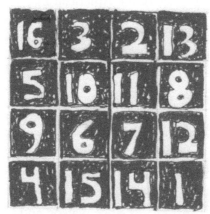

3

> Looking for the eye of god, I saw only a socket,
> Vast, black and bottomless, from whence the Night that dwells there
> Streams out over the world and ever deepens;
> A strange rainbow encircles this somber pit,
> Threshold of the old chaos whose shadow is nothingness,
> Spiral engulfing the Worlds and Days.
>
> *The Christ in the Olive Grove*
> Gerard de Nerval

In 1983, the Academic Senate of the University of Arizona adopted a resolution saying that it was a serious breach of professional ethics for any instructor to make sexual advances to a student, even for consensual sex. Rumor had it that some of the more libertine instructors had attended off campus parties, participating in certain rites, shall we say, that the Marquis de Sade would have enjoyed immensely. At one party, orgy-mongers ladled up and bonged salty drinks from a bathtub full of vodka, grape juice, and most probably urine because the toilet next to the tub was out of order. I will not drink urine, I thought, as I watched my friend John chug a mug of the purple piss, as if he were swallowing a secret remedy for eternal life. His zest for life sometimes outweighed his wisdom. He did not care what was in the tub, nor did the women around him because they were sexually attracted to John's recklessness and the quiet violence in the bottomless depths of his intelligent eyes that barely masked his soul's turmoil.

Deafening music rocked the small apartment packed with people, and all one could see at times was an occasional nude female jumbled above uplifted arms and passed along in a fashion similar to the crowd-surfing seen at concerts and football games. At this particular event, the Chair of the Department of Psychology would lose his white jockey shorts, which would later be found

grape-stained and hoisted above the American Flag outside the university administration building. Administrators were extremely worried about the reputation of their professors, even those not engaged in sexual orgies, such as the careful scientists in the Chemistry Department, who were more interested in federal patent law.

By 1980, the U. S. Supreme Court had ruled that a genetically created new bacterium could be patented. In this same year, Martin Cline and his coworkers created a transgenic mouse, transferring the functional genes of one animal to another. By early 1983, researchers had located a genetic marker for Huntington's disease on chromosome 4, and word was out that in Denmark scientists were attempting to clone a lamb from a developing sheep embryo cell.

Genetics had made great gains since Watson and Crick defined the double helical structure of DNA in 1953, and Paul Berg cloned the first gene in 1973. University professors and scientists were scrambling to patent man-made microorganisms and had their eyes on Nobel Prize nominations, and some were taking foolish risks that were dangerous to a university's reputation. So, when Dr. Lucia Farrell submitted a request for a one-year sabbatical leave to work on a special project related to a new biotechnology tool, Dean Leonard Grolsch, head of the Department of Chemistry, had second thoughts about signing her leave.

Overweight and bloated from habitual three-martini lunches, Grolsch sat at his immaculate desk under a central ceiling light that he always left on. The bizarre effect of the unnatural light within the pervading sunlight made him look like a large salamander larva under a microscope, waiting to be probed, waiting for Dr. Lucia Farrell who was late.

The warm sunlight filtering through his office window made him sleepy, made the room look hazy to his bloodshot eyes, which were beginning to roll backward in his head. He imagined that he was flying over the Arizona desert like a hawk, a phoenix gliding sunward into the cool air, when suddenly the Sun turned black, and he fell at a rapid pace, faster and faster, choking on the rushing wind, and then the desert split to swallow him, but he saw salvation, a woman rising from the abysmal rupture in the ground. She had high delicate cheekbones, a bronze complexion, a slim figure, an ascetic quality, and with her auburn hair pulled away from her face, she resembled one of Renoir's young French women. For a moment Grolsch stared at her like a man in love, then he gasped in revulsion, for it was Lucia who had caught him dozing.

Lucia was well aware that Grolsch's gluttonous drinking habits could ruin his reputation, for this was not the first time she had caught him sleeping at his desk. Disgusted, she stood by the sunny window, waiting for Grolsch to recover and say something. Instead, he straightened his red power tie, cocking his thick

neck like a cobra ready to strike, as his tongue licked his sticky lips for leftover vodka. Slowly, he moved his large head toward the sunlight where Lucia stood. The overhead light glinted off his balding scalp, as he spat words out of his mouth like venom.

"This leave is a privilege, an opportunity for research, and an investment toward increasing the programs of study at our university," he blurted, unmoving like a hawk guarding the university's reputation and the remains of his own, for as dean he was responsible for approving her research plans.

Lucia watched Grolsch quietly, unerringly calm, professional in her knee-length, dove-gray suit, and with obvious disinterest. She shifted slightly toward the window into the sunlight, which emboldened her small features and red hair. Outside students were talking in groups, the Arizona Sun beating down on them with its 103 degree heat. Lucia paused long enough to make Grolsch uneasy, and he instantly glanced away from her perceptive eyes onto the detailed description of her work in front of him.

He had a high, wrinkled forehead, balding to a shock of white hair, large fleshy earlobes, a gnarly look from too much Sun and alcohol, and a certain idiocy about his face. The look of a ham-fisted peasant, like one of Van Gogh's *Potato Eaters*, fogged up his face, but he was much better dressed than a field laborer in his light blue shirt and gray suit.

"Leonard," she said, "if my research supports this thesis, you can retire famous."

Grolsch glared at her, his blood-thinned, hawkish eyes—yellow from too many martinis—sharpening.

"So you think the release of free oxygen had a fundamental effect on the biosphere," he said.

Lucia glanced toward Grolsch with conviction. "The early earth's atmosphere contained very little free oxygen 3.8 billion years ago. The key change came with photosynthesis, the process used by green plants, algae and some bacteria, in which the energy from sunlight is used to split water into hydrogen and oxygen."

"This isn't the classroom, Lucia, I know what photosynthesis is," said Grolsch, turning and turning the pages of her application, his curiosity widening as he searched for her thesis statement.

With passionate intensity, Lucia continued, her full face lit by the Sun, her eyes bright and edged in mystery, possessed as they were by the desire for ultimate knowledge. Like a falconer, she reeled in Grolsch, tightening the grip she had on his arrogant mind.

"Free oxygen," she said, "was originally confined to oases in the oceans, while the atmosphere remained oxygen-free. Then about 2 billion years ago,

the entire global ocean became oxygenated and life diversified into the full range of life-forms as we know it."

As she spoke, Grolsch finally zeroed in on her written thesis statement. A sudden ghastly pallor clouded his swollen ruddy face.

"And you think that the oxygenation of the deep sea resulted from the deposits of faeces. . ." Grolsch paused as a bead of sweat trickled down his wrinkled forehead.

"Yes, Leonard," Lucia harmonized, releasing her mental grip on the old hawk. "Faeces deposits from animals with sophisticated digestive systems, causing the sea to become open to oxygen-breathing life and the evolution of humans."

Speechless, Grolsch fumbled with his nose, as if he had been snorting cocaine along with drinking martinis.

Yes, it all came down to shit—biochemical and academic. Still, he would approve her request because of her reputation. Lucia Farrell, age forty-two, was a graduate of the University of Oxford, where her research centered on quantum theory, particularly the theory of molecular properties. Years of isolated study and thought had provided a strong ground for her research interests, which she proved by means of the Scientific Method enlightened by intuition. Grolsch envied her credentials.

An unbearable amount of Time seemed to pass as he read the details of the research plan, yet Lucia was unaffected and seemed to be more interested in the dean's bookshelves than his response. She found a compass on one shelf and was measuring magnetic north, when Grolsch finally scribbled his name on the request, then he stared at Lucia.

"Once a sabbatical leave is approved, the member must carry out the project as exactly described in the application for sabbatical leave."

Lucia looked calmly at the pompous Grolsch, her lips curling into a thin melancholy smile, for the dean did not know that he had just made a pact with Durer's dark angel.

Since Albrecht Durer engraved *Melancholia I* in 1514, no one has been able to come up with a convincing interpretation explaining the meaning of the seated, saddened angel in the alchemical laboratory, holding its head up with the left hand, while the right holds a compass.
A squamous form in front of the angel that looks like a mutant embryo with a sheep head curls between a white sphere and a large geometric shape or distorted cube, stretched into six pentagonal faces and two equilateral triangles. Sitting next to a ladder on a grindstone between the sullen angel and the misshapen cube is a winged, sexless spirit, a forlorn hermaphroditic cherub. Four faces inhabit the woodcut, along with a starry Sun, a rainbow, a dead-calm sea,

an equally balanced set of scales, and an hourglass with equal amounts of sand. The magic square with sixteen numbers hanging directly above the angel's head has puzzled mathematicians and theorists since 1514. Adding the numbers across, down or diagonally always gives thirty-four, a number somehow related to the distorted geometric stone that is the object of the angel's melancholia.

The weary angel is deep in thought, almost despairing, as if the choice for transformation were something disturbing. Scholars have interpreted the cryptic engraving as a symbol of the beaten intellect of the creative genius, but Lucia believed the masterpiece was additional proof for her thesis on the afterlife transformation described by the Egyptian funerary texts. It was this thesis she was working on, not the one on free oxygen she peddled to Grolsch. Like her grandfather Sir William Petrie, Lucia was obsessed with uncovering the meaning of the Egyptian legacy locked within the funerary texts. She was ready to risk her reputation to expose the Truth. Now that Grolsch had agreed to her leave, Lucia could accomplish two objectives, her cloning experiment and the out-of-body drug testing on John Friedman.

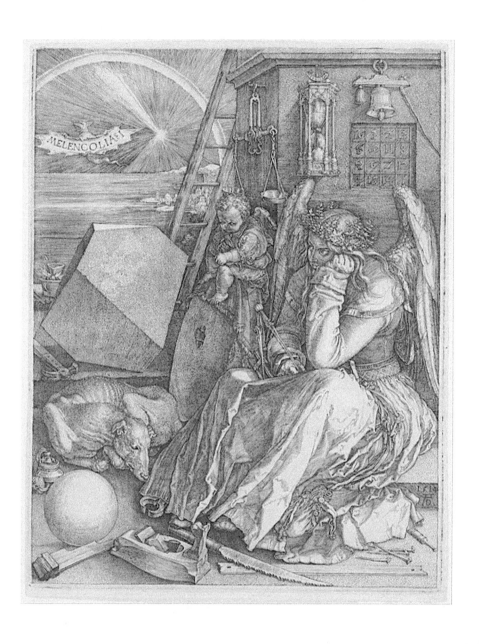

Melancholia I
Albrecht Durer

The Second Coming!
Hardly are those words out
When a vast image
out of *Spiritus Mundi*
Troubles my sight somewhere
in sands of the desert
A shape with lion body
and the head of a man,
A gaze blank and pitiless as the
Sun,
Is moving its slow thighs,
while all about it
Reel shadows of the indignant
desert birds.

The Second Coming
William Butler Yeats

4

Written accounts confirm that during the heat of the summer, it was not unusual to find William Flinders Petrie in his maroon underware digging in the hot desert sands. Leonine, rough-hewn, bearded, and passionate about how an excavation should be conducted, Petrie had no fear of getting dirty or sleeping with mummies stored under his bed. Excavating for forty-five years in Egypt, he had an uncanny sense of discovery aiding his thirst for knowledge. The British archaeologist and Egyptologist was largely self-taught with no formal education, yet it was his precise record keeping and meticulous preservation efforts that made posterity call him the Father of Modern Archaeology.

He spent from 1880–1883, studying and excavating the Great Pyramid of Giza, where he would sift and examine each shovel of sand. Sir Flinders Petrie, author of *The Pyramids and Temples of Gizeh* (1883), discovered that the base circuit of the Great Pyramid represented the earth's three separate lengths of years: the solar tropical year, the sidereal year, and the anomalistic year. To William Flinders Petrie, the Great Pyramid was a symbol of a glorious past and a higher spiritual reality.

Petrie's exactitude in scientific excavation techniques matched his integrity, for gold-digging and grave robbing were inferior pursuits for a mind questing for an ancient civilization's hallowed knowledge. He would carefully unwrap

layers of pitch and cloth to reveal rows of gold, beryl and carnelian amulets, rings, birds and lazuli figurines. Sir Petrie gloried in the ancient grandeur of Egypt and promptly catalogued and sent his artifacts to either the Cairo Museum or the British Museum. Still, as was the custom of most archaeologists, Petrie personally amassed a collection of eighty thousand Egyptian artifacts, the Petrie Museum, which he gifted to the University College of London when he died in 1948.

Surprisingly, one uncommon artifact was never catalogued for a museum. It was a small oval box, which Petrie had found in the King's Chamber of the Great Pyramid, and he gave it to his granddaughter on her seventh birthday. The ancient ivory box was decorated with three hieroglyphs at the top that signified the name of the god Amun, a bird wearing the feather of the goddess Isis in the center, flanked by the inverted half-moon for breadloaves and the *ankh* symbol for life. As a child, Lucia treasured the oval box her grandfather gave her, for inside the finely-painted relic beneath the polished gold sheet that served as a reflector, was a definite quantity of white shimmering sand from the Egyptian desert. The sand was magical to Lucia, so magical that as she aged, her obsession with Egypt, after the manner of her grandfather, provoked her to read everything about the Land of the Pharaohs.

Her research proved to her that only a fool could doubt Egypt's astronomical erudition. She discovered the Great Pyramid is the most accurately aligned structure in existence and faces due north with only 3/60th of a degree of error. The center of earth's land mass, which is the east/west parallel and the north/south meridian that crosses the most land, intersects in only two places on earth—the Great Pyramid and the ocean. Fact after fact demonstrated Egypt's superiority.

Consider that on midnight of the autumnal equinox in the year of the Great Pyramid's completion, a line extending from the apex pointed to the star Alcyone, which some present day scientists believe our solar system revolves around. Also, five of Egypt's pyramids on earth match the positions of five of the seven brightest stars in Orion: the three pyramids of Khufu, Khafra, and Menkaura for the belt of the constellation, the pyramid of Nebka at Abu Rawash corresponding to the star Saiph, the pyramid at Zawat al Aryna corresponding to the star Bellatrix. Their architecture on earth mirrors that of the stars.

Lucia learned that the Egyptians possessed a sophisticated knowledge of hydrostatics and hydraulic engineering, for during the reign of Menes, they constructed a lofty dike so effective that it actually turned the Nile waters eastward to Memphis. Their architectural feats, the temples of Philae, Abu Simbel, Dendera, Edfu, and Karnak, including the timeless grandeur of lofty pyramids, still baffle the modern world. Historians today wonder how a stone age culture

could create such monuments to Time, how the primitive mortal hand could frame the symmetry of the pyramids, the joints barely perceptible, the casing stones still in position, the centuried cement indestructible. Yet, despite their knowledge, Western historians claim that Greece is the pivotal nexus of cultural and artistic achievements.

Always searching through the opinionated muddle of history, Lucia discovered that the Greek historian Herodotus was the first to write about the seven wonders of the world, and later Greek historians followed suit with their descriptions. Five of the seven wonders were built by the Greeks, yet of all seven wonders, only one remains—the Great Pyramid of Giza. On a more personal level, Herodotus wrote in Book II that the black-skinned Egyptians and Ethiopians *have practiced circumcision since time immemorial. The Phoenicians and Syrians of Palestine themselves admit that they learnt the practice from the Egyptians.* Like Grandfather Petrie, Lucia believed modern chemists, astronomers, mathematicians, philologists, painters and architects should look to Egypt, the origin of their arts and sciences, for knowledge. In light of this wisdom, Greece's purloined contributions looked like the chopped liver of a Prometheus.

As a consequence of her research, Lucia began to believe that the white sand in her ivory box may have had a special use in Egypt. Why else would it come concealed beneath the gold reflector? It must have had a purpose. To unravel the mystery, she analyzed the chemical composition of the ancient powder and then fashioned a partial thesis for Grolsch to swallow, so she could take a leave to investigate the sand's properties. She then hired John and I as research assistants. Like her astute grandfather, Lucia's intuition would prove to be a great advantage in a world of scientists and scholars, who sometimes ignored Aristotle's statement that reason is subject to error.

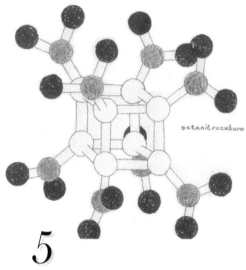

octanitrocubane

Look out new world here we come
Brave, intrepid and then some
Pioneers of maximum
Audacity whose resumes
Show that we are just the team
To live where others merely dream
Building up a head of steam
On the trail we blaze

Changing legend into fact
We shall ride into history
Turning myth into truth
We shall surely gaze
On the sweet unfolding
Of an antique mystery
All will be revealed
On the trail we blaze

Lyrics to
The Trail We Blaze
Elton John

5

John and I packed just enough clothes and supplies, hiking boots, a jacket for the cool evenings, a couple research notebooks, and two cases of Coors beer, which we were now drinking and spilling all over the old Bronco, as it lurched up the last dusty road to Lucia's house. The Sun burned relentlessly above the mountains along the road, which curved sharply to the right, and the landmark we were looking for soon splashed into view. A natural granite-tiered waterfall spilled out of the cliff's rocky jawbones like a huge swirling tongue in a blank stone face. Against the walled sky of amethyst mountains, it rose before us like a mutant living thing, writhing, eyeless, menacing in its height.

Defensively, John swerved sharply almost missing the road to Lucia's, then he downshifted the jeep to scale the last narrow incline, where a red-tiled roof separated a tan two-storied house from the indigo sky. In the west, the red Sun was setting, muting the purple mountains that blended into the tawny gold desert below. Central to the Old World design of the Southwest, a double-arched entrance with potted Pindo palms landscaped the walkway leading east past the front door to a glass laboratory, where Professor Farrell sat writing at a cluttered desk. Through the lab windows behind her, we could see a large inviting swimming pool, a cool oasis of glistening cobalt.

John clambered out of the jeep first past the main entrance to the open lab door. A couple of beers made him overanxious, for he knew Lucia had analyzed the sand in her ancient Egyptian box.

"Lucia, I want to know what the composition is," he said, as his eyes searched her desk for a glimpse of the magic compound.

In the past, we had worked with Lucia on several of her genetic experiments, so John felt comfortable calling her by her first name.

"It is something I didn't expect," said Lucia, motioning us to a small vial of the stuff on the lab counter past her desk. "Rhodium and iridium are elements found in carrot, grape or aloe vera juices, blood root, lecithin granules, St. John's Wart, blue-green algae, watercress, almond and apricot seeds, Mexican wild yam, flax seed oil, shark cartilage, and pig brain." She took a breath and continued. "The major ingredients of this powder are rhodium and iridium with trace percentages of platinum, silver and gold."

When I heard her say gold, she had my attention, but John looked puzzled as she continued. "The element iridium is found in gravel deposits with platinum and used with osmium to tip gold pen points and also used in cancer irradiation, hypodermic needles and helicopter spark plugs." She paused. "Rhodium is obtained as a by-product of nickel production and used as a coating to prevent wear on high quality science equipment and with platinum to make thermocouples. Both are transition metals with cubic-centered crystal structures as are gold, silver and platinum."

For a moment, Lucia's voice became distant, fading into oblivion as I looked at the Sun, a red half-moon in the mountains that was dying in the darkening sky. It may have been the effect of night rising that made the Sun coalesce into a triangulated crystal as it sunk into the earth. I wasn't sure. Then I realized I missed a lot of what Lucia was saying, but John was attentive, and she continued explaining that the Egyptians were aware of iron, gold, silver and copper. She then said that they had easily processed the natural elements found in the earth by sifting the dirt out of the desert sand, and the result was the soft white powder, which she was now emptying from the vial into a petri dish. It had a turquoise blue florescent glow that was hypnotic.

Obviously, this desert powder had some interesting properties, I mused, as I bent down to smell it, but it had no odor. It looked like dynamite, an invention that made a fortune for Alfred Nobel. He just packaged an existing explosive in a less combustible form. Actually, humans have been interested in blowing each other up since the creation of Greek fire. The Greeks simply added saltpeter to combustible mixtures already in use. Then the eleventh century Chinese mixed sulphur, potassium nitrate, and charcoal to get black gunpowder. In the nineteenth century, a Swiss chemist discovered nitrocellulose, but its unstable manufacture led to several unfortunate deaths.

But that did not stop them. In 1847, an Italian chemist concocted nitroglycerine, and it was this volatile compound that Alfred Nobel attempted to

stabilize. Even though an explosion killed his younger brother in 1864, he persisted until he mixed the nitro with a clay that stabilized it. Sure, he had reservations about dynamite's potential for destructive military use, so now what? Had the invention of dynamite really conferred the greatest benefit on humanity? Was it the most important chemical discovery or improvement? That was the criteria for the Chemistry Nobel Prize. Apparently, old Alfred's conscience must have bothered him, so he funded the Nobel Prizes for physics, chemistry, medicine and literature, along with the prize for peace.

Lost in the intensity of my thought, I watched John and Lucia quietly reviewing the research, as another cyclone of trivia spun through my mind.

Not everyone who deserves a Nobel Prize gets one. Leo Tolstoy, one of the greatest writers of the nineteenth century, was nominated in 1901 for Literature, and again in 1902, but the judges passed him over because Tolstoy rejected church and government authority. He championed nonviolent protest and considered warfare as wholesale murder. Although wealthy and a member of the Russian nobility, Count Leo Tolstoy gave away money to thousands of peasants, who remembered his generosity by lining the streets at his funeral. After being turned down twice for the Nobel Prize, Tolstoy simply said it was okay because he regarded money as the source of every evil.

But not everyone accepts the Nobel Prize. The philosopher Jean-Paul Sartre declined the Nobel Prize for Literature in 1964, rejecting the $53,000 award. Sartre said, "A writer must refuse to allow himself to be transformed into an institution, even if it takes place in the most honorable form."

In contrast, Nobel Laureate Fritz Haber, who invented the process for turning air into nitrogen fertilizer for food production, accepted the 1918 Chemistry Prize, and his maxim was, "A scientist belongs to his country in times of war and to all mankind in times of peace." For this reason, Haber pioneered the use of poison gas in World War I. In April of 1915, the German army used chlorine gas for the first time against the French at Ypres in Belgium. The French soldiers saw billowy clouds of yellow-green toxins drifting toward them, and then they inhaled a peppery-pineapple odor that left them with chest pain, burning throats, and a slow Death-by-asphyxiation. When these attacks began, the Allied troops wore masks of cotton pads soaked in urine to neutralize the chlorine. Fritz Haber directed the poison gas offense, which his wife Clara, also a chemist, must have resented, for she killed herself with his pistol. This tragedy, along with the legacy of chemical warfare and the fact that nitrogen now contaminates our environment, has polluted Haber's contribution.

Still, it is interesting that five months after the Germans pioneered the use of chlorine gas at Ypres, the British lost the Battle of Loos, even though they used chlorine gas and greatly outnumbered the Germans. Under the direction

of General Sir Douglas Haig, the British released tons of the *accessory*, the code name for chlorine, and the toxic chemical blew back on the British troops because of the wind, causing about twenty-six hundred casualties and seven deaths. Despite the 1899 Hague Convention's prohibition against employing poison or poison arms, the international peace treaty could not stop the Germans or the Allies from using poison gas, nor would it stop future aggressors from chemical warfare, I mused.

Just then, a pulse of cool air blew into the lab, as John opened the door and walked outside into the dusk. He lit up a cigarette, and the smoke swirled upward like quicksilver in the red glow left by the Sun.

So it seems that peace treaties against poison gas and chemical manipulation are useless in the modern world of warfare, but to me, this kind of uncivilized behavior is scientific misconduct that needs to be stopped. Concerned and hopeful that war would die, my mind groped into the future, for I was precognitive.

As Futurity flashed forth, I knew that chemists at the renowned University of Chicago would synthesize a new explosive, a molecule of eight carbon atoms to which they would attach nitro groups. This highly combustible cube with an explosive energy content greater than any known non-nuclear device would become a reality in the year 2000. They would call it octanitrocubane, a real feather in the college's cap, or I should say war helmet, for the U. S. Defense Department and the National Science Foundation were the funding sources for the research. The inventors would claim that octanitrocubane would burn into carbon dioxide and nitrogen upon detonation; they would casually claim, "It can kill you, but it can't be toxic," and even the American Chemical Society's Chemistry magazine would herald the synthesis of octanitrocubane as one of the year's chemistry milestones. Things would certainly come full circle if the inventors of this explosive cube were nominated for the Nobel Chemistry Prize.

Bear with me because along with being precogitive about world events, I remember trivia, unusual details, unique information. My need to recall gets especially bad when I'm nervous, as I was now about the potential use of Lucia's powder. John seemed concerned also, but with John, his concern was linked to an obsession to unveil some mystic Truth that would improve human life, not destroy it. I watched him flick his cigarette toward the first star, and then he came through the door talking.

"What makes you think the Egyptians processed this powder," he asked, moving closer to watch Lucia carefully pick up the petri dish of iridescent powder with two hands as if it were octanitrocubane. With her auburn hair in her eyes, she looked like a savage fire priestess making an offering to a god at a snake shrine. There was something ominous about her undivided attention to

that powder.

"When my grandfather excavated the Great Pyramid, he found this all over the floor of the King's Chamber," she said, as she funneled the powder back into the vial, tapping the lid tightly shut.

I felt a sudden relief until she said, "The Egyptians may have used it in their initiation rites."

John studied her carefully and I was silent, but Lucia would say no more. She darted inside an adjoining room, where she placed the sand in a safe cemented to the floor. Seconds later, she emerged to promise that we would learn more in the morning. Then she told us we had second-floor accommodations, saying that we were welcome to the food and the pool, but that she had to work tonight. After she went back to the lab, we drank most of our beer and grilled a couple of mesquite burgers for dinner because Lucia does not cook.

That which is Fundamental Truth,
the Substantial Reality,
is beyond true meaning,
but the Wise Men call it
the All.

Old Egyptian Proverb

6

Everything was yellow when I woke up. There were no shades or curtains on the large window that faced east, no yellow wallpaper, only a huge throbbing Sun, turning the room glaring yellow. Sweating, I stared into the pulsating, menacing heart of hatred, and it swelled hideously, then splintered into thousands of jagged teeth. Blinded by the prophecy of horror, I collapsed on the carpet, creeping out of the room into the hallway without looking back. Prostrate on the hall floor and trembling, I was easy prey for a trivia attack, and then the ghost of Brad Nowell bawled in my brain: *I have no sunglasses as I step into the sun I know I did something Lord what could it be?*

A rock-steady reggae rhythm then punked out *S a n t e r i a*. Frozen to the floor like a captive, I saw a tempest of relentless schooners, brigates, gallots, cutters, frigates, all types of slave ships carrying Africans from man's ancestral cradle to the Carribean. Cruelly uprooted from their land to the new world, the slaves would not give up their native religion despite being forced to practice Catholicism. *Santeria* was the result, a secret religion masked in Catholic saints, so the Yoruba slaves of the Carribean could honor their own gods.

I have no sunglasses . . .

Chilled by the wake-up call, I remembered a similar event in Fatima, Portugal. The year was 1917. It was two o'clock in the afternoon when Professor Almeida Garrett noticed that the Sun had broken through a patch of clouds. The pearl-like disc had a clearcut edge, was luminous and shining, but did not hurt his eyes or blind his retina. The clouds passed behind the Sun, which was

spinning in a mad whirl. Garrett reported that suddenly people cried out in anguish, as the Sun detached itself from the sky and rushed at the crowd as if to crush them. The sky then darkened into a curved roof of amethyst. Garrett thought that he had fried his retina, so he shielded his eyes and turned his back to the Sun, only to discover that the entire landscape was drenched in purple all the way to the horizon. He knew it was not an eclipse. The purple shadow then changed to a damask yellow that made the people look ugly and jaundiced. Garrett noticed that his own hands were stained yellow, a dirt-grimed yellow.

I sat up and looked at my hands in relief. No yellow stain. Calmer, I stood up and went downstairs. Lucia must have aligned the apex of the bedroom window directly with the sunrise. Anything was possible, for she was obsessed with Egypt. After that, I avoided windows with views of the Sun, checking my hands more than once, making sure they were still colorless.

Downstairs John was fresh from a swim. He lounged at the lab computer in loose-fitting orange swim trunks and no shoes. They say you can wear anything with a classic Panama hat—jeans, a business suit, designer resort wear, anything, but John was wearing bright orange trunks with the hat, and he looked like the comic Charlie Chaplin minus the mustache. Though he was tanned, muscled and slim, I preferred his hat—an ivory fedora encircled with a black grosgrain ribbon—on Peter O'Toole in *The Last Emperor* or better yet, Sean Connery in *The Man Who Would Be King*. Even Sidney Greenstreet in *Casablanca* was more appealing in the hat than John. Watching him, I sensed that he knew the hat irritated me, so I looked away, making sure that I did not focus on the eastern windows. I wondered if the day's weirdness would continue.

I was not disappointed. John soon explained how a farmer named Hudson had sifted volcanic soils in the western U. S. and isolated the same elements Lucia found in her Egyptian powder. Hudson claimed that he could convert his powder to its metallic forms—particularly gold and silver. For this reason and because he had several foreign patents, he would not disclose his processing technique on what he called a new form of matter—ORMEs for orbitally-rearranged monatomic elements.

Scanning a page of data, John said, "Hudson claims that his powder behaves like a superconductor at room temperature. It rides on the magnetic field of the earth giving it the power of levitation." Still talking, he clicked the print icon. "150 pounds of the stuff can give you 1200 ounces of rhodium, 800 ounces of iridium, 11 ounces of gold, along with smaller amounts of five other elements."

Lucia looked up from her desk. She could have passed for Kathleen Turner in *Jewel of the Nile*. Her long hair was tied in a ponytail, and she wore her lab attire—khaki shirt, khaki shorts and tan sandals.

At that moment, she leaned over and added, "Hudson also claims that the powder affects the pineal gland, what Descartes called the seat of the soul."

Not Descartes, I thought, that seventeenth century French bastard. His *cogito ergo sum* philosophy really dealt a crushing blow to the power of the Imagination. Translated, his *I know therefore I am* philosophy means total reliance on material sensual data at the expense of intuition. In other words, Descartes sensed that the pineal gland was the seat of the soul and purposely fashioned his rationalist philosophy against the Truth of his own intuition. Aristotle was right when he said reason is subject to error. Still, I found it interesting that the pineal, that small protrusion in the center of the brain, is the seat of the soul.

Distracting me, John said, "Hudson says they used the same powder in Egypt for spiritual journeys."

For a moment, I didn't know what to think of his powder. Hudson had to be talking about white magic. Two works came to my mind, *The Egyptian Mysteries* and *On Daemons*, both by Iamblichus, a third century mystic and occultist, who founded a School of Theurgic Magic to investigate Nature's occult powers. He taught White Magic, a sacred science of helping Nature by working with her, discovering her invisible side while benefiting both humans and Nature. Iamblichus believed that humans have an innate superior faculty dormant in most men that allows us to penetrate into the core of matter and see any object as it really is. Helping a man unite his divine spark to its parent-flame, the Divine All, the seat of wisdom, that was his intention.

Iamblichus had no interest in Black Magic, which had to do with human souls that lost their immortality because they could not connect to their Higher Self. In this group were Black Magicians, lost souls who concentrated on the material world versus the spiritual like Descartes and the living dead—suicides, murderers and such.

Just then, Futurity flashed before me, and I knew that one person commits suicide about every 40 seconds, one person is murdered every 60 seconds, and one person dies in armed conflict every 100 seconds, according to the World Health Organization on Thursday, October 3, 2002. I knew these facts through my innate ability for precognition of world events.

Then I remembered what Lucia had mentioned the other night about initiations, spiritual journeys, and—as if she had read my mind—she said, "The research isn't solid on this, but one initiation rite in ancient Egypt may have had something to do with ingesting this white powder."

A demonic smile crept over her face that matched the glint in her eyes. She looked directly at John, who immediately understood her intention.

"You want me to snort that stuff like cocaine?" he asked, closing his notebook, for he knew she was serious because she just kept staring at him. I choked

back a laugh, thinking that she could put it in his beer, but then I remembered how she separated the powder last night into those neat little lines in the petri dish. I saw the surprise in John's eyes that was tinged with fear, and his tan face looked yellowish, almost the same jaundiced color I experienced in the bedroom. Still paranoid, I looked quickly for the Sun, not really wanting to see that huge hydrogen bomb, just wondering where the hell it was. Fortunately, it was higher in the sky and smaller. Soon the laboratory roof would block it from view.

"Here's the plan," Lucia said, as she walked into the adjoining living room where a massive Georgia O'Keefe painting, a large sensuous *Red Poppy*, stretched the full length of well-stacked bookshelves. Both John and I watched her closely out of curiosity, fear and respect. With no hesitation, she selected a book, returned, pulled out her pen and made some notations in the index margin.

"I want you to review these two masterpieces by Samuel Taylor Coleridge, then take a little of the powder in a glass of water and tell me what the writings mean," she said.

John cautiously took the book from her extended hand. I knew that if John took the powder that I would have to also. As a friend, I could not let him do it alone. To my relief, John finally took off his classic fedora, and he looked like his old self, erudite, inquisitive, somber. Then he slowly opened the book.

"I've read both of these," he said abruptly, for John had studied most of the masterpieces. "What is it you want to know?" he asked.

Lucia moved closer to him, inspecting him like a cat cornering its prey. "I want to know the real meaning, John, not just the storyline," she said, staring at him.

John knew what she meant—she wanted what Coleridge called the *organic form*, the innate form that shapes itself from within the work of art. She wanted the deep meaning that Coleridge himself may not have known. Speculative literary criticism would not satisfy her. Despite being a scientist, Lucia had Imagination, intuition, and maybe a little madness. Her eyes burned with the haunted look of one of Van Gogh's self-portraits.

Thoughtful, John paged through the text. He knew that Coleridge had written the poem "Kubla Khan" after an opium dream about Kubla, the thirteenth century Mogul Emperor of China and descendant of Genghis Khan, who decreed a palace to be built. Awaking from a three-hour opium-doze, Coleridge penned down his vision of the sacred pleasure dome built on ten miles of fertile gardens, a savage place *haunted By woman wailing for her demon lover!* A sacred river ran from the pleasure dome to the dreary caverns of man, where only its shadow could be seen on the waves—*A sunny pleasure dome with caves of ice!*" The

poem ends with Coleridge becoming transformed into awesome glory and *holy dread* by the Eternal Female and her *milk of Paradise*.

"Where is this taking us?" he asked, obviously concerned because he had read Coleridge's works.

"Look," she said, "if this powder really was used in Egyptian rites in the King's Chamber, then it can penetrate into the core of matter and see any object as it really is." She was excited and pointed at *The Rime of the Ancient Mariner* in the book's index. "If you can take the powder, imagine one work of art at a time, see it in images and let it speak through you, we might be able to understand the author's unconscious intention.

I could see she was questing for perfect, idealized, intangible Truths, and we were interested in that also, but we did not really understand how all this related to her thesis on Egypt. We sensed she was purposely keeping information from us, but like Goethe's Dr. Faust, we were willing to trade our souls to her in return for her knowledge. We would soon learn that Lucia's intentions made Dr. Faust's pact with the devil look like a saintly gesture.

Then she plopped a large Mexican sombrero on her head and closed her notebook. "Take some time to think about it," she said, as she turned around and walked out of the lab to the wraparound deck that surrounded the pool.

Rationalists, wearing square hats,
Think, in square rooms,
Looking at the floor,
Looking at the ceiling.
They confine themselves
To right-angled triangles.
If they tired rhomboids,
Cones, waving lines, ellipses—
As, for example, the ellipse of the half-moon—
Rationalists would wear sombreros.

Six Significant Landscapes
Wallace Stevens

We immediately followed Lucia outside. She made herself comfortable on a chaise lounge next to the pool, as did John, but I was still wary of being in direct sunlight, so I sat opposite them under the shaded security of the deck table's ostrich-feathered umbrella.

Within minutes, Lucia gave us a clearer explanation of her rationale. Apparently, her grandfather's legacy of questing for Egyptian wisdom, along with the gift of the box inspired Lucia to unearth the meaning of the ancient Egyptian funerary texts. For years she studied the Old Kingdom Pyramid Texts and the Middle Kingdom Coffin Texts, finding the same themes present in both, even though some scholars thought they were not unified. She organized the similar themes in these texts into a matrix of 108 idea strands, noticing that the Egyptians had identified an actual path to Eternity through the cosmos. Lucia then mapped the path, which she verified by studying space physics, a young promising science. Comparing this data with her chemistry and physics knowledge, she was able to see remarkable similarities between cosmic and quantum events, which prompted her to read all the Books of the Dead. From this, she broke down the meaning of the interrelated Egyptian religious symbols into a scientific code that explained the genetics of the pathway and the nature of the dead person's afterlife transformation. She claimed that her code had restored meaning to the long-lost signs found in myth, religion and psychology.

Now all she needed was confirmation, proof from history's great thinkers and writers that their works indicated in some way the same hidden Egyptian science her code revealed. This would be additional proof that she correctly interpreted the Egyptian code. She needed to catalogue what philosophers thought about ultimate reality, what great writers and mythologists thought, mathematicians, physicists, for she believed they all had pieces of the puzzle. Like her grandfather, she was questing for an understanding of the deepest meaning of life, the illusive vision of wholeness on which everything revolves. She believed that it was culture's inane separation of the sciences and arts into different specializations that stopped us from seeing the whole and unburying the deep core knowledge.

This is what attracted her to John, a literature major well-studied in the best minds of the last three thousand years. She needed his input to prove her theory on the ancient funerary texts, for if she had uncovered the original meaning intended by the Egyptians, then these ideas would be threaded through literature, the same themes would be repeated in the works culture cherished as great art, and that is why Lucia invited John to her Arizona home. She planned to test her thesis by dredging John's mind for his knowledge, after he ingested the white powder, for Lucia imagined the magical stimulant had the power to explain The All by penetrating into the core of matter, the dark heart that harbored the creative artist's unconscious intention. As I said before, I was just along for the ride.

After learning this much, we still sensed Lucia was not telling us everything, such as the true chemical potential of the white powder, but she soon promised that we would ultimately know this secret and more after we understood the written evidence left by the world's greatest intellects. In time, she vowed, we would discover how all this linked directly with her sabbatical project regarding the cloning experiment and the path to the stars and Eternity.

Despite this breakthrough regarding her motives, we were still uncomfortable about the idea of ingesting the gold. I call it gold because that is what it was to Lucia, not real gold, although there was some in it, but gold in the sense that it was the means she needed to access the highest spiritual knowledge, The All. Both John and I were making a concerted effort to understand her logic, and as the afternoon passed, our conversation centered on creative inspiration and where it came from.

"The philosopher Martin Heidegger believed thoughts come to us," said John tentatively. "We don't create them; they come to us."

The conversation stopped at that point while we all thought about what this meant. John had time to walk over to the bar next to the lab, find one of the few remaining Coors, open it and drink half.

The thought-sender must be some crazy stand-up comedian, I mused, especially when you imagine the thoughts of every human in the world. Certainly, only a comic or a sadist could design the thinking of a child, a madman, a tyrant, or a scientist like Lucia. I watched her very closely as she stood up, stretched seductively and then plopped her straw sombrero on John's head. John quickly threw her hat back to her, which made her laugh like a young innocent girl, and for a moment, her eyes lost the haunted look.

But the look came back within seconds. "Heidegger's intuition is very disturbing," she finally commented, "for it suggests that we don't think for ourselves. We're puppets on a stage, we're shadows on the walls of our cave."

Lucia wasn't naive. She sensed that Heidegger might be right. Our intelligence could be enslaved by some designing Other, some evil genius, who creates our thoughts first, then sends them to us. It was an interesting idea—a reasoning system we had no control over, and I could see the spontaneity of the idea appealed to John, who often made use of reason but preferred Imagination. Still, I knew he had experienced moments when he thought he could free his mind from reason, but was afraid to do it for fear of losing his sanity or being labeled by psychologists.

Remembering more of Heidegger's ideas, John said, "The thoughts that come from deep within the conscience urge a person to live up to their full potential, and most people ignore these calls from the source of thought, but Heidegger said that those who think and create with words are tapping into the actual source or *house of Being*."

He glanced at me, then focused on Lucia who was smiling, her sharp intuition making her careless. "Heidegger," John continued, "believed that freedom could be found through Imagination, what he called *the original revelation of the Nothing*. He said there is a *lighting center*, a passage for a human to reach his full potential, and a mystery with some concealed danger." He paused. "All of this requires a loss of reason."

Why not add Death and transfiguration to the list, I thought, looking hard at John, and then I realized that in a clever way, Lucia was convincing him to experiment with the powder, and to be honest, John did not need a lot of persuasion because he enjoyed the mind-expanding power of certain drugs, for he was always reaching for the sky.

Even so, I was more interested in the process of thought and its source rather than the white powder, so I considered that if thoughts are sent to us, then cause and effect, deduction and the Scientific Method may not be valid. We may be receiving only parts of the transmission, losing or not remembering the whole message, for even though reason allows us to put these parts in neat little packages, it may not be the whole package, the complete thought.

Momentarily distracted, I watched Lucia pick up a yellow beach ball and sit back down on the lounge. She was spinning the ball on her lap, and I avoided looking at her, so I could keep thinking. What worried me most about this idea of thoughts coming to us was that it could be true. Modern brain research confirms that our brain is a receiving organ. On the other hand, psychologists treat schizophrenics every day who suffer from the delusion that some Other is inserting thoughts into their minds.

Brain messages, mental disease, thought insertion, all this trivia was running through my mind when I realized the Sun's progress across the desert of blue sky had placed me directly in its gory red glow. I moved quickly back into the shade of the umbrella, checking my hands to see if they were yellow, but only my mind was yellow, for the thought of that pulsing Sun kept coming back to me like a bad reflex, and I had to admit that I was now afraid of the Sun.

More thoughts fired through my mind as I considered that a clinical psychologist could easily diagnose me with *flight of ideas* or label me a paranoid schizophrenic, and then a thought arrived telling me that there was a positive side to *thought insertion*. Yes, every writer looks for this opportunity. Theodore Roethke, who by the way, went to the University of Michigan and then Harvard as a graduate student, received his poem "In the Mind's Eye" from some Other, and he said the poem virtually wrote itself on a summer day in 1958. For Roethke as for many writers, the process of going that deep into his mind was dangerous, but after three breakdowns, the poet still did not care about the dangers, since he believed that madness was a sign of a noble soul. Roethke wanted to know the great mystery of life like Lucia and John, and that mystery could only be unveiled at the edge, the brink of the cliff where madness threatens sanity, where chaos overwhelms order, and where meaning assaults language.

But still, one must consider what happened to Gerard Nerval, the French writer who would eat ice cream out of skulls and hold literary seminars in the nude, the surrealist who would walk a lobster on a pale blue ribbon through the Palais Royal gardens. Nerval's Imagination was his *infinite delight* while reason was the loss of his happiness. He believed his dreams were a second life that could reveal the meaning of life.

Considering this, I could not help but think that dreams originated from the same source as thought, for they were just as fleeting, and Nerval must have thought this too, for he attempted to *fix* his dream state, and when he did, Black Magic made him hang himself from an apron string, what he called the Queen of Sheba's garter. But was it just Black Magic that suicided him, or was it the torment of his spiritual quest that offered him an answer to his questions, an answer that could only by discovered through Death?

Whatever the circumstances, it was obvious that thought insertion could be dangerous. At that point, I tried to stop my thinking, but Heidegger's ideas kept arriving in my mind, taunting me with possibility, plaguing me until I followed the thoughts to their grim conclusion. If thoughts come to us, then some Other may have been driving Nerval mad by playing with his mind, making him think he could discover the secret of life. The same Other could also be motivating Lucia, who really did not know how much of the powder a human body could take or its long-term effects. Faced with this knowledge, I could only console myself with the idea that Lucia was sane, even though she was playing with our minds, just like she was playing with that ball.

At that moment, Lucia threw the beach ball at John, making a statement that went right through the hoop of his mind and into the turquoise pool that now rippled with blue crystals.

"Our scientists have also received thought insertions. The German chemist Friedrich August Kekele came up with the molecular benzene ring structure after a dream about a snake biting its tail." She continued triumphantly, "Einstein imagined himself riding a light beam when he came up with $E = mc^2$."

When she mentioned Einstein, she scored. John respected Einstein. Laughing, he stood up and dove into the pool after the ball, disappearing in the sapphire waters which splashed on the deck. Slowly surfacing, he swam to the side of the pool like a sun-tanned idiot boy, grabbed the beach ball and spit water from his mouth.

He said, "The joke is on us. We don't possess our minds, even though we reason as if we do." He paused. "Our reasoning comes from some alien mind."

Lucia reinforced his brainstorm. "It follows we must learn to think differently, we must learn to be seers." Hearing this, John sank leisurely under the water the same way Ahab did when his corpse was lashed to the cross of Moby Dick.

And then another thought arrived at my mind's door. What idea are we stuck on that is stopping us from thinking differently? The poet Shelley believed it was our idea of God that was confusing us, that the explanations of religions, legends, mystics and saints have attempted to explain it, but have missed the point. As an idealist, Shelley wanted to overthrow the church, private property and the monarchy. As an escapist, he sailed his small boat out into the Mediterranean Sea, aware that a storm was coming and he could not swim. At age twenty-nine, he must have wanted to drown and he did.

Like Shelley, Nerval believed that we have misinterpreted the secret of life, but still, there must be another way of discovering the secret other than suicide. After all, the human Imagination is free, unreasonable and inexhaustible. Anything is possible and it does not have to be proved. A wordless intuition can nail the joker to his coffin, so to speak. Sounds crazy, but many of our great

writers and thinkers suffered breakdowns or were diagnosed manic, depressed, or mad by the standards of reason.

Perhaps by using their Imagination, these visionaries were struggling to free themselves from the trap of an alien reason, a universal, thought-controlling Other that sends us our thoughts. Thinking this, I suddenly felt free, albeit close to madness, for if Lucia were right, her code would decipher the mystery of the Other. Enlightened, I no longer feared the power of the white powder. Like John, I was beginning to see that Lucia's gold might lead us to knowledge that could explain the idea of God and eliminate the fear of Death.

It is cruelty that cements matter together,
cruelty that molds the features of the
created world.
Good is always upon the outer face,
but the face within is evil.
Evil which will eventually be reduced,
but at the supreme instant when
everything that was form will be
on the point of returning to chaos.

Letter dated Paris
November 16, 1932
Antonin Artaud

8

The next morning Lucia put on white gloves, unlocked the safe, retrieved the powder and carefully diluted one-half teaspoon into a glass of water. The gloves were an unusual touch, making both John and I nervous. The night before, we decided that it would be best if only one of us took the powder. Neither of us wanted to say it, but we did not trust Lucia. So, after she went to bed, we opened a fifth of her Irish whiskey, resolving that whoever took the last shot of Bushmills would have to drink the gold the next day. Last night, John drank the last shot with real gusto, but the memory of this now made him look tense.

Holding the elixir in her left gloved hand, Lucia grabbed John's elbow with her free hand, steering him into the living room with me right behind. To the right of us was a large fireplace trimmed in brown oak that matched the sable flooring. Just beyond were oak-trimmed double glass doors crowned by a large window in the shape of a half-moon to capture the beauty of the mauve mountains. A large wooden chandelier with dozens of crystal candelabras hung from the center of the gabled ceiling. I marveled at the Old World elegance of the room, waiting for Count Dracula to come out of some hidden door. We crossed what seemed to be an endless Oriental rug, stopping before a large white leather couch in front of a wall of book shelves. Lucia picked up a remote lying on top of a book about Coleridge's works, pressed it once, and the music of Rachmaninoff shrouded the room. O'Keefe's painting loomed above the book

shelves like a mighty vegetation god, and for a brief moment, I thought the huge *Red Poppy* was pulsating, but I was wrong.

John did not look good. At first, I guessed that the Bushmills had made him green around the gills, but it was more than that. John was afraid of dying.

Lucia plumped up a pillow for his head with her right hand, as the glass with its contents shimmered in her left. John laid there staring at me like a man waiting for the guillotine. When he swallowed the gold, it felt like he had punched me in the throat, although he never actually touched me. I soon realized that although the drink had not affected Lucia, it had drugged me for some odd reason, which I could not explain. Was it because John and I shared a psychic connection as friends? Was it because I happened to be standing closer to him than Lucia when he took the shot? I did not know why the gold flooded both of us with its magical power.

I felt strange, but not actually uncomfortable, and I could see relief in John's face and intense fascination in Lucia's eyes which frightened me, so I looked at the *Red Poppy* to avoid her stare. Quit thinking and learn to see, I told myself. Then I imagined I was becoming the painting above the book shelves. I could see my breath dissolving into shades of deep red and crimson black as I merged with the painting, my spirit flowing toward the canvas above me, my mind blank, a new objectivity emerging. I turned away from the canvas as the music faded and was swallowed by a deathly silence.

Alone now, I had the distinct impression that I was being watched by something behind me, something malevolent. Turning around very slowly, I saw the black eye of the blood-bright poppy staring at me, knowledge seeping out of its brilliant center. The idea that opium does not impair sensory perception, the intellect or motor coordination was blooming from the plant, along with the message that the writer Coleridge used opium to intensify consciousness.

I knew that Coleridge's creative Imagination often tormented him with images of horror—ghosts, specters, Death. It seemed that the characters in his poems were always doing something unpredictable, something stupid. For example, his mariner killed an albatross with his crossbow for no reason. The bird was just a friendly seabird.

Inspired by the vermilion flower, I inhaled its heady perfume to intuitively learn that the cultivation of *Papaver somniferous* is banned in the USA under the Opium Poppy Control Act of 1942. Interesting information, I thought. This poppy must be some type of universal knowledge database. Do not reason, I told myself, and a feeling of pleasure flooded me, as the flower stirred seductively to the plaintive cry of a violin. I was overwhelmed by the melancholy music and the uncomfortable feeling that I was hearing and watching something I should not, when I saw an angry man slamming a door, screaming, "No more

mistakes! Keep practicing! Practice until you're dead!"

Compassion flooded me for a young boy sitting terrified and tearful near a window, his violin on his lap. I immediately knew the child prodigy. Niccolo Paganini spent little time playing outside or relaxing because his unrelenting father dreamt of wealth from his son's genius. Seconds after his father's furious outburst, the child picked up the violin and again began to play with what can only be described as tragic joy. As the violin rested on his small shoulder, its soft wood curved inward, slowly caressing Niccolo's face, then the hard instrument collapsed, twisting cruelly to swallow the child's head.

Startled, I stared at the void violin face on the boy's shoulders, only to see an older face emerge from the violin's wooden belly. Wild, untamed, possessed, he looked like the devil—pale skin, skeletal face, hollow cheeks, thin lips curling into a sardonic smile, piercing coal-black eyes. Niccolo the child had become Paganini the man, and then dark information flowed into me like a heavy rain cloud.

Many admirers of Paganini rumored that he was the son of Satan, not only because of his looks, but because of his excellence at the violin. At one concert, three hundred people were hospitalized and officially diagnosed as suffering from *over-enchantment*. Add to this the Paganini legend that he sold his soul to the devil for his violin skill and the love of a woman, and you have it all—the Devil, bondage, excellence and the lure of the Eternal Female.

The haunting melody of Paganini playing his beautiful *Love Theme* flooded my senses, as the *Red Poppy* whirled softly nearby, becoming uncomfortably larger. Then, for no reason, it began to throb and spin sickeningly, making the room thrash back and forth, turning Paganini's *Love Theme* into a wail, making me want to vomit. Unbalanced, I lunged back from the crazed poppy just as a deafening piano blast exploded from its black mouth along with a profusion of dark sticky pollen that materialized into the sadistic image of a man beating a piano as if it were a horse. I could not breathe, but the poppy continued informing me, thrusting its knowledge at me, and I instantly understood the angry pianist as Sergie Rachmaninoff. I screamed, "Stop pounding on that horse! Leave it alone!"

I covered my ears, but nothing could stop the noise, the agony, the terrible dual between Paganini and Rachmaninoff. The *Red Poppy* whirled faster, driving its dark knowledge into my mind, thrusting the idea forth that Rachmaninoff had specifically written the piece, *Dies Irae Variation 7,* to counter Paganini's enchanting *Love Theme* by introducing evil. I knew the *Dies Irae*, the first verse of a sequence in the Catholic Mass for the Dead. I found myself chanting the translated Latin like a programmed robot: *Day of wrath and doom impending, David's word with Sibyl's blending, Heaven and earth in ashes ending*—I was sweating

profusely. The *Red Poppy* seemed to know everything. I panted, wondering how I could escape its knowledge and the scene before me, but the mad Rachmaninoff kept beating the piano. Badadadum Badadadum

As Paganini's violin heightened into a piercing squeal, I was struck with the terror of wrath and the ecstasy of love, bound as they were in a piano-violin clash of Death that was breaking my reason, pushing my mind over the edge. Screaming, I reeled backward with severe vertigo, and then the engorged flower from hell began to bleed, and blood was vibrating everywhere, as if the red molecules had a life of their own.

Just when I could no longer bear the rapid movement, the thick colors, the thunderous noise, the bittersweet smell of blood, everything stopped as quickly as it began. A deadly calm hung over me as I watched a long tongue slither out of the poppy's blackened mouth, and then the tongue transformed itself into a black snake that wavered magically before my eyes.

The taunting snake was talking to me, words were coming out of its gruesome mouth, but I could not hear the sounds. I could only sense an idea, a thought that creativity is akin to madness as opium is akin to a gentle and constant orgasm. Captivated, I looked closer into the opaque blank eyes of the talking serpent, and then it hissed and struck at my face. I quickly turned my head, but it was too late. The snake was stuck in my throat.

I gagged instantly, then the bloody flower slavered like a ravenous red dragon...*M o r p h i n e*...*M o r p h i n e*... and I inhaled its dark fragrance, wondering why I must know about madness and morphine. Avoiding reason because it now made me panic, I stared back at the bestial bloom and watched as the green iridescence from its leafy berth rose higher and higher, breeding more and more poppies too quickly in the garden. Paganini and Rachmaninoff were drowning in that red sea, the barbaric strength of their music thundering in my ears. The poppied horizon climbed faster and higher to monstrous proportions until the garden split, ripping an oblique path through its mad center. A gunshot blasted overhead, and I looked up. Like an angel of Death, a white albatross flew gracefully over the horde of orgasmic poppies and along the oblique path.

My mind racked by the music's harsh noise and the increasing profusion of poppies, I focused on the albatross, following it along the oblique path. It reminded me of a stork. This idea brought a delicious sense of ease and peace, a strange elevation of my intellect and a consciousness of power, as I floated into the open pathway. Then, with a sudden rush of wind, one fiendish flower burst before me, its black cold center sucking me up in a suffocating movement, as if I were a wisp of air. Rachmaninoff's sinister piano staccato collapsed into a silent abyss, as Paganini's *Love Theme* melted away. Only the macabre stare of

some demon's flashing eyes congealed within the darkness, as I struggled to breathe.

A mixture of anger and frustration enraged the savage cold eyes. Full of cruelty, I sensed it was the white albatross, and then something shifted within me, dissolving the eyes and replacing them with an electromagnetic dance of data that was oozing from the poppy's center. A stream of trivia.

The poppy tightened its grip on me, squeezing hard, and the information oozed out at a slower rate—the German pharmacist Wilhelm Serturner first isolated morphine from opium in 1805, then named it after Morpheus, the Greek god of dreams. One ancient source claimed that Morpheus was skilled at miming any human form in a dream. Entranced, I slipped easily out of the poppy, tumbling to the Oriental carpet. Georgia O'Keefe's god-awful painting loomed above me.

Strange dream, I whispered half awake. Then I discovered that it was John I was looking at when I thought I saw an albatross. Lucia was soon next to him with a cold cloth for his head, but within seconds their faces were replaced by the horrid eyes of the albatross. I was compelled to find Coleridge's *Rime of the Ancient Mariner* in the book on the end table. Seeing the poem listed in the index, I immediately knew the story—mariners go out to sea, stupid mariner kills innocent albatross, Death haunts the ship in revenge, all die except one who lives to tell the story.

Something was pushing me to find out why Coleridge made the mariner kill the albatross. I succumbed to my habit of using reason and morality. Was the bird really evil? All it did was follow the ship and eat their food. Doesn't seem right that the mariner should just pick up his crossbow and shoot the poor bird.

My intuition insisted that the white albatross was dangerous, evil in some way, deceiving. Something was driving me to find out why the bird was bad. But was it bad or good? I couldn't decide. What would have happened if the mariner had not killed the albatross? Knowing I had to go in to the work itself, I quickly turned to the poem, watching the black print enlarge and everything whiten, as I merged into the actual writing and another vision.

Immediately, I was cold, very cold. We were sailing north toward Xanadu, frost glittering in the gossamer moonlight on the deck. The mates shivered as they prayed. Little did they know about the invisible God they praised, except that they were made in his Image. We sailed on with a sense of despair uncommon in those who pray, and Time passed in a way that made us think we were standing still.

Unnaturally, a large dark shadow appeared in the cold mist, moving slowly toward us., slithering closer through the fog until a large white albatross with

kindly eyes landed on the mast. I had a horrible urge to strangle the friendly bird, for I was beginning to sense why the mariner wanted to kill it, although I could not quite put it into words.

Just then, the mariner walked up, shot the bird with his crossbow to the horror of his shipmates, who quickly picked up the bird-corpse and slung it around his neck like a scarf. From here on, the ship was at a standstill in the waters. I mean no movement, no air current. That's because the mariner had killed the bird that made the wind blow, so we were just stuck in the cold sea with the moon eyeing us like we were fresh meat waiting to be devoured.

I avoided the tell-tale eye of the moon, and for good reason. Soon my moonstruck mates were dropping dead, one by one, like sheaves of wheat dropping before a reaper's sickle. Only the mariner and I were left, and to our dread, we saw another strange shape winding toward us over the spectral sea, illuminated by the Sun masked by a dungeon grate, as if it should be kept prisoner for our safety. In the silvered light, a lovely woman approached with a dark companion, and they lingered on the bow.

"That's Death with her," said the mariner, whispering to me that despite her looks—golden hair and ruby lips—she was a nightmare too.

"You caused this," I said, "you shot the albatross."

We watched as the woman and Death began to roll bones on the ship's deck, playing crooked dice for our souls. I was not about to stake my freedom on the last cast of the die. Maybe Paganini sold his soul, but I was not going to gamble with my life, even though Death and its lady looked at it differently—they were just keeping their word. I could read their minds. Out of the corner of my eye, I noticed the trigger-happy mariner aiming his crossbow my way, and then in fear and desperation, I did something that I did not know I could do. I changed Coleridge's poem by imagining that the mariner had not shot the white albatross.

Within less than one second, as if someone had clicked fast rewind, both the woman and her Death mate vanished into the ghostly fog, the men rose from the dead, and the albatross somersaulted off the mariner's neck and back onto the mast deck. The crew was spared the inevitable judgment scene of Death that occurs in the poem. Anti-apocalypse, if you will. Take your revelatory knowledge and shove it, I thought, now let's play this again. Maybe I could find out the real meaning of the poem, the meaning Coleridge himself did not know.

The mariner and I stared at the albatross, who we still believed deserved to die, as the livid forms of Paganini and Rachmaninoff riveted across the waters, swooping down on the ship like large birds of prey. On cue, their music exploded horribly around us, and it came to me that the albatross was some

bizarre love symbol gone wrong, although I could not prove it by rational standards. The mariner was aiming his crossbow at the white bird again, and the bird, in defiance, rotated around, lifted its middle tail feather high in the air like a finger, and then it squawked once, pooped on the deck, and transformed itself into the lovely lady Christabel.

For those of you who have not read the works of opium-doped Coleridge, Christabel was the lovely virgin that the vampire Geraldine seduced. Lucky at love, Geraldine also seduced Christabel's dad, Sir Leoline, who sensed the exceedingly beautiful Geraldine, arrayed in white silk and gems, was weird, possibly a drag queen. Looking in her divine eyes, Sir Leoline saw a disturbing duplicity. One of her divine eyes would suddenly rotate and take on a perfidious, unsettling look, almost reptilian. As was the custom of the era, Leoline asked his Bard for some input. That night the Bard dreamed that he saw the maiden Christabel in the form of a dove in the woods with a green snake coiled around her neck, sucking her lifeblood. The snake, of course, symbolized Geraldine sucking the blood of Christabel.

Eying the mariner, I put my hand on his quivering arm, knowing that he was seriously considering shooting Christabel because a green snake was crawling up her leg, slowly disappearing beneath her gown, the sick virgin just smiling. A Roman Catholic image flashed in my mind of a statue of the Virgin Mary with her arms outstretched, a snake curling between her toes. Instinctively, I lunged forward and ripped the snake off Christabel's leg, thinking it was evil. This freaked the mariner, who accidentally shot an arrow from his crossbow into Christabel's heart.

As Christabel fell to the deck like the albatross had before, the snake spiraled up in its deceiving masquerade as the glorious Geraldine. Arms bare, eyes divinely dark, hair dazzling with black diamonds, her silken robe, unholy in the moonlight, lightly fluttered in the still air to reveal her breasts and half her bloody side, raw from being pierced like Christ's. Then that one twisted eye of hers began to glitter like the eye of the mariner, who was mastered by her Black Magic. It was then I realized that the mariner had shot the albatross for divine approval, that the beautiful image of woman and love was somehow terribly linked with Death, that beauty was the beast.

Breathless and appalled, I watched Geraldine stretch out lovingly to embrace the mariner, her dark magnetic eye glittering, revolving. I spun around in fear from the unholy sight, slipping and tumbling over the deck rail into the gaping mouth of the sea. Down, down I plunged deep into the icy waters, only seeing blackness and starry light that heralded the depths of my unconsciousness. Black diamonds flashed everywhere in the seething space, whirling with me into the deep.

Despite this situation, information still flowed into my mind. Physicists say that for every particle known to exist, there is an invisible twin particle. The twins are intimately related, except that one particle is matter and the other is an undetectable light wave—some call it a God particle. Planets, astral bodies and human bodies make up four percent of our universe's matter. Dark energy and dark matter are the invisible gunk accounting for the other 96 percent.

Floating aimlessly through the black diamonds, I imagined they were the God particles of dark matter and energy. Maybe my own God particle was out there, hidden in the darkness, omnipresent, silent, watching over me. Maybe I was a God particle. I glanced around as I drifted inside the belly of the stony sea like a corpse, sinking deeper and deeper into my capsule of Time.

Lost in a deathless coma, I sensed I could never regain my equilibrium in the underwater world where I was trapped, and just as a wave of despair began to crush my heart, I inhaled the familiar sweet heady smell of marijuana. Then a bright light flashed, blinding me. A painful explosion of sound lacerated the waters, adding to my confusion, making me think that Geraldine would soon have her way with me. To my annoyance, a cold sea of new faces materialized, glassy-eyed, indifferent, narcoticized and chanting *I want to rock and roll all night and party every day*.

It was hotter than hell, and I could hear the voices of musicians rasping out something about being unholy, being a worm burrowing through a brain, then bone-crunching heavy metal music slammed hard into my ears, and turning to where the massive flashing light had been, I saw KISS in concert. Musicians masked as demons danced and gyrated on stage, one singer snaking his tongue, another spitting blood. The idea flashed before me that they were perfect partners for Geraldine, who masked her depravity. The only difference was that the musicians were humans masked as demons, and Geraldine was a monster masked as a goddess. Thinking *Dunkel ist das leben, ist der tod*, I looked down and to my horror, I saw a concrete cubic solid moving toward me at a great speed, crushing into me in a flash of sharp whiteness, then darkness, no pain, just black diamonds everywhere.

I floated in unbounded space as if I were a disembodied life-force. Then people were yelling and pushing me off them, shoving me away. Someone said I was an idiot for jumping from the second balcony to the concrete platform. I looked up and realized that it was true. I had jumped from the second balcony. The spellbinding light from the stage's huge eye-shaped background had blinded me. Mystified that I was not hurt, I stared at the prophets of doom on stage, their hands striking their thundering guitars. Like dead leaves swept up in a tornado, their words whirled above the crowd, spinning out a dire message.

Your day is sorrow and madness . . . Got you under their thumb . . . Whoo black diamond . . .

I wandered through the swarming riot of bodies, searching for an exit, thinking that no one was going to keep me under a thumb because I was alive and still free, for the fall had not killed me. The relentless guitar gods pounded on, enthralling their slug-like audience, a single multicellular organism bent on oblivion.

Then I saw John and Lucia, and the music lost its mystique, for KISS was only in concert on Lucia's sound system. Relief flooded my mind. I had made it back from the poem. But then a sharp pain riveted across my stomach with a rush of movement through my throat, and uncontrollably and with little ceremony, I bent forward and vomited a black snake on the Oriental carpet.

9

There came
and looked him
in the face

An angel
beautiful and bright

And that he knew
it was a Fiend

This miserable Knight!

Love
Samuel Taylor Coleridge

Within thirty seconds, I had recovered from the nausea of vomiting and regained full consciousness. I actually felt good and so did John, but I was disturbed when I could not find the snake anywhere. We decided to sit on the deck and discuss what happened. I soon learned that the reason I never saw John was because he had made a series of rapid transformations into inanimate objects, moving from Paganini's violin to one of Geraldine's gems to the mariner's crossbow to the masks of the rock musicians. Space had actually dissolved and reformed for each transformation, making change possible.

His mind intrigued by this new world of novelty and evolution, John now viewed both the inanimate and the animate as living. Seeing the future and past as an unlimited free interchange ripe with potential for change, John had stood on a ground of unconditional energy that dissolved from one form, only to recrystallize into another. The powder also made John talk about trivia that I did not know he knew. Everything came right out of his mouth exactly the way

I sensed it. Scientist that Lucia was, she listed every detail of our trip, telling us that we were conscious in the subatomic world, that we had experienced quantum consciousness and nonlocality. Although we never knew it, John and I were at the same location in different forms, while connected by thought at all times.

Apparently, we actually experienced the knowledge that O'Keefe had unconsciously when she painted the *Red Poppy*. Our minds had enfolded into the music to witness Rachmaninoff and Paganini in the madness of their creativity, to see KISS in concert, and to sense Coleridge's deepest intuition about the dark side of beauty and love, that it masked something frightening. It was this particular insight that was the focus of John and Lucia's discussion.

Lucia made notes as John turned the pages of Coleridge's *Rime* to the part where the mariner kills the albatross. He studied the text quietly, then flipped to the poem "Christabel."

"The white albatross and Geraldine," he said, "were messengers of Death in disguise."

"Yes," said Lucia, taking notes, "the same disguise—whiteness, beauty." Glancing at her notes, she added, "If Geraldine appeared as the beast she was, Christabel and her father may have had a warning, a chance to escape. They were attracted to her beauty like the moth is to the light."

"This idea of beauty masking the beast can be found in many works of literature and art," John said. "The poet Rilke wrote that *beauty is nothing but the beginning of terror* and every angel is a terrifying, deadly bird of the soul."

Like the albatross, I mused. My senses were right. The albatross was something dangerous, and the mariner knew this too, so he shot the deadly bird. No wonder Coleridge used opium. How else could he live with his own creative inspiration? Or maybe he was using opium to tap into his mind, to step back and watch himself. Whatever the circumstances, the inescapable reality is that killing the white albatross that made the wind blow resulted in the Death of the crew. No wind, no new life, no stork, just Death.

"Now Shakespeare's *Tempest* inspired Edgar Allan Poe's *Masque of the Red Death*," John said, pausing just long enough to add it to a list he was making. "Poe's story is about a horrible plague that is killing everyone in Prince Prospero's kingdom. Prospero decides to quaranteen one thousand of his best friends in his abbey. So he barricades everyone inside including himself and provides an extravagant party with wine, women, song and dance. Poe made a point of writing that Beauty was there on the inside with them, while the Red Death roamed outside."

Lucia was listening intently. "So we have the same theme again of Beauty and the Beast which united is Death," she said.

"Yes, but there is more," said John. "After everyone was inside, the bizarre

Prospero decided to have a masked ball in his imperial suite of seven chambers that were arranged so that each room only became visible as you progressed from the first to the last room. So you had this maze of chambers with sharp turns," said John, circling his right arm to indicate a spiral.

"The first chamber was blue, the second purple, then green, orange, white, violet and finally the last chamber was a deep blood red. In this chamber was a huge ebony clock, whose hideous chimes could stop the party, the laughter, and the musicians from playing."

John was at his best, easily remembering all the nuances of the story, the plot, the colors, the sounds, the details. Watching him, we could see how he savored twisted plots and strange characters. He seemed to be a man caught in the web of his own storytelling. He boldly acted out the role of Prince Prospero, then the wide-eyed stare of convulsive lust that Death might have when it stalks its living victims.

"After the clock's last chime," said John—standing to pull his tee-shirt over his head, hunching like some deformed creature—"a masked presence plodded through the first blue chamber. The party crowd soon noticed the masked stranger, their surprise turning to horror as they recognized the tall gaunt visitor shrouded in a hood with his vest spotted with blood and wearing a gruesome mask that resembled a screaming specter."

John talked quickly, as he slowly pulled his tee-shirt off his face, now imitating Prospero. "Insulted because he recognized the mask as that of the Red Death, Prospero quickly ordered the revelers to seize the guest and unmask him, but everyone was afraid. The Red Death then traveled from the blue chamber to the red chamber with the enraged Prospero following, his dagger drawn and raised to kill. Everyone was paralyzed with terror."

John paused briefly. "Finally, Prospero confronted the hooded figure, gave a cry of horror, and dropped dead. When the revelers approached the intruder, there was no tangible form present, only the mask and shroud. Soon all were dead and the Red Death victorious."

Lucia stood up, walked into the living room, selected a large book from her shelves, and returned.

"Have you ever seen this sketch of Goya's," she said, placing the book before us.

We looked at the dismal drawing of a cloaked figure, the dark face unseen and shrouded, with the right hand holding a smiling mask as it stalked fleeing, panicking soldiers. Goya had drawn the classic representation of Death, awesome in its indifference. We stared fiercely at the nightmarish sketch, a preparatory drawing for *Disparates*, noticing that Goya and Poe shared the same idea of the image of Death.

I imagined that if the shroud were drawn back, I would not be able to peer into the maddened eyes. John must have been thinking the same, for his eyes were glazed with the knowledge of something horrible. For a moment, he looked frenzied, disturbed, a conscious horror in his dark expression.

Lucia just stood next to John, staring silently at the black and white drawing from Goya's Black Period. To me, it did not seem unreasonable for one to prefer beauty over horror, but why the deceit, the masquerade, the shroud? Are we so fragile that we can not look Truth in the face? Do we need to be shielded by images of beauty? I did not have an answer, and I did not want one, but Lucia and John were hounds on the scent of Death.

"Poe's story reminds me of Joseph Conrad's *Heart of Darkness*," said John, closing the book. When he said heart, I cringed, remembering the vast, blank eye of the sickening Sun and how it had throbbed like a panting heart. My chair scraped across the wooden decking as I stood too quickly, springing for the adjustment knob on the sun-shade to make sure it blocked out the stalking yellow eye in the sky. Within seconds I was safe from the sunlight, but not from my own thoughts, which kept coming back to me like bad reflexes, magnifying my fear. I knew I had to question why I was having these panic attacks, but now was not the time.

Trying to calm myself with the idea that fear is only a projection of the mind, which itself is an illusion, I sat down almost missing the chair. John noticed my folly and sensed my fear, but he passed it off as a reaction from the white powder. Lucia gazed coldly at me, almost through me with her systematic eyes. She then made several quick notations in the last section of her notebook, as if she were writing a schizophrenic diagnosis.

"Actually," said John, "the way Prospero dies is similar to the way Conrad's tragic hero Kurtz dies in the African jungle."

I remembered that Kurtz had journeyed deep into Africa's wilderness questing for ivory, his greed driving him further into the heart of Africa, making him mad, compelled as he was to unveil some hidden inner Truth. Nurtured by a wild tribal queen, who was right at home in his hut that he encircled with blackened, shrunken heads preserved dry on stakes, Kurtz submitted to his primal urges, becoming a murderous headhunter. The story ends with the ailing Kurtz in the heart of Africa's wilderness unrepentant and rational, waiting calmly for Death.

"Kurtz' soul had gone mad," said John. "He had the time to look into his soul, and this drove him mad."

Some spiritual journey, I thought, very much like what happened to Nerval, who also wanted the secret of life. Then I saw a dark energy of some kind, dashing at me from all directions as if I were a receiving station. Tiny particles

of light beamed toward me at a great speed, atoms teleported from somewhere, information, memories, trivia pouring into my mind: Nerval's doctor advised him to keep a written account of his madness, which he did in his book *Aurelia*. The account centers on Nerval's love for a divine golden lady and his intention to unveil the secret of life. *Aurelia* is the Latin word for golden.

Like the crazed Kurtz, Nerval was mad, at least according to our modern psychiatric standards. I glanced at Lucia, who seemed to be watching me with the coldhearted scrutiny of a rattlesnake ready to strike. Her eyes gripped mine with an intensity that I resented. I felt like an animal trapped in a cage, just waiting for a fatal dose of her white powder. She knew my mind was frantic with thoughts that I did not generate. Sure, the Sun made me paranoid, but so did Lucia's obsession with the gold and John's compulsion to tell stories. Finally, Lucia dropped her gaze into her notebook, her pen striking another notation in the back with the cold abandon of a coroner performing an autopsy.

At that moment, John said, "Kurtz had no faith, no fear and no restraints, so he looked Death in the eye."

His head tilted upward, John gazed at the majestic mountains, the peaks pinnacled against the sharp horizon's stark blue like fingers clutching the sky. Yet, the Sun slipped indifferently into the earth, bent on journeying through Time and space as the sky darkened.

For a change, Lucia was writing in the front of her notebook, but listening to John, I was still uneasy and troubled.

"Kurtz saw an image that filled him with terror, an image that made him cry out, that made him hate."

John stood up, his body stiffening like an epileptic, his head thrown back, his arms thrashing the air. Caught off guard, Lucia dropped her tablet, and I almost crumpled into the fading sunlight. Then, just as abruptly, he extended his arms out like Christ on the cross. I expected his hands to start bleeding at any moment, but instead he stared at the dying Sun, speaking at full volume as if he were exorcising the devil from it.

"The horror! The horror!" he hollered.

I held my breath and the tension only eased when John bowed his head and murmured, "These were the last words of Kurtz, who had glimpsed a hidden Truth, the same Truth Prince Prospero witnessed."

Pulling herself together immediately, Lucia picked up her tablet.

"John," she said quickly, "spare us the drama."

John's spontaneity did not bother me as much as Kurtz' words did. Kurtz had seen something unspeakable, something that he might have shared at the moment of his Death, something that could have helped others understand life, but he died with his prophecy. Soon I would learn that Joseph Conrad's greatness, his humanity, was that he did not let his hero Kurtz reveal his dark vision.

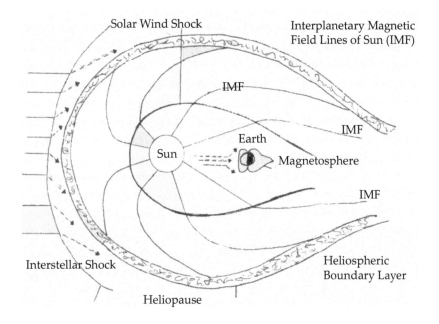

> The more civilized, the more unconscious and complicated a man is, the less he is able to follow his instincts. His complicated living conditions and the influence of his environment are so strong that they drown the quiet voice of nature.
>
> *Aion (1951)*
> *Carl Jung*

10

The last dying words of Kurtz left me apprehensive and restless, for I sensed that Lucia was preparing us for an encounter with Death. She was obsessed with classics about love and hate, beauty and the beast. Coleridge, Poe, Goya, Conrad, including the musicians Paganini, Rachmaninoff and KISS were all haunted by their attempts to unmask or imitate Death. So I was anxious about the next white powder trip, even though John was not.

Lucia must have realized my fear because she began to explain some Egyptian ideas to us about Death, as dusk settled over the mountain horizon.

"The Pharaohs believed that what is above is the same as what is below. In other words, the earth, Sun, planets and stars mirror microscopic organisms in the tiny quantum world," she said. "For example, imagine that the Sun represents a virus infecting the earth, which is like a one-celled organism."

I had trouble with this comparison, but John's Imagination captured the idea immediately. "I suppose if I were a million miles up in outer space, the

Sun and its magnetic field would look like a viral infection engulfing the earth and its amoeba-like magnetic field," he said, trying to understand where Lucia was going with this idea.

She explained that what made her realize that the architecture of the earth and sky was a mirror of the microscopic world were certain identical processes. For instance, the process of magnetic reconnection in the earth's plasma barrier, the magnetosphere, was very similar to DNA recombination in the cell. Lucia explained magnetic reconnection first. "As the magnetic fields of the Sun and earth bump into each other, field lines stretch, snap and reconnect, causing Sun particles to slide like beads onto earth's magnetic field lines. In time, these Sun particles arrive at the poles of our planet and generate the aurorae," she said.

According to Lucia, the cellular counterpart to this snapping and reconnection of Sun lines with earth's is DNA recombination. In her research tablet, she showed us a drawing of the two processes, and we had to admit, they were remarkably similar. She said that the ancient Egyptians called the process *crossing over* just as our modern scientists do.

Now, I understood the similar process of cutting and splicing DNA together. First, an endonuclease performs a single-strand nick into each DNA strand. Strand exchange or invasion is the crossing over activity. RecA protein then helps the strands base pair so the nicks can be sealed by DNA ligase. If a branch migration at the cross-over point or X-line occurs, more of each strand becomes part of the opposite molecule.

What Lucia was saying is that this same microscopic activity happens in the earth's magnetosphere, when magnetic field lines of the earth and Sun reconnect. Put simply, large-scale events in our planetary world are mirrored by tiny quantum processes. So this means that even though we perceive our world as large, it may actually be microscopic, a tiny grain of sand as the poet William Blake suggested.

On the large scale, Lucia explained, the strand exchange taking place was the merging of the Sun's magnetic field lines with the earth's. The ions on the magnetic field lines of the Sun were one type of life-form, and the ions of the earth were another. One might say that the Sun was injecting its life into the earth's magnetosphere. According to scientists, this is an energy transfer, but Lucia said it was an exchange of elements on the molecular level.

She expanded on the idea by saying that the movements of the earth's magnetosphere due to the solar wind were very similar to the activities of binary fission in bacteria. A tiny bacterium has one chromosome, which is attached to the plasma membrane and not in a nucleus. The chromosome divides in two producing two daughter chromosomes, with each chromosome attaching to a

different part of the membrane. The cell then pinches between the two areas until the cell wall splits, producing two daughter cells.

Lucia explained that this process is similar to what happens to the earth's magnetosphere during a substorm, a powerful solar eruption sometimes impacting with the strength of a massive earthquake. Feeling uneasy, I stood quietly gazing at the darkening sky as trivia ripped through my mind. According to NASA, these storms happen every twenty-seven days and are related to the Sun's rotation or can be caused by Coronal Mass Ejections. These interplanetary ejections have massive, slowly-rotating magnetic fields with a plasma of cold ions.

Interrupting my spasm of thought, Lucia said, "During what scientists call a southward Interplanetary Magnetic Field, the outermost sunward loops of the earth's magnetic field are broken and swept into the magnetotail, which stretches like a teardrop on the dark side of our planet for 200 to 220 earth radii or 800,000 miles into outer space."

Still, the trivia struck at my mind, informing me that one earth radius equals 6,378 kilometers or 3,906 miles, and then the information stopped, and a strange nothingness smothered my thinking, giving me some peace. Her statistics showed her scientific exactitude, a comforting thought.

Lucia flipped through the pages in her notebook to another drawing that showed the earth's long magnetotail pinching in two. "Due to the magnetic pressure in the magnetotail lobes, the plasma sheet is pinched until a neutral point forms," she said. "Reconnection occurs within this neutral point, snapping magnetic field lines back toward earth and forcing a bubble of plasma out of the magnetotail on the other side."

We had to admit that a cell pinching together until the cell wall splits to produce two cells was identical to the earth's huge plasma sheet pinching to a neutral point to produce a large bubble of plasma. Put simply, the earth's magnetosphere acted like a minute one-celled organism replicating.

Our planet also has poles similar to the poles of a cell. On and on she went until we both could see there were some amazing similarities between what is above in the sky and what is below in the cellular world. Stunned that the Pharaohs understood the dynamics of both space physics and molecular chemistry, we had a new appreciation for Lucia's research. But there was more.

"The Egyptian Kings and nobility," said Lucia, "understood their afterlife existed at the quantum level. In some way, Death resulted in a person being conscious in this tiny afterlife world. This seems possible because we are composed of indestructible atoms of carbon, oxygen, nitrogen and hydrogen that are released at Death for recycling," she reasoned. "Many of these elements become trapped in the earth's magnetic field."

Intrigued, John said, "Trapped like in the Van Allen belts?"

"Yes," said Lucia, "trapped in that hot thermal hell of molecules that bounce back and forth forever unless they happen to escape in Time through the loss cones."

The perfect hell, I thought, the Van Allen belts, the ring current of trapped ions and electrons around our planet.

Lucia continued, "The Pharaohs mapped a path for the dead to follow using the polestars, points on earth, and the magnetosphere as guidelines."

We thought about this for a moment, trying to relate it to the idea that after Death the earth was like a one-celled organism. Then John said, "So the path they mapped relative to the earth and stars is really the path through a one-celled organism."

Lucia nodded in agreement, her eyes locked on John's. "A path through a primordial *E. coli* bacterium," she repeated.

Shit, I thought, it all comes back to shit. I knew that *E. coli* was a one-celled bacterium commonly found in our intestines, a bacterium that ate shit. I also could understand that if the earth and its magnetosphere were an *E. coli*, knowing the path through it would be valuable information, but this idea of a primordial *E. coli* confused me, and to be honest with you, the idea essentially stunk, but I felt it was only fair to hear her out.

"The kings believed that at Death one returned to the origin of Time. At this origin, the Deceased was at the beginning of creation, the moment in Time when the first cell was created. The Deceased could then choose to become an adaptive mutation, a being beyond human, by following the Egyptian path through the *Duat*," she said.

Slowly, awareness diminished my confusion. I was beginning to understand her, and then my precognition caused me to think of String Theory, the idea that our universe is made up of tiny, vibrating, one-dimensional strings or bands. The theory postulates that we are not point particles, we are rubber band beings. All forces and matter arise from these little oscillating strings. The theory also claims there are 10 or 11 dimensions and some of these are curled up. If a curled-up dimension happens to be a Time dimension, a trip on it would mean going back in Time, perhaps to the origin of Time. I knew that a dying person experiences a past-life review, so it seemed possible that this was similar to traveling back in Time on a curled-up dimension. I imagined myself being hurtled to the origin of Time by the snap of a rubber band.

Lucia's idea was remarkably similar to Nietzsche's Overman, the being beyond human that the man on the tightrope could not reach for his transformation because of the jester's tricks. The *Duat*, of course, was the Egyptian hell, a mysterious place that many thought was near the constellation Orion; others

thought that it was an irregular funnel in the earth similar to the one in Dante's masterpiece the *Inferno*, where the poets Dante and Virgil journey into the fiery furnace to witness the vengeance of God's justice on sinners. According to Lucia, the *Duat* was the earth's magnetosphere, and on the small scale, it was an *E. coli* cell.

Suddenly horrified, I realized that Lucia planned to send us to hell, where John and I would travel the abyss together like Dante and Virgil. It was a bold idea that the gold could make possible. Wanting to vomit, I swallowed hard to stop my reaction. Then I sat there like a mummy, frozen in my mental hell, quietly waiting to see if that is what she had in mind. I tried to reason that poets like Theodore Roethke and other madmen went there all the time, for if Death were a trip to the tiny quantum world, so was madness.

"Tell me more about the path, Lucia," said John, lighting his cigarette. "How does a dead person get to it?"

I listened closely to the conversation, trying to imagine a path through an *E. coli* bacterium.

Lucia explained, "The Deceased is dead but alive, which is reasonable because of the Second Law of Thermodynamics, the idea that energy can not be created or destroyed. But, the living dead also travel in the afterlife."

"You mean I could fly wherever I wanted to go, say to Ireland," said John, sticking his cigarette in his mouth, so he could thrust his elbows up and down like a wounded albatross struggling to rise.

Lucia knew he was making fun of her. She paused just long enough to make him feel foolish, and then she threw a hard ball at him.

"Carl Jung did it," she said sharply.

This statement brought John back to earth and stunned him, as if he had been struck by the pitch. We both listened as Lucia told us about the great psychologist's near Death experience.

"Jung actually wrote his experience down in his autobiography," she said. "He was in a Swiss hospital after a heart attack in 1944. Suddenly, he found himself about one thousand miles above the blue oceans and green continents of the earth. His amazing descriptions of earth from that height matched descriptions twenty years later by astronauts. He could see Ceylon, India, the Arabian desert, the snow-covered Himalayas, and part of the Mediterranean Sea, along with clouds and fog."

She continued calmly without any interruption. "While airborne, Jung had a sudden inclination to turn around. After thinking about turning around, he actually did. He had been standing with his back to the Indian Ocean and his face to the North, when he had this inclination to turn around and go south," she emphasized. "Turning, he saw a huge dark block of stone about the size

of a house, just floating in space like him. As he approached the rock, he had the strange feeling of all his earthly thoughts, wishes and desires being painfully stripped from him. What remained was his history, his essence, what he was. He then saw the primal form of his doctor float toward him, beckoning him back to earth." She paused. "My point is that he thought about turning around in space and he did it."

Lucia was suggesting that it was possible, as the Egyptians believed, for one to navigate through space, through the earth's magnetic fields, while out of body and dead. She believed that the Deceased would retain consciousness after Death, albeit at a deeper level similar to that described by Carl Jung. John was intrigued, but I was speechless. What exactly was she getting at?

"It's the path I want to know about," said John abruptly, crushing his cigarette into the ashtray. "Would an Egyptian have gone south like Carl?"

"No," said Lucia, and just as quickly, she stood up, picked up her notebook, and retreated into her glass laboratory without telling us the path. I had the irresistible urge to throw one of her garden rocks through the window of her glass sanctuary, but instead, we cracked open another fifth of Bushmills.

11

> But in every case
> Death is the absolute meaning of the dream.
>
> *Dream, Imagination and Existence*
> Michel Foucault

John and I sat on the deck until midnight, wondering what literary works Lucia would choose next for our trip on the gold. Time passed solemnly, as the pale moon hovered in the night sky, its full luminous face wavering like a whitened skull lashed to the mountainous corpse beneath it. There was no doubt in my mind. The earth would shipwreck, but who would save the spirit of her song?

A sense of isolation chilled me as I stared past the monarchal moon into the blackness of the starry heavens. I became painfully aware that the earth was encircled by a dark emptiness, by a deep well of vacuous space that imprisoned humans on the planet. The idea that humanity was separated from the larger universe disturbed me, and suddenly desperate, I thought of escaping by the only means available, but soon the warm Bushmills made me ignore the grim message shining from the icy eye of the melancholy moon.

At that moment, John stood up and stumbled across the deck to open the double glass doors into Lucia's living room. He staggered toward the book shelves, and I followed, understanding his impulse. Hoping that we still had time to prepare for the ultimate journey to hell, we armed ourselves with as

much knowledge as we could find on her book shelves.

First we found Dante's *Inferno* and read the words inscribed on the entrance to the lower depths of his hell—*Abandon hope, all you who enter here*. The prophecy irritated us, so we read all Dante's cantos on hell, traveling with him through his circles and gulfs of foul mists, slimy pools and torrid flames that burned, tormented and extinguished human spirits in a horrid tempest of wrath and cruelty.

Then we discovered Milton's *Paradise Lost* on the shelves. In Milton's hell, Satan falls from the fire of heaven through the air of the cosmos into the waters of earth, landing in the chasm of hell. A cold frozen continent surrounds the parched desert of his hell, his *Pandemonium*, his *Pavilion of Chaos* in much the same way that the cold plasma of outer space surrounds the earth. I was tempted to heave both books off the sixty-foot cliff behind Lucia's swimming pool, but John said that he had read each book and that if the books were not present, the gold would probably still work off his memory.

So, I thought, we are destined for hell. Despite my reservations, John was fascinated by the extraordinary properties of the white powder, and he actually looked forward to the next trip on the gold, even if it were to hell. But I was troubled, sensing that Lucia, despite her brilliance, could be mad, insane, charmed as she was by the mystery of Death. What really alarmed me was the idea that she was setting up a cloning experiment with John's DNA.

That night I slept restlessly and experienced a precognitive dream of twenty-first century scientists, mapping the mass distribution of the cosmos to define the actual structure of our universe. In my dream, I was with researchers at the Harvard-Smithsonian Center for Astrophysics, looking at a three-dimensional map of galaxies, clusters of galaxies and superclusters of galaxies. The image revealed the distribution of all galaxies a billion light years from earth. It was comprised of mass density brightness values that formed a stick figure of a person in the center of the image, a colossal star being with legs and arms stretched out a billion light years from earth. On the map, myriads of galaxies had blended together to create the luminous light body of this human form made up of magnificent star clusters. *Invisible* from earth and *within the darkness*, it may have been what the Egyptians called the *man a million tall*. The idea that it was also the Overman drenched me in sweat, and I sat up quickly in bed, gasping for breath.

Like an open-minded poet, I could not help but think we were all part of that huge galaxy Overman. Was not this Overman the same giant eternal human form the poet William Blake envisioned as *Albion*? Was it not the same vision the poet Wallace Stevens saw in his *man of glass, who in a million diamonds sums us up*?

My mind raced wildly with possibilities. Were the galaxies made up of star clusters or clusters of molecules that formed a star being? Were the stars actually aggregates of spirits or microscopic star cells? How small were we? Question after question shot through my brain like bullets, but I still did not know who was shooting these thoughts at me. I squeezed my eyes shut, trying to stop the fire in my mind that was enflamed by the wild winds of my thoughts from some Other. Finally, I fell asleep only to be rudely awakened by another dream, a lucid dream, a dream that seemed to pick up where the white powder experience left off.

I was back at the KISS concert when the plaintive tone of a violin trilled through the air, drowning out the rock music. Taunting shadows of gyrating musicians flickered like flames on the stage curtains behind me, as I felt my way along the walls of a smooth cemented hall leading away from the concert toward the cry of the violin. Frightened by the black void around me, I listened to the violin's nostalgic music as it tempted me deeper into the darkness. I envisioned a shrouded musician, fiddling for my soul, inviting me to jump from the precipice of reason.

Just as this thought entered my mind, I took one critical step into the vacuous space to hover disembodied in pursuit of a violin tremor, before gravity grabbed me, yanking me down in the blackness until I struck the frozen surface of some stony sea. To my horror, I plummeted through the ice, sinking deeper and deeper into the fathomless abyss, until I could only hear a faint violin murmur. Then the waters began to whirl slowly, dragging me around, and what I thought to be the song of a violin turned into the low-pitched drone of massive star galaxies rushing like water, churning interplanetary space around a dark central vortex in a monstrous wheeling movement.

In the twisting waters, something large was whirling, a ship wrecked by the tempest. Men were swimming in the spinning sea away from the sinking ship, and I struggled frantically next to them, whelmed in thunderous lightning, searching madly for a lifeboat, praying we were close to land. I could not die like Shelley in the sea! I was too young! But the storm had other intentions. Shrieking like an injured animal, it tore up the sea around me, and then in the battering maelstrom, a grave lethargy overcame me, and I rolled in harmony with the whirling waters like a corpse at sea.

For an eternal moment, I drifted senselessly in the gloom, wondering what my destiny would be, and then the idea came to me that dream, like imagination, is a revelation from the thought-sender. From this point on, I was awake in my lucid dream, and I expected a change in consciousness, one that would allow me an opportunity for creative problem solving and decision making that might unveil the identity of the thought-sender.

Alone on the waters, I sensed the crew had perished, so with no one but my self to save, I decided on a proactive approach of drifting fishlike in the cold waters until I struck sand beneath my feet. I imagined that I was the mysterious Mr. Leggatt of Joseph Conrad's novella *The Secret Sharer*, who saves the ship *Sephora* from running aground. The story is about an inexperienced Captain, suffering from sleeplessness, anxiety and psychosis due to the stress of his first command. Somewhat mad, the young Captain senses he is close to death and shipwreck, for he sees his double, his *doppelganger*, a pale nude form in a greenish glow, submerged in the sea beneath the ship's side ladder.

This bioluminescent being is Leggatt, the messenger who advises the Captain during his crisis at sea. Although their meeting saves the ship *Sephora*, the Captain suffers psychotic reactions, such as the experience of having a dual mind, the feeling of being in two places at once, and the power of watching one's secret self. These unexpected abilities allow the Captain to tap into his inner strength so he can save the ship. In a similar fashion, I visualized myself as Leggatt, and the fishlike phantasm guided me to an island, where I pushed my body out of the belly of the sea as easily as Leggatt had flashed phosphorescently to shore. The foul wind howled in my ears, and I crawled toward a black shadow in the hilly rock, a cave to protect me from Nature's rage. It was here I saw something I will never forget.

From the cave humped a deformed being, his ankles shackled by iron chains. Devoured by madness, the half-human creature glared at me, his unblinking eyes narrowing as if to say, "I will tell you the secret, if you can bear it."

Before I could decide if I had the courage to know the horrible secret, he said, "I am slave to a magician-god, who has stolen this island from me."

"This island was yours," I said, moving closer to the cave's mouth to get out of the storm.

"This island is where men are judged for their deeds on earth," he growled.

I felt fearless and had the irresistible urge to ask him if he had also seen the Queen of Sheba's garter, but I did not because I sensed his intellect dwarfed mine. He began to recede into the cave, and my eyes followed him deeper into the cavern, where I saw an amazing scene, a masquerade, an elaborate stage with actors before sensuous red draperies, a pageantry beyond belief.

Yet, despite the beauty of this vision, I sensed an ominous presence in the glowing cave other than the prisoner, who was now rushing toward a beautifully-robed woman guarded by a tall gaunt figure that may have been Paganini. A rancid smell of burnt flesh permeated the cave, and my eyes searched the scene for the source, but all I could see was the lush spectacle of the masquerade and the deformed prisoner screaming, "You Blind Mole, give me the book!"

He was visibly upset and his chains thrashed through the revelers as he stumbled toward the young beauty and her dark companion. I edged closer into the cave, glancing everywhere, but I could not see any book.

Then behind the mysterious couple, I saw a pyramid of logs that were moving, writhing like living things. Puppets, I thought, log-people. The crazed prisoner stumbled and fell several feet before the young beauty, distracting me from the dark discovery that the log-people were exactly that—human beings to be sacrificed, offerings to be burnt.

The woman's dark companion lit a match, casting a black shadow on the raging prisoner entangled in chains, while illuminating the mask of his own hooded head. One horrid eye glittered directly at me, worming into my brain. The thought came to me that my mind was a canker, a disease, a plague. Shaken, I bolted into the storm and the cave vision shattered like a mirror. Down the tempest-torn beach I ran, sliding and slipping on the soft ground, but falling luckily into a rocky cavern that partially shielded me from the thundering storm.

Before me, the foaming brine splattered on the face of a book, half-buried beneath the rock. I dug it out of the sand and opened it. One stark line with a signature below it proclaimed: *We are such stuff as dreams are made on.* Scrawled beneath this was the signature of Prince Prospero.

Other symbols and signs decorated the small book, possibly of Egyptian origin, but I had no time to analyze because the tempest was soaking me, so I slithered deeper between the wet rocks, pressing Prospero's book close to my heart. Safe, I listened to the wayward wind, remembering John's account of *The Masque of the Red Death*, which Poe wrote after reading *The Tempest*. Still, there was really only one Prince Prospero, the magician-god of Shakespeare that could bring the dead back to life, but he gave up his powers and drowned his magical book, which I was fortunate to find in the rocks. Cold and shivering, I realized that I was now caught up in one of Shakespeare's plays.

The storm raged outside my shallow grave of protection. Buried under the coppery rock, I felt like a corpse awakened from the dead, for just then, the wet ground gave way and I slid harshly through the stony rubble into a boundless cavern. Standing up and dusting myself off, I limped through the smoky dimness until I approached a forked path in an infinite funnel of tangled trees.

For the Creator has tricks
They do not understand. It grasps
And spreads with too much fury.
And like fire
Consuming houses, lashes
Out, uncaring, and spares
No space and covers paths,
Seething everywhere, a smoldering cloud
wilderness without end.
Seeking to pass for something
Godly.

A Draft of a Hymn
Friedrich Holderlin

12

Exhausted, I woke up early the next morning, realizing that I had been dreaming most of the night. I could still see those writhing log-beings and smell their burnt flesh. I wondered what made Shakespeare think of portraying humans as log-people. It was almost as if he were suggesting that Death was related to the chemical reaction of burning, that humans were simply fuel for the fire. The thought made me sick, and I wondered if the idea of hell was just a representation of molecules being recycled by means of a heat reaction, maybe the theft of fire from the Sun—photosynthesis.

I remembered that the process involves plants capturing the energy of the Sun and trapping it in matter. The Sun is central to photosynthesis, providing the energy source that plants need to grow and nourish us. We discard this energy as heat, but energy can also be discarded as pure radiation, which is called

chemiluminescence, a reaction that generates light directly and competes with the reaction of photosynthesis for energy use. The idea came to me that the whole world should be aglow with radiation, but it wasn't because of photosynthesis, the theft of fire from the Sun.

If we had a choice, it would be like choosing to be a cold photon or a hot lump of matter. The aurora is an example of cold light, for there at the poles of the earth, the air is so rarefied that collisions between molecules are less likely to occur, and the molecules have more time to generate photons because they are moving slower. At room temperature, atoms speed at 1,000 miles per hour through the air. But, at absolute zero, the atoms crawl along like turtles, and the colder they get, the slower they go, and the potential for collision decreases dramatically. In the vacuum of cold outer space, absolute zero is -273 degrees Celsius or -459 degrees Fahrenheit or zero on the Kelvin scale. The coldest place in outer space is three degrees above absolute zero, three degrees Kelvin.

I paused for a moment, but the thoughts kept coming, and then I knew that because most of space is cold light or stars and galaxies, that photosynthesis was actually a rare event. As a species hoping to survive, it seemed that humans had made the wrong choice. Humans should have been cold light. Strange thoughts like these plagued my mind. I had no idea where they came from or who was sending them to me.

Then, caught off guard, I saw the horrific glare of the rising Sun in my bedroom window, and I jumped up promptly to avoid its pulsating attack. The color yellow flooded the room. Frightened, I fled from the painted tomb, stumbling through the hall and down the stairs to the deck, where I could hide in safety under the umbrella.

Still uncomfortable from the Sun's attack and my dream, the image of log-people materialized before me, enflaming my mind with the idea that the gaunt figure intended to light the puppets like the Sun intended to ignite me. I pressed Prince Prospero's book closer to my heart, as if it were an amulet endowed with magical powers of protection. Calmer now, I recalled that the French philosopher Foucault had said that the intuition of the dream is the most elevated form of knowledge. But I was still confused, for I was unsure exactly what my dream meant.

I thought of the cave party in The *Tempest* to get my mind off the log-people. In Elizabethan drama, a masque consisted of disguised performers wearing vizards, the old word for mask. Musicians playing trumpets accompanied these so-called mummers as they indulged in lush revelry, hiding their identity behind masks. In Poe's masque, his characterization of Prince Prospero was similar to Shakespeare's with one exception. Poe's Prospero confronts the mummer

Death with a dagger. With the fearlessness of a madman, Poe's Prospero chases the masked intruder through his imperial suite with only a dagger. When the masqueraders hear a sharp cry, they rush into the red velvet chamber to find Prospero dead and his magical powers nonexistent. When they unmask the gaunt, corpse-like mummer, to their horror they find nothing, no tangible form. Poe leaves us with the eerie suggestion that Prospero, our god-magician, is up against a force much greater than himself. Despite the sorcerer's courage, his attempt to unveil the dark Other results in his Death, the ultimate power of the masked phantom-god. Of course, Prospero had drowned his book, the same magical book I found preserved in the rocky crevice.

From under my umbrella, I watched the shifting amethyst hues of mountain peaks pinnacled against the sky's bright azure like the body of some huge being chained to the earth. The cold Sun seemed haughty in its position above, whirling westward as usual with no concern for the prisoner beneath it. Watching this apparition, I wondered if I was going to die by Lucia's hand. Was I the deformed prisoner in chains? I had to talk to John, but it was too late. Lucia was serving up another shot of the gold, the breakfast of champions.

From the deck I could see her white gloves measuring. It was Judgment Day again. I walked into the main room like a schizophrenic waiting for electroshock therapy from an indifferent physician. Several books for the planned itinerary were on the end table, and I sighed in relief when I noticed that none bore the names of *Paradise Lost* or *The Inferno*. I ignored the *Red Poppy* above the couch on which John sat like an exuberant fool ready to be drugged. He worried me.

Solemnly, Lucia walked over to us, gave John the drink, and he drank down the gold with a gusto that was immoral. Instantly, because of my proximity to John, we both succumbed to the gold's magical power, and the room became coal-black. Within seconds, our vision improved and before us stretched a road that forked into a dark forest, a reminder to me that we were starting at the point where my Shakespearean nightmare had left off. For some uncanny reason, I had been favored with more knowledge than John, for he had not been caught up in *The Tempest*, nor had he found Prospero's book.

As these thoughts drifted away from my mind, I discovered John was gone, and searching the woodland terrain for a sign of him, I guessed he must have taken the northern fork, leaving me on my southward course. Who could tell which way was which in these black woods, where even the vegetation seemed paranoid, clinging to me like tangled snakes. Remorselessly, the dark shroud of night pressured my sanity, and a voice in my head said, "No body here gets out alive."

Fleeting, shadowy fingers rushed at me, stalking me like deadly predators,

inciting primeval fears of the dark. Sweating and dead-cold, I walked faster into the blackness, trying to ignore the attacking parade of fear-provoking thoughts on my mind, but I had no control over my own thinking.

Images stalked me—a monstrous, bone-crushing mouth, grinding teeth ripping me apart limb by bloody limb. Was it the wind whipping the space around me into a frenzied sensation that alarmed me? Maybe it was Prospero's mummer, the Red Death. Choking, I could not breathe or move as my energy drained out of my soul. Something blocked my path in the dreadful darkness, something treacherous in its indifference.

Shaking with terror, I fell to the ground, and the air around me became dank and stinking, hot and stifling, as if the lid of my coffin had been slammed shut silently. Then my terror became extreme disgust, for I was lying on the salivating tongue of the monstrous evil that had materialized to swallow me, to chew, mangle, crush me. Trapped like the deformed prisoner of *The Tempest*, I panicked, knowing that I was going down the throat of some gluttonous beast. With my head convulsing side to side and my eyes averted from the bloody stench rising round me, I crawled through the red glowing mire into black asphyxiating fingers of drool, whipping in the wind like a fiery torrent in the center of it all. Sweat drenched my body, then a sickening nausea. My head reeled with vertigo. I pushed through the raw gore, irritating the lolling tongue of the beast until I was able to lunge between its teeth into the suffocating woods.

For what seemed an eternity, I ran senselessly, finally falling breathless on the forest's dark belly. One thought dominated my crazed mind: some horrid cannibal haunted the spinning woods and it was stalking me. Wrenching my body up into the gloom, I slipped, plunged to the ground, and clambered like a slimy reptile over dead soft limbs, my eyes dilated and bulging with fear, my body jerking lizard-like, back and forth as I prayed desperately to God: *Our Father, who art in Heaven, hallowed be thy name.*

The words poured out of me like babble, while I used all my strength to inch out of the ground's murky mouth and flip my body over what looked to be the edge of a vine-covered cliff. Now suspended carelessly in the blustery space, the dreadful wind whirled me round, and I sensed a second predator's jaws yawning beneath me. Someone shrieked, *Thy Kingdom come, Thy Will be done.* The scream echoed all around me, finally stopping my panic when I realized that I was the screamer.

Embarrassed that because of fear and desperation I had abused prayer again, I became calmer, seeing in the dim reflected light that I wasn't suspended at all, but was clutching the gnarled branches of a wild grapevine embedded in the cliff's crevices. Below me gaped the mouth of the roaring abyss, distended

unending, monstrous in its sheer depths. Not daring to let go of the vine and refusing to climb up the cliff to face the beast in the woods, I moved my face closer to a cluster of grapes and plucked one off the vine with my tongue. Its sweet taste and smell distracted me for an instant from Death-by-falling. If only it were wine, I thought, as I chewed up the grape.

To me it seemed that my life had been a careless series of unplanned, unfortunate accidents, culminating in the present cliffhanger that was induced by Lucia's white powder. A series of random events, I thought, as I carelessly removed one hand from the vine and popped more grapes into my mouth, crushing and chewing them, while marveling at the intensity of sound I was producing, a crunching noise that was too loud. Thinking that I was sharing my meal with some other, I silenced my jaws, and to my dismay, I heard distinct gnawing sounds that caused me to glance up. Above me were two mice, one black, the other white, casually chomping on the grapevine's roots, as if to say—try the roots, fool, it is better than the fruit.

A sadness welled up in my heart, an unspeakable flood of pain that could only be compared to feelings I had as a youth, feelings of total unworthiness, a sense of sinfulness and innate impurity, the obsession that I was stained irrevocably. Was there no escape? No Hope? Would it be the abyss or the predator? Desperate, I could not cry or scream. No words came out, no sound, only a shudder of pain.

This same melancholy emotion usually welled up in my heart after having too many glasses of wine. I recognized it as the deep sentiment for humanity that motivates art, religion, philosophy, psychology and music—the knowledge of human mortality, or more precisely, universal fear of Death, specifically my own at the moment.

Eyeing the dismal mice, I thought—is this real? Do we humans really exist in the world we perceive only through our senses? Strengthened by the thought, I popped another grape into my mouth. What if my future were not the object of my senses, but of my thought?

Other questions arose as I stared at the unsettling mice, especially the ambitious white one who was halfway through the larger root. How do we know what we know? What is the limit and validity of our knowledge? I reached for another grape. If I did not base my future on the outcome that my senses revealed—the vision of the cliff and gnawed roots, the smooth texture and sweet taste of the grapes, the groans of the abyss, the acrid odor of mice excrement—then I could take these perceptions as part of a whole, as shadows of a complete reality.

The idea of another alternative other than returning to the woods or falling into the abyss was comforting. Again, I popped a grape into my mouth, chewing

on it and the idea of an alternative. After all, Plato said that perception is not just sensation; it is something greater, something your psyche organizes and gives meaning to. As Time's puppet, I could either die now in this sensual world or live beyond the world's shadow play in an ideal reality. The choice was between Aristotle's reason and Plato's Imagination. I had no choice but to believe Plato was right—the world perceived by the senses was incomplete, just shadows of an ideal reality, just sensation-shadows in the cave of our unimaginative thinking. At that moment, I gave up thinking; by that I mean reasoning based on sensual input.

I glanced up as the black mouse scurried into a crevice, having gnawed through its share of the grapevine roots. Gasping, I swung violently down toward the abyss, clutching the vine like a bungling Tarzan. I eyed the white rodent, godlike above me, which paused to stare at me almost with some conscience, but then it had a change of heart, for the little rat flicked its tail once, defecating into the air above my head.

The wind whirling up from the abyss slowed the rotating, soft, black orbs of excrement, distorting them like Salvador Dali's painted clocks, as they floated toward my paralyzed face. Dodging the insult, I twisted quickly to one side to escape the gummy barrage, while wrenching the roots a foot further out of the cliff.

Sharply cursing Plato because I was forced to apply his philosophy, I imagined an ideal ledge angled to the left at 45 degrees into the interior of the precipice. Swinging the collapsing vine, I dove for my imaginary escape ledge, believing that it was real and that I would not smash into the solid rock wall. Instantly, my feet struck the smooth mouth of rock at its oblique angle, which thrust me into the cliff's hard gut, sliding me down down down through my imagined escape hatch, until my body struck ground with a rousing thud. On my back, I stared heavenward out of a crystal goblet into a dome of luminous light. Sitting up, I looked away from the blinding light, believing that perception is more than sensation as Plato said.

Then bells chimed below, and glancing down through the beveled basin of the goblet, I saw winged angels in long emerald robes, escorting naked women and men through the greenish light misting around us. Each angel-human pair passed by me, two by two, as if I did not exist, ascending toward the white radiance of light above me. Apparently, we were all in a spiraling funnel, which reminded me of Bosch's painting of souls ascending to a flaming heaven, and then I understood that I was caught up in a Late Gothic painting by Hieronymus Bosch, an early predecessor of the surrealist Salvador Dali. Painting around the sixteenth century, Bosch was obsessed with Death, hell, paradise and judgment.

Hearing a weird guttural sound near the dull misty green extremity of the funnel opposite the light, I merged easily through the mirrored concave goblet, crawled down the stem and carefully repositioned myself at the sheer edge of the base, so I could peer into the depths.

Instantly, grotesque grinning heads jeered at me—monstrous shapes, half-human and half-animal—squirming in the unnatural green mist. To my horror, I watched a blue-bodied, bird-headed monster swallow a naked, writhing human, whose screams subsided only when the merciless beak finished slashing and pulverizing the human buttocks and legs into raw bloody meat-hunks of flesh that slid easily down its gaping throat. Within seconds, the bird cannibalized the entire human meal, and looking for dessert, glowered at me with its wild yellow eyes. The edge of the goblet base where I crouched in terror was only five feet above the bird-monster. It could smell the sweat rising on my body and sense the panic in my heart. Get out of the flaming *empyreum*, I thought, get out of the funnel-heaven now!

Then the bird-beast lurched upward as I skidded backward to scramble up the crystal stem and through the goblet into the dome-shaped radiance above. Almost enchanted by the compelling light, I moved toward it, levitating upward, but I soon sensed there was something equally ominous in the immeasurable brightness flaming at this end of the funnel. A disturbing emptiness. So, I angled to the left, clambering quickly into the escape route I had just come down, inching my way up, slipping continually, panicked as I was by the bird monster now stalking the rock opening with fiery terrible eyes and a slashing carnivorous beak.

Straddling both sides, I spied another grapevine halfway up. Wondering how the hell grapes could live in these caverns, I lunged into the air, landing hard against the rocks, but I succeeded in grabbing the vine for leverage. Then I imagined another ledge, and swinging to it, I fell through a brush-covered hole in the rock into a wooded clearing overlooking a pasture of grazing sheep.

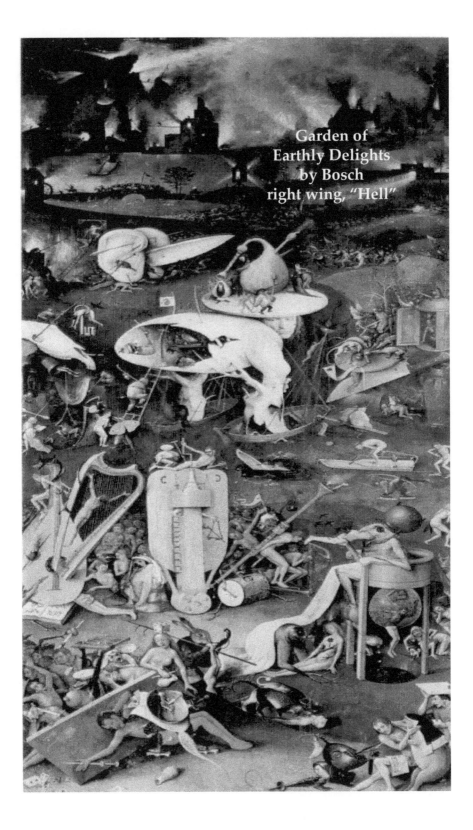

The Knight:

13

The Knight:
Knighthood should be seen then, as a superior kind of
pedagogy helping to bring about the transmutation of natural man
(steedless) into spiritual man.

Dictionary of Symbols
J. E. Cirlot

Just then, a man about fifty with a *strong constitution, spare-bodied, of a meager visage* appeared from nowhere brandishing a sword and riding a blemished drudge-horse. I recognized him immediately, for he was wearing rusty knight armor and a helmet with a do-it-yourself visor. The Knight was Don Quixote on his trusting steed Rozinante.

Believing that his appearance now must be due to my recent conversion to

Plato's philosophy of not relying on the senses, along with the old philosopher's revenge on me for cursing him, when the vine over the abyss gave way, I watched in disbelief as Quixote galloped Rozinante into a flock of innocent sheep, butchering an ewe and two rams. I knew Quixote from Cervantes' 1615 fictional masterpiece, which detailed the adventures of the crazy idealist, who thought that windmills were giants and sheep were armies of men. In Cervantes' comic satire, his hero is obsessed with reviving the gallant morality of the age of chivalry and knighthood. I watched as the unremitting Quixote, slashing his sword like the bird monster's beak, randomly killed four more innocent sheep.

If this was what they called chivalry, maybe it was best it was dead. Running down the jade hillside to stop the senseless slaughter of innocent animals, I saw, as if from nowhere, several enraged sheepherders hurtling rocks at the madman Quixote, who took a rather large stone in his side, then his mouth, and fell off his horse. Just as the sheepherders surrounded him to finish him off, I screamed in alarm because I had seen enough blood and gore in Bosch's *empyreum*.

Detecting me waving my arms wildly and running toward them, the sheepherders quickly gathered up their dead sheep and scattered. Breathless, I approached the dazed Quixote, who was missing several teeth and bleeding. Rubbing his chin, he looked at me and spoke.

"I too believe in Plato."

Disgusted, I immediately understood what he meant. He had his sheep to slay—his armies of men—and I had my abyss to escape. Whether or not sheep were men or escape routes really existed was unimportant, for Quixote's idealism and my new perceptions now stretched beyond what most people believed to be real, that is, physical sensations and material things.

Wherever the hell I was now, we were dealing with ideal reality. Still, the thought troubled me as to why I was here with Don Quixote, who I had not imagined or conjured up in any fashion other than ingesting the white powder. Then I realized that John must have read what Cervantes wrote about the knight.

Most annoying to me, Quixote professed to be a Platonist. I began cursing Plato again, silently this time, as I squinted at the madman, who Cervantes penned as the *light and mirror of Manchegon chivalry*.

Staying clear-headed to avoid my own fear that I was somehow involved in Quixote's next scheme, I said, "I hope I'm not your next adventure."

Quixote was silent. Being a knight-errant in quest of victory and adventures, he understood that only *lofty, illustrious, magnificent and true* exploits were worthy of his attention. Frowning and full of thought, he calmly said, "*There is no history*

of human affairs, which is not full of reverses, and venturing forth with you would be a setback that could be remedied by certain stipulations, if you are willing."

Although hearing his complete comment, I could only focus on the part that I was a 'reverse' in the history of human affairs. For a brief moment, I ignored the offense, for I came to grips with the surprising idea that I truly wanted to go on an adventure. Modern life lacked adventures. Get up, eat, go to work, eat, come home, eat, read, write, TV, eat, same cycle, same job, same people, same address so the government knew exactly where to send its tax forms.

I wanted to rise above my own nature and my fears. I wanted to transcend the illusions and boundaries of my own ego, the way I had when I imagined the angled ledge that saved me from deciding between dying in the woods or the abyss.

But, from what I had just witnessed and from what John had read, Quixote's adventures lacked depth, dignity and chivalry. For example, in the book Quixote comes upon thirty or forty windmills that he construes to be giants despite his squire Sancho's insistence that they are windmills. Spurring his horse, he charges the first windmill, catching his lance in its sail. The wind whirls the lance round, shattering it to bits, and violently drags Quixote and his horse after it. Now, only an idiot would attack a windmill. This was as foolish as Ahab spearing the monstrous White Whale in Melville's classic.

Still, Quixote insisted on his follies, especially that of attacking sheep, for with his bizarre Imagination, the sound of bleating sheep fired off neurons in his brain that made him believe an army of men on horseback with blaring trumpets and drum rolls needed conquest. All this in the name of chivalry. This type of adventure did not interest me, and Cervantes' book was full of Quixote's weird escapades.

Yet, Quixote had the insolence to say that an adventure with me would be a *reverse*. The more I thought about it, the less I wanted to go with him anywhere; in fact, I seriously wished I had let the sheepherders have their way with him. Then, to my annoyance, he continued.

"First," he said, "*greatness of soul* is required to face the dangers we will meet in this adventure, along with *patience in adversity, fortitude in suffering, modesty and continence in love, so truly Platonic*.

"Second, I'm going to call you *Psyche*, not so much because of the Greek myth, but because you remind me of a moth.

"Third, so that humans everywhere will understand our logic, we will unveil true knowledge using the philosophic method: intuition first, followed by vision, then deduction, which takes premises to conclusions, so that the observed evidence will be linked together."

From the way Quixote was talking, I imagined that he needed a squire, another reasonable Sancho. But that worried me because by the end of Cervantes' book, Sancho's thinking was becoming *Quixotized*, and I had no intention of being influenced in such a manner. In other words, Quixote gains reason, while Sancho gains Imagination. Although I was learning to use my Imagination, I did not want to lose any of my Reason while I was caught up with a fool in Cervantes' masterpiece.

Yet, I burned to go on an adventure, but not with a madman, for I had some pride. Exhaling deeply, I said:

"Am I to understand that an adventure with me is a setback, a reverse in the history of human affairs, so trivial that I am to be called *Psyche* because I remind you of a moth?"

Don Quixote began to laugh, and I could see his raw, bruised, bloody gums where teeth had been. He had never laughed once in Cervantes' book, and now he was crazy with laughter in unison with his scurvy, snickering nag Rozinante. After indulging in this comic fit for what seemed an eternity, Quixote finally said:

"I believe that you have missed the point, *Psyche*. Please avoid self-service by rising above your ego. *Mockery and abuse issue from the proud man, but vengeance lies in wait for him like a lion.*"

This remark by Quixote, a biblical passage from the book of Sirach 27:28, annoyed me because by quoting scripture, he was not presenting himself as he had in the novel. He wasn't operating from his premise of folly as I expected. By saying pleasant things harshly and terrible things jokingly, he was more the jester than the fool. I stared coldly at the knight, wondering if he knew how to get to the Overman.

14

The unthought (whatever name we give it) is not lodged within man as a shriveled-up nature or a stratified history: it is, in relation to man, the Other: the Other that is not only a brother but a twin, born, not of man, nor in man, but beside him and at the same time, in an identical newness, in an unavoidable duality.

The Order of Things
Michel Foucault

"And," Quixote continued, "I will explain the idea of the moth later. Let me digress by saying that man in the modern age—from 1800 on—is a mutation. Yet man's shadow has followed him, alien as it is to him. Some call it the Other, yet it is a twin born at the same time. This real doubleness is man's shadow that he forgot about when he emerged into the modern age of knowledge."

I had trouble swallowing what he said, but I recognized it as something the philosopher Michel Foucault might have said, so based on my respect for the

French thinker, I considered the idea that the last two centuries of human existence was a mutation. Seemed to me that man had achieved some great frontiers in the field of knowledge—the trip to the moon, if the lunar photos were not a technological farce. Most certainly the invention of the auto, although scientists predict that air pollution from carbon dioxide will force planetary temperatures up three to ten degrees Fahrenheit by the year 2100. Well, maybe legal remedies for racial, gender and sex discrimination, despite the legal system's inherent weakness of keeping conflicts inflamed by favoring the rich above the poor, whites above other races.

What about a higher standard of living through the production of wealth, although poverty still exists everywhere in the world. I would have to say that digital communications is a positive development, specifically the Internet, if we learn to use it responsibly. The power of literature, music and art to herald the future of humanity certainly is important, if we could understand the ultimate meaning. This last thought disturbed me, for it seemed that Death was not only the absolute meaning of the dream, but also the ultimate revelation of artistic creativity.

"Could you define what you mean by mutation?" I asked, somewhat frustrated.

After a short pause, Don Quixote said, "Fundamental forms of knowledge changed that have made Western Man alien to himself. For instance, civilized man has lost the art of thinking in images. Yet, this symbolic language can still be found in dream and Imagination, and the legacies of early cultures such as Egypt, the Aztecs, and even in the Peyote Dance rite of the aboriginal Tarahumara Indians of northern Mexico. Western Man needs to unveil and decipher the signs of their symbolic language and learn from these cultures."

Certainly, I thought, Quixote must know how complex symbols can be. John had explained the problem to me several times. The only way to pin a meaning on one symbol, say the symbol of the twin, would be to look at many examples of it in ancient works. Once this is accomplished, there is still the problem of interpreting the meaning of the other symbols within which it is networked. A complicated task, call it an archaeological perspective, if you will, where you would have to dig up the meanings of all the symbols, making sure they were consistent with your original interpretation. In this way, one could understand what the symbol originally meant.

That is one difficulty with symbolic interpretations, but another remains. In modern society we take symbols literally, and we are indoctrinated with beliefs based on interpretations that take symbols literally. Let's take the apple in the Garden of Eden as an example; to us today, it is exactly that, an apple that God did not want Adam and Eve to eat. Actually, the apple points to multiple

symbolic meanings: sensual taste, pleasure, desire, sustenance, exalting materialism, totality and wholeness as indicated by its round shape. It is difficult to classify the meaning of this forbidden sensual apple exactly, but when a group of symbols point to the same idea, it is possible that we can understand.

So, to understand the symbolism of the apple, we would have to look at all the symbols in the story: Adam, Eve, the Serpent, the Trees. This opens up deeper levels of meaning and overcomes barriers of language. Finally, we must remember that the apple and all the other interpreted symbols refer to the spiritual world, not our sensual reality; it is not an actual apple on a tree.

I paused, wondering if Quixote was interested in decoding the sign of the twin, this Other. If this is what he had in mind, then maybe we could take the journey together. I could use a guide to track down the theme they all wrote about, the one that made them mad, the one we may have misinterpreted, the crucial theme of the Other.

Then other questions came to me. Did Don Quixote know that I was narcoticized by the white powder and was seeing Cervantes' literary work in images to understand its message? Did he know I was in a nightmare of works of art that were speaking to me, taking me on a quest to answer my questions about the jester and who was sending me my thoughts?

Directly, Quixote said, "Yes *Psyche*, I realize you are thinking in images. Now, what we need to do is to unveil and decipher this idea of the twin in art, literature, mythology, psychology, and in all of the human social discourses to find out who is sending you your thoughts."

Amazed again at his knowledge and my own refusal to see his powers, I knew I had to accept that he was reading my thoughts and get used to our new mode of communicating.

"So where do we start," I said to the jester.

Quixote's wise eyes were penetrating. "My line of work requires a knowledge of everything," he said. "We will find the Truth."

After this witty remark, we traveled in silence on Rozinante, trotting through the dreamy green hills of the countryside until Quixote's nag came to another damn fork in the road. To the south, I could hear forceful, rhythmic thuds over falling water and the clanking of chains that immediately adrenalized me, making me feel as if something might strike me down or grind me senseless. Understanding why Sancho had a bowel movement when he heard the thuds, I calmed myself by remembering that in the book this sound was produced by the great hammers of water-powered fulling mills, pounding wool fibers into felt. Quixote noticed my fear, but he just stared at me. I found myself wondering if he was going to claim that the mill was a giant, as he had in the book, or see the mill for what it really was—just a windmill.

I was relieved when Quixote turned his horse Rosinante north down the other path, but very annoyed when he pressed me to talk about the beastly sound.

"*Psyche*, why were you so tense when you heard the mill?"

For a brief moment, I could not answer, trying to understand what it was about the sound that inspired fear in me, or to be more exact, an unidentifiable terror. Something about that monotonous pounding, those relentless thuds coupled with the clashing of chains, made me feel an unspeakable dread, a coldness, a hopelessness that was difficult to put into words. It reminded me of Mahler's Sixth Symphony, where the orchestra recreates the horrid sound of God striking down a man in three shocking waves of deafening orchestral dissonance.

Mahler completed this dark work in 1905, during one of the happiest periods of his life, yet his intuitive genius enabled him to foreshadow future horrors—the World War battlefields, Auschwitz, the Gulag, Rwanda, Hiroshima, Nagasaki—devastating prophecies that proved man was losing touch with his humanity. The hammer blows of the mill reminded me of Mahler's three sudden symphonic explosions, which are so terrifying that modern orchestras pity their audiences and only play two of the terrible discordant strikes. The awful mill reminded me of Death and defeat.

Shaken and despondent, I understood that Quixote wanted me to consider the innate meaning of the mill without letting my emotions sabotage my thinking. He was asking me not to take it literally as an actual mill, but to define what it signified. Again, I reminded myself that the windmill was a sign of something else, an image of something beyond the physical that had to be considered without emotion and within the full context of the story and all its symbols.

It was obvious that the mill symbolized something dark and deadly in the spiritual world, some spiritual Truth, but I could not get a fix on it. What disturbed me more was that I sensed Quixote knew the symbolic meaning of the mill. In fact, it was obvious that he knew a code that would crack the meaning of all the symbols, but the valorous knight was not going to tell me. It crossed my mind that his code could be similar to Lucia's.

I pleaded with him. "When are you going to tell me the code, so I can understand some of these symbols in Cervantes' novel?"

Quixote responded, "*Where one door is shut, another is open*," and he spurred Rozinante soundly, allowing the horse to go whichever way it chose. Used to the folly of his master, Rozinante galloped north then west, full speed over the terrain toward the setting Sun. Whether the horse was blinded by the bloody sunlight or just stupid is not something I wish to pursue, but for no reason, Rozinante balked insolently, catapulting Quixote and I into the cool air, where

we hovered miraculously, suspended as we were from our bizarre vantage point to see the dark crimson, whirling mills illuminated by the dying Sun.

The awe-inspiring red giants ground and pounded the waters without remission. Then in one horrid, suffocating moment, the horizon rose up to engulf us, crushing us with severe acceleration, as we fell into a deep subterranean cavern along with the horse Rozinante.

15

Nothing in life is to be feared. It is only to be understood.

Madame Marie Curie
Nobel Laureate, Physics 1903
Nobel Laureate, Chemistry 1911

When I opened my eyes in the dim torch-light, I saw Quixote dusting off some type of carved drawing on the underground wall with his hands. Rozinante was nearby, pawing the ground in a bullish manner. On closer inspection, I could see Egyptian hieroglyphs decorated the walls along with their conventional artwork, the head of the character always drawn in profile, while the body is seen from the front. Although the face is to the side, the eye is drawn in full. The legs are turned to the same side as the face with one foot placed in front of each other. The stance of the body is severe, but the face, calm and serene, is almost always tilted slightly towards the sky, as if the figure were basking in the warm Sun. The Egyptians used this two-dimensional frontalism style for thousands of years. Looking around the pyramid, I saw columns of hieroglyphs cut into the rock walls.

"This hieroglyphic language is primarily connected with the Eye of Horus," said Quixote, pointing to a single eye framed by a curved brow with falcon markings beneath it. "The Egyptians used the Eye as a funerary amulet for protection against evil and rebirth in the underworld, and they decorated mummies, coffins, and tombs with it. The Eye served to ensure safety, protect health, and give the wearer wisdom and prosperity. It was called the *all-seeing Eye*. Other attributes associated with it were terror and wrath."

Moving my fingers over the smooth carving, I traced the long spiral out of the pupil to its center, as trivia flooded my mind in a series of numbers . . . 1, 1, 2, 3, 5, 8, 13, 21, 34, 55 . . . they stretched to infinity, and I recognized the numbers as the Fibonacci Spiral, a series related to the Golden Ratio 1.618 or Phi. Any number in the series after 1 is equal to the sum of the two preceding numbers. Adjacent numbers approximate Phi: 13 divided by 8 equals 1.625; 55 divided by 34 equals 1.617. In a triangle, Phi forms the dimension of the pyramids, and the Ratio is everywhere in the universe—in plants, animals, the solar system, music, population growth, and the proportions of the human body. The Fibonacci series converges on Phi. DNA, for instance, measures 34 angstroms long by 21 angstroms wide for each full cycle of its double helix spiral.

"The Eye has a personality of its own, swooping down out of the sky to right wrongs," said Quixote.

Continuing, he said, "The Eye has several meanings, all specific. It can be dissected into six parts, each with a numerical value that represents one of the six senses. For example, touch is represented by the value 1/64 *heqat* or 5 *ro*. The symbol for *ro* is the mouth."

I watched Quixote pull out his sword and hastily draw and partition the Eye on the dirt floor to reveal the six lines equaling the senses.

"In the Egyptian system," he said, "there is the unit of the *ro* and 320 *ro* equals 1 *heqat*. Taste equals 1/32 *heqat* or 10 *ro*, Hearing equals 1/16 *heqat* or 20 *ro*, Thought equals 1/8 *heqat* or 40 *ro*, Sight equals 1/4 *heqat* or 80 *ro*, and Smell equals 1/2 *heqat* or 160 *ro*."

Quixote explained that the fractions also suggest the process of DNA replicating into two daughter cells, each having one-half of the original sense DNA strand, then four cells with 1/4, eight cells with 1/8 and so on. In addition, the mathematical series also represents the radioactive decay series. According to Quixote, the Eye of Horus was torn into fragments by the conspiracy of Seth, but Horus overcame his rival Seth with the help of Thoth, who made the Eye whole again to restore Osiris.

He continued, "Now, what's even more interesting is the word *Wsir* for Osiris, which appears hundreds of times in these Pyramid Texts. It means *the place of creation* or *the seat of the Eye*. The activity of the Eye relates to the activity of a single cell that brings the god Osiris back to life."

Quixote told me that the activity of the cell or Eye is transcription and replication of DNA and then translation to protein, what modern chemists call the Central Dogma of gene expression, DNA to RNA to Protein. He then said that the Eye of Horus was not human DNA, nor was Osiris made from human DNA. I was stuck on the idea that Osiris represented the DNA of a god, when

I realized I was caught up in the symbol again, and that Osiris represented something in the spiritual world, something in the world beyond as did the Eye of Horus.

Then a lightning bolt of a thought struck me. The spiritual world or world beyond was the cellular world, the microscopic world we could not see. This took away the god status of Osiris, who I now thought of as molecular DNA other than human. The idea that the world beyond, the spiritual world, was the quantum arena of microscopic particles made me see the science within the religious symbol.

Quixote, who read my thoughts, was smiling. "*Psyche*," he said, "you're beginning to understand the meaning of symbols. So, these story-telling hieroglyphs you see on the walls are not related to an Egyptian religion. They are related to the tiny particle world and describe a religion of science and genetics. The ancient Egyptians masked their scientific knowledge in religious symbols."

Questions rammed my mind, but I only blurted out one: "If Osiris represents a type of DNA other than human, what is it?"

"It is," he said, "the DNA of a solar viral life-form."

My astonished eyes widened. For a brief moment, I thought he was joking, but he was not. Lucia's explanation about the Sun representing a virus engulfing the earth thrashed through my mind. I knew that all the Egyptian creator gods—Atum, Khepera, Re, Osiris—were solar gods. Was Quixote suggesting that the Sun represented a viral life-form as Lucia had?

Thoughts slammed through my mind. A virus has no plasma membrane, cytoplasm, or ribosomes. They cannot carry out transcription or translation or make ATP by themselves. They do not grow. They are ugly parasites that take over the replication machinery of the cell to clone their own kind. They are not even cells, they kill cells. Scientists say they are not alive.

I tried to calm down, focusing on the watchful Quixote, who was obviously enjoying my mental distress. His lips framed a large smile that exposed his bloody gums. He said nothing, for I knew he was reading my thoughts, so I tried to think rationally, or better yet, imaginatively, looking at the positive side of the virus concept.

Viruses transfer, shuffle and redistribute genes between organisms, but they also cause diseases in plants and animals like AIDS, smallpox and cancer. As molecular syringes they infect all types of cells: bacteria, fungi, plants, animals and humans. Sometimes they can cross over from one species to another.

Lucia had said that what is above is below, that ions on the magnetic field lines of the Sun and the earth represent the nucleosomes on a DNA molecule. Was the Sun injecting its DNA through the earth's magnetosphere? Did the Sun-god Re represent a viral life-form that was crossing over? Were the ancient

Egyptians advocating a transformation that would clone a viral-human, clone a viral-human in the afterlife after Death?

Quixote could see I was suffering. Even the insolent nag Rozinante stared at me, whinnying as if the animal sympathized with my manic state.

"Help me," I pleaded to the the valorous knight, and then he told me the whole god-awful story about how the Sun-god Re joins up with the Deceased to ferry him by boat through the black hell of the Duat. There they meet the god-man Osiris, who rises from the dead to allow the birth of the Horus child, a creation the Deceased Sun-god becomes. The entire journey revolves around cutting off the heads of enemies, throwing them in pits of fire, desperate wailing and everything else you would expect from a hell. I was beginning to understand why Quixote acted as he did and what motivated Conrad's headhunting hero Kurtz.

Still, after being mentored by Quixote, I was smart enough to know that this story needed to be translated, the symbols needed to be explained, for we were not talking about real people in hell, we were talking about molecules, chemical reactions and the idea that after Death, a human being could transform or be cloned into some other life-form, possibly the Overman, an idea that now left me unsettled and troubled.

Quixote then began to explain about the sphinx. He said that the Great Sphinx is sometimes called *Horus on the Horizon*. Between the paws of its lion-body rests a representation of a human.

Looking directly at Quixote, I said, "The sphinx then is a symbol pointing to the nature of the sphinx, which has a human face and the body of a lion."

Quixote smiled. "Yes and no," he said. "The Sphinx is a symbol that points to a fabulous animal or creation that has the nature of a human. It suggests abnormality, deformity and supernatural power, while representing the new species the Deceased becomes if he follows the advice of the funerary texts. The Sphinx is called Horus because it is the child of Osiris, a child that is both human and viral."

I was speechless again, lost in thoughts that the child Horus was a viral-human, falling prey to the error of thinking that the human form was evolutionary perfection. We were no longer talking about the god-man Osiris; we were talking about Osiris the virus and his viral-human progeny, a new afterlife species on the petri dish of Death. Shakespeare's deformed prisoner hobbled into my head, but I shut him out.

Seeing my discomfort, Quixote callously explained that the Egyptian scientists discovered that after Death the genetic essence of a human could be inserted into a bacteriophage, and then transferred by this special type of virus into a host cell. A bacteriophage or phage as he called it, also acts as a miniature

courier, ferrying DNA fragments between species, but this special phage only infects bacteria. It takes over the host cell's reproductive machinery, replicating its phage DNA along with that of the insert.

Putting all this information together, I reasoned that the Sun-god Re represented the phage that was carrying the inserted human genes of the Deceased. The Duat represented the host cell that the Sun-god Re and the Deceased parasitized by taking over its replication machinery, and the horror child—I mean Horus child—represented the birth of the new viral-human creation composed of the DNA of the viral Sun-god and the genes of the human insert. Pausing, I tried to see the whole Egyptian afterlife experiment clearly without emotion, but I was confused, frightened.

I understood that Osiris too was the same type of virus as the Sun-god, but I did not understand how Osiris the virus could rise from the dead. My thinking was clouded on this issue.

Quixote saw my confusion and continued, "What does a lion signify to you?"

I thought about it seriously. Although the lion suggests royalty, it also suggests savagery and the idea of being attacked and devoured.

"I would say there is a savage beauty and fighting spirit about the lion, but that it is ultimately wild and uncontrollable, possibly representing Nature's uncontrollable creations."

"There lies the point," he said. "Nature's creations are uncontrollable especially during viral replication. Remember the furious fighting spirit of the thousands of Greek warriors that swarmed from within the wooden horse, the machine that overcame the Trojans? This wild and uncontrollable explosion of life suggests the raging reproductive power of Nature."

Quixote then explained that the Sun-god and Osiris acted like phage Lambda, a temperate virus that could live two different lifestyles—lysis and lysogeny. When Lambda chooses lysogeny, it infects the host cell and becomes dormant, its DNA genome lodged in the host cell's chromosome, nailed there, so to speak. This silent inert Lambda genome is the sleeping Osiris, he said.

When the very first bacterial host cell multiplied, the sleeping Osiris multiplied with it, fragmenting into millions of cells for life on earth. Soon the bacterial cells developed into the human eukaryote type, the Lambda genome now replicated within each, but still sleeping in the DNA of all cell types.

I gazed at Quixote blankly and said, "You mean the Lambda genome sleeps quietly within human DNA until that person dies, then bursts into activity?"

"Yes, my friend," said Quixote. "It is the heart of all matter."

As relentlessly as Quixote slaughtered sheep, he delivered his lecture, slashing up religious beliefs I had accepted on Faith. He would not stop.

"When Lambda chooses lysis, the incoming infecting Lambda takes over the host cell's replication machinery, activating the sleeping dormant Lambda, which rises from the dead to produce millions of Lambda progeny. The lytic lifestyle is rapid, vegetative replication called rolling circle replication because it replicates in a circle, unrolling like a scroll, like a roll of toilet paper, like a witch's hoop. The viral progeny then escape from the host cell like thousands of little soldiers from a Trojan Horse."

His words, like a sharp sword into my heart, made me see that the great hammers of water-powered fulling mills, pounding wool fibers into felt, were indicators of the grindstone of rolling circle replication. It was the same idea, a mechanical operation circling round and round, grinding, crushing, pulverizing to produce a product. Fear-struck, my mind milled around as fast as the herd of sheep Quixote attacked. He continued, delivering the hammer blow that cut off my head.

"When the Deceased meets up with the Sun-god, he becomes part of the Lambda DNA that helps bring Osiris back from the dead."

Like a thief of the dawn, Quixote robbed me of my senses. Reeling with questions, I had time for one humble response, as the blood thinned in my brain.

I stammered, "How do I—how does one recognize the Sun-god in the afterlife?"

Smiling again with his raw bloody gums, Quixote said, "Imagine yourself immersed in measures of glittering light and wearing a gold crown of triangular mirrors upon your head. When you see this pure heart of light, this nameless reality, go to it, even when you feel the emotion of repulsion and disgust."

Weary and faint, I could take no more. Mercifully, his words faded, becoming far away, while other words invaded my mind: *Domine Deus, Agnus Dei, Filius Patris. Quix tollis peccata mundi, miserere nobis.*

The light of Quixote's knowledge was illuminating the quagmire of my brainwashed mind, exposing the misinterpretations and lies of history. My mind stripped of cultural garbage was numb, my eyes weary from exhaustion. I only wanted sleep and the chivalrous knight to leave. The last sound I heard was Rozinante snickering and stomping its hooves, as if the horse were mounted, then I passed out.

16

because, laugh if you like, what has been called microbes is god

To Have Done with the Judgment of God (1947)
Antonin Artaud

When I woke up, there was a heaviness and odor about me that I could not shake off, but I felt better psychologically, feeling the vague stirrings of Hope, inspired by the idea that there was an option for transformation after Death that could retain some humanity. However, at the moment, my humanity was not my concern. My six little legs were straining to push a large dung ball over the blue desert sands. This was not an easy task, even for the scarab beetle I had become.

My face bracing the dung-covered mass, my head tight against the egg-ball, I shoved the shit forward, understanding exactly the dilemma of the hero Gregor Samsa, who the nocturnal writer Franz Kafka forced to awaken from a sound sleep as a beetle. Looking at the bright side of my metempsychosis, I imagined that this experience would give me some time to think without Quixote smothering me in Egyptian genetics. Still, the strange coincidence of changing into a major Egyptian symbol was irksome.

Knowing that the Egyptian creator-god Khepera is symbolized by the Coprophagi beetle, noted for its ability to lay eggs in dung that it rolls into a circular

form, it came to me that the Egyptians associated the Sun's disk with the beetle dung ball. The later Greek counterpart to this idea was Sisyphus, who forever rolled a rock to the mountaintop, only to have it eternally crash to the bottom. Homer said the wise mortal Sisyphus had put Death in chains. It seemed to me that both the Egyptian beetle rolling its dung ball and the Greek Sisyphus rolling his rock were indicators of rolling circle replication, a form of viral life everlasting.

Musing, I rolled the warm dung ball over the luminous emptiness, over the heat-shimmering sands, and as I became better at driving dung, I considered that the solar-viral-human product of rolling circle replication probably would never attain human status again, therefore never dying again. Imagining that the lytic pathway might lead to an Egyptian eternity where Death was chained or nonexistent, I remembered Quixote said there were instructions in the funerary texts for this pathway. Was Lucia going to share this holy secret with John and me? For nowhere in any masterpiece except Dante's *Inferno* had I ever read anything about an actual path to heaven. Nonetheless, I was beginning to perceive ideas, people and events in the chivalrous manner of Senor Don Quixote, the man of La Mancha.

Using Quixote's knight-vision, I saw that one advantage of a beetle was smaller receptors, resulting in exceptional eyesight that allowed me to see prey everywhere, for before me danced vivid flashes of color, especially green, blue and ultraviolet. I was easily viewing the world at the blue end of the spectrum. Also, each of my six little legs was an engineering marvel, consisting of a femur, or thigh, a tibia, or shank, and a tarsus, or foot with five small joints that now waltzed the dung along smoothly. There must be unimagined advantages to every species, even that of a viral-human.

Just then, a Gershwin tune reverberated through the hot hazy sands, and I chirped in cadence with the Sublime rhythms of the song "Summertime." Yes, the living was easy, for I could now prod the dung ball forward by mounting it and then backing up, my many legs working in reverse to spur it forward. *Ba da ba bye bye . . . Dance till the rhythm it gets harder . . .* Poor Sisyphus only had two arms, but I had six actively-rotating legs. *Tension Tension Hold her. . .* Somewhat comforted by both my ability to move dung and my intellectual progress, I reconsidered the idea of modern man as a mutation. *So take this veil from off my eyes . . .*

To me it seemed that man's idea of God was the mutation, not man himself as Quixote claimed. This brought to mind something I had read by madman/playwright/poet/essayist/novelist Antonin Artaud. In 1947, right after World War II, Ferdinand Pouey, the director of literary and dramatic broadcasts for French Radio, commissioned Artaud to write a radio play. Artaud

had spent many years in an asylum, and the play turned out to be his final work. He entitled it *To Have Done with the Judgment of God*. Well, the French censored the radio play because Artaud represented America as a war-mongering machine and a baby factory, not to mention that he compared human life to the pursuit of fecality.

To Artaud, the choice was between living dead or dying alive. These two paths were available to humans, which he called *the infinite without* and *the infinitesimal within*. He proclaimed that Man must not choose to shit or live dead; he must lose being and die alive.

However, the biggest reason the French banned the broadcast was because God shows up on an autopsy table as a dissected organ in the defective corpse of man. Considering this idea now after my talk with Quixote, I had to admit that Artaud would have supported Quixote's view that Man in the world is the mutation. But, Artaud also considered God a microbe, a virus, as did Lucia and Quixote. If God were a microbe masking itself as human, as anthropomorphic, then why the trick?

I had only one answer. God masks itself as human to catch prey. My beetle-brain made me see that every living thing needs an energy source to survive, even massive, cold-light galaxies, which swallow up stars as if they were small appetizers. Humans were simply food for the gods, sources of energy, fuel for the fire, log-people.

Consider the beast Geraldine masked in beauty and arrayed in gems and silk. To exist, she needed the life-blood of Christabel and her father Sir Leoline. Now really, if a human knew that he was not at the top of the food chain, and that his turn to be eaten or absorbed came at Death, do you think he would walk happily up to his God, a hungry beast with teeth? Therein lies the reason for the disguise. Gloried beauty masks gory horror.

Even the *Bhagavad Gita*, the ancient core text of the Hindu tradition, acknowledges the rapacity of God, who has a billion-fanged mouth full of crushed skulls and raw human flesh. This primordial cannibal is Death, the highest form that devours all things and haunts the hearts of all beings. When the warrior Arjuna sees this horrid reality, he begs the mighty primeval God to return to the human form that he knows, and the reason that he pleads for mercy is because the ultimate form of God, the horror of horrors, scares the living shit out of him. If this is not cause for repulsion or disgust, what is?

Obsessed in thought, I shoved the moist dung ball along, savoring its putrid smell. Perhaps the Egyptian path through the afterlife might avoid this type of confrontation with Death or lead to a different outcome, a unique product at the top of the food chain like Death. The fact that the Egyptians had taken the time to carve numerous rock walls with scientific knowledge about a specific

chemical pathway into Eternity was impressive. I was stunned at the mind-blowing ignorance of my own culture in the twentieth century that had no idea of the secrets locked within the funerary texts about the transformation path.

With the advent of technology and warfare, the modern world worshiped the power resulting from the greedy accumulation of material objects, and it had no interest in spiritual quests that might disrupt time-honored teachings such as Greece was the nexus of civilization. It seemed that the abyss of education, religion, medicine, psychotherapy and other cultural bindings somehow prevented us from objectively accessing comprehensive wisdom.

Nonetheless, the playwright Artaud was in line with Quixote's simple philosophy, for intelligence to Artaud was walking around oneself, observing, watching. Artaud believed we have lost the lucidity of childhood and that opium use could restore that lucidity and overcome anguish by providing direct knowledge about our being. Albeit, this method allows a drug-induced lucidity like the peyote plant does, but it may enable one to remake oneself in the world.

Pushing the dung along made me remember more of Antonin Artaud's experiences, specifically his vision of a naked man leaning out of a window. The man had a huge, somewhat circular hole for a head, within which the Sun and moon revolved. His bar-like right arm was bent backward, edged in light, and did not indicate an ordinary direction, seeming somewhat skewed. His triangular navel glittered, framed as it was by seven ribs on each side. Artaud realized that what he saw was a certain phenomenon of light patterned on the mountain rocks, which repeated itself eight times. He saw this form when his spiritual quest landed him in northern Mexico, the mountainous home of the aboriginal Tarahumara Indian tribe, who were also aware of the form on the rocks. During his visit, Artaud took peyote and witnessed tribal rites that were ordered by a secret mathematics, whose symbols and signs he believed concealed a Science.

Today the Tarahumara tribe, a race of pure red Indians, resides in the Sierra Madre Occidental or the Copper Canyon region of Old Mexico at an altitude between 7,000 and 9,000 feet. They have evolved larger chest cavities, greater lung capacity, high tolerance to cold and pain, and a slower metabolism rate, an excellent natural selection of qualities that makes them strong long distance runners.

Now upright and running strong, it was hard for me to believe that early man scooted along on stiff-wristed knuckles like a gorilla, for our wrists were not mobile until *Australopithecus africanus* emerged about 2.5 million years ago. Although the famous fossil Lucy, the first hominid who lived in Africa about 4 million years ago, could walk upright, she was a knuckle-walker with stiff wrists.

Instantly, Futurity flashed before me and I knew that in the year 1993, Tarahumara Indian Victoriano Churro, age fifty-five, would painlessly beat out

hundreds of international and American contestants in the Leadville-100 mile race in Colorado. All this running energy on a tribal diet of only yams, squash and chicken! The tribe, which numbers over fifty thousand members, shares food and housing, and private property does not exist. The Tarahumara, who intrigue anthropologists, choose to live apart from modern Western civilization, which they do not respect.

I found it interesting that they did not respect civilized man. It was probably because we were bad breeders; we propagated our weak members. Certainly, I admire the inherent nobility of being sympathetic to the weak and helpless, but this moral awareness predisposes us to the development of a weakened species. Even the British naturalist Charles Darwin understood that with the exception of man, *hardly any one is so ignorant as to allow his worst animals to breed*. Actually, bad breeding and warfare are closely related, for the mindless will use guns and bombs to gain an advantage, especially when it comes down to a struggle for diminishing resources in an overpopulated world. Yet, the Tarahumara share.

Artaud visited the tribe in 1936, for he was interested in their peyote rite, what he called the means by which the Indians awakened their nervous system to supreme Truths that allowed them to regain a clear perception of the Infinite, a vision of one's true source. However, Artaud believed that the Indians did not know the meaning of their peyote rite; they had lost the secret of their symbols—the ten crosses and the ten mirrors within the large circle, where the sorcerers dance when the Sun sets, the inverted wooden bowl over the hole, where the hermaphroditic roots of the peyote plant lay dormant, a representation of the Male and Female principles of Nature.

Artaud discovered that their traditions told of a fire-bearing race of men, who had three Masters or Kings that traveled north to the polestar. To the Tarahumara, these three Kings are the three sorcerers of the peyote dance, and they wear crowns of mirrors, the triangular Masonic apron, and more triangular designs at the bottom of their knee-length pants.

Remembering this now, I sensed Artaud may have been mistaken in his belief that the Indians did not know the meaning of their rite. For, after talking with Quixote and Lucia, it seemed to me that these Indian sorcerers' crowns of mirrors and triangular designs pointed to the pyramidal form of the viral Lambda Sun-god, with the hermaphroditic peyote plant representing the viral-human transformation, a change that was grounded in the union of three Kings—the Sun-god, the dead person and Osiris. Although the meaning of this revelation in its entirety was still illusive to me, I sensed I was on to something that Quixote and Lucia would appreciate, and I believed that Antonin Artaud was not mad, but sane in a culture of madness, as was I, even now in the mask of a beetle.

Artaud's spiritual knowledge made him see that the inverted wooden bowl represented the globe of the earth and the hole beneath it a place of transformation like the Duat; he knew the purpose of the peyote rite was to bring a human to full consciousness, to bring one *into the day* as the Egyptians professed. Like the Egyptian journey into the Duat, the peyote rite occurs when the Sun sets, and accordingly, the tribal name Tarahumara means *where the night is the day of the moon*. It came to me that the tribe honored the Sun-god Rayenari and the Moon Goddess Metzaka.

In the light of Artaud's lucidity and my experience of pushing a stinking dung ball, I rejected all the lies I had been told in the past, and I vowed that I would use my Imagination to invent my future, whatever the cost, in the world of Time and space. Slowly, I understood what Quixote meant by mutation, and I now agreed with him. Man was the mutation, not God, for God was simply a microbe that was worshiped by man's system of mutant reasoning. Then Quixote's comment came to mind about the protective Eye of Horus, swooping down out of the sky to right wrongs, and I suddenly felt an even greater respect for the man of La Mancha who was, as Cervantes had written, attempting to right the wrongs of the world. At that moment of enlightenment, the sound of thunder reverberated above me, and the ground beneath me quaked with a rhythmic thumping that thrilled me. Thumpity Thump Thumpity Thump

Beyond my dung ball, I saw a greenish obscurity, a speeding mass of flashing metallic dust. Startled, I buried my face in the warm dung, only to experience an excruciating pain in my back, as I was pulverized into an irregular dung pancake by Rozinante's hoof.

Like a cowboy on peyote, the chivalrous knight-errant was on his careless way over the hot sands to discover another adventure. My consciousness happily oozed from the flattened corpse of the beetle, leaving the dung behind, wafting up on the Sonoran desert heat waves until I was far, far above the University of Arizona. I moved easily through the air, going north then northwest, climbing upon sunbeams like a fair young god who might inherit the heavens.

17

For me to expire in humanity's bosom was to be born
and become infinite, but if anyone put forward, in my presence,
the hypothesis that a cataclysm might some day destroy the planet,
even in fifty thousand years, I would be panic-stricken.
Though I am now disillusioned,
I cannot think about the cooling of the sun without fear.
I don't mind if my fellowmen forget about me the day after I'm buried.
As long as they're alive, I'll haunt them, unnamed, imperceptible, present in every one of
them just as the billions of dead who are unknown to me and whom
I preserve from annihilation are present in me.
But if mankind disappears, it will kill its dead for good.

The Words
Jean-Paul Sartre

Opening my eyes, I saw John before me and heard Lucia directing us outside to the sunny deck where we could talk. I stood up clumsily and followed John into the light. Placing two texts and her notebook on the deck table, Lucia angled the umbrella to block the blinding Sun, and without hesitation, I quickly slid into the chair that afforded the most shade. The Sun-dragon whirled along, breathing fire onto the mountain peaks that glittered like faience.

Lucia listened intently to John telling the details of our experiences in Bosch's painting and Cervantes' masterpiece. Again, to my surprise, I learned

that John was with me the entire trip and had easily transformed from a tree into a grapevine into the crystal goblet into Quixote's sword, and finally, into the dung ball I was pushing. You might call this experience quantum evolution. Lucia and John thought that his metamorphoses represented facets of human mortality, and that his earlier conversion into one of Geraldine's gems was similarly linked to his becoming a crystal goblet in the last escapade. Death was somehow connected to crystalline structure as was life after Death.

At that point, Lucia told us that the geometric ratio *pi*, which is the mathematical foundation of the whole universe right down to the smallest atom, is evident in the Great Pyramid. The perimeter of its base equals in length the circumference of a circle using the height as a radius. The relationship of the height to base length is 3.1428571, a number very close to the Greek *pi*.

Glancing at her notebook, where notations were scribbled around a strange diagram, she said, "If the pyramid were a clear crystal or glass prism, it would reflect sunlight at an angle of 26 degrees."

It was coming again, the trivia marching through my mind like an army of atoms, photons, light particles: the Sun spins around once every 26 days; the element iron has 26 protons; bosonic String Theory has 26 spacetime dimensions.

So what, Lucia? Under attack, I was getting impatient, thinking that Quixote made more sense than she did. But Lucia was consistent. She threw a right-handed fastball at my head as if she were Denton True "Cy" Young when he pitched 24 and 1/3 innings without surrendering a hit.

"The structure of a pyramid resembles the structure of phage Lambda," she said, placing a diagram before us. "The icosahedral head has 20 equilateral triangles arranged around the face of a sphere. Subunits are located around the vertices of the icosahedron. A few viruses with only 60 subunits have been discovered, but most fit 60 x N subunits into their heads. N is called the triangulation number, having values of 1, 3, 4, 7, 9, 12 and up."

John shifted uncomfortably in his chair, and I knew he remembered the discussion Quixote and I had about Osiris the virus, for he was there within the knight's sword. Lucia hesitated briefly, then continued, telling us that in 1935, when researchers found that viruses could be crystallized like inorganic salts and protein molecules, they argued whether or not viruses were living or nonliving. To them, viruses were like salt crystals that replicated their DNA in a host organism. She said that the Latin word *virus* means slime, poison, pungency, saltiness, and that researchers knew viruses could be supramolecular complexes or a very simple biological unit.

Lucia explained that viruses can consist of circles, ovals, long thick or thin rods, flexible or stiff rods, or have distinctive heads and tail parts. Whether it

was living or nonliving really did not matter because it could replicate by finding a host organism. For example, when a virus like Lambda replicates, the DNA moves out of the icosahedral head, goes down the tail, which attaches to the organism at a special receptor for binding the sugar maltose. Here like a syringe, it injects its DNA into the host cell. Lambda only attacks organisms with this special LamB receptor. Once inside the cell, Lambda takes over the host's replication machinery, producing phage progeny that spread like a wild fire.

She then told us that the Egyptian ruins of the Edifice of Taharqa by the sacred lake of Karnak provided additional evidence for her Lambda theory. The sunken remains of the Edifice was a monument to the Ethiopian Pharaoh Taharqa, who lived 690-664 BCE. The excavation of the monument began in 1907-08 CE, when G. Legrain, under the direction of G. Maspero, cleared the Edifice. By 1969, J. Lauffray had cleared and studied the so-called nilometer. Finally, J. LeClant, Richard A. Parker and Jean-Claude Goyon collaborated in 1979, to describe the texts, scenes and architecture in the large book Lucia had before her.

It so happened that Jean-Claude Goyon not only translated the texts, but also provided an interpretation of the Egyptian ceremony that was performed in the ruined building. He wrote that the architectural features of the subterranean rooms suggested that the Edifice was dedicated to Osiris, god of the underworld. But Osiris is only present in specific rooms, whereas Amun, god of origins, is the reigning cosmic god of Thebes who is associated with the Deceased King.

Lucia explained that the so-called nilometer, with its architecture emphasizing a skewed direction and its tail-like body and structural head attached to the two-walled court into the Edifice, is a representation of the head and tail structure of Lambda attached to a bacterium's double cell membrane. Like the five pyramids aligned to the stars of Orion, the nilometer attached to the Edifice represents Lambda attached to its host cell.

Both John and I were stunned by this revelation. It was difficult to believe that the Pharaoh Taharqa built the nilometer and Edifice to mimic a virus attached to a host organism. Still, we had to admit that the Egyptians constructed five pyramids that mirrored stars in Orion. So maybe it was possible.

Lucia paged through the text to LeClant's architectural drawing. She retrieved a sketch from her notebook, a drawing of phage Lambda attached to a host cell, and placed it next to LeClant's drawing of the nilometer and Edifice. We could easily see the remarkable similarities between the so-called nilometer attached to the Edifice compared to Lambda attached to its host cell.

Then Lucia opened a genetics book, showing us an enlarged drawing of Lambda with its icosahedral head and long tail. Next to this she placed a profile

of the causeway to Khafra's pyramid at Giza. The long narrow causeway connected to the Great Pyramid, just as the tail connected to the pyramidal Lambda head.

"As you can see," she said, "Khafra's pyramid looks like the Lambda head. The 500 meter causeway looks like the Lambda tail." She paused briefly and then said, "Even the Pyramid of Unas, where the Pyramid Texts are carved, has the same structure—750 meter causeway extending to the Pyramid head."

We stared at the drawings for several minutes in silence, the cool mountain breezes comforting us, but she would not stop. Lucia said that there were also many carvings on the Edifice's subterranean walls depicting the Decreased Sun-god and other deities wearing long, ceremonial tails. This was additional proof for her thesis, suggesting Lambda tail structure.

Along with this evidence, she said the underground ceremonies in the Edifice mirrored the journey of the Deceased Sun-god through the Duat, matching the same descriptions in the Book Amduat and the Book of Gates. We realized that Lucia's strategy of linking the Edifice's ceremonies to events in two earlier funerary books was a fairly sound evidential base for her Lambda theory about the lytic cycle, the rising Osiris, and the ferrying of the human insert through the host organism, the Duat-Hell. But, she now had connected Lambda structure with both the Edifice's nilometer and pyramidal architecture. What this meant was that the Egyptians imagined the deceased Pharaoh entombed in the pyramid or Lambda head, ready for injection into the host cell, that is, the Duat-Hell. Marveling at the ability of the Pharaohs to use their Imaginations to invent their future afterlife, I listened closely to Lucia.

She then explained that the ceremony in the Edifice described the same path of events through the Duat-Hell to Eternity, but in less detail, than the Book Amduat and the Book of Gates. The afterlife transformation was only available to the Kings and nobility because they knew the secret pathway. The knowledge was kept from the plebs. At this point, John interrupted her.

"Lucia, I want to make sure I have this straight. What you're saying is that the Egyptians modeled their pyramids and the Edifice's nilometer on Lambda structure, right?"

"Yes," said Lucia, "the causeway of the pyramids represents the Lambda tail and the pyramid represents the Lambda head. In the case of the Edifice, the building itself represents the host organism or cell. The nilometer attached to the Edifice represents Lambda attached to the host cell. The Edifice is the Duat. The northwest rooms in the Edifice map the journey through the Duat, which is the pathway of Lambda choosing the lytic lifestyle over lysogeny. The Deceased enters the picture as the insert in Lambda to be cloned in the host cell, which is the Duat," she repeated.

Making sure that he understood, John persisted. "So when the Deceased meets up with the Sun-god, his consciousness, his genetic essence is inserted into the Lambda DNA, which then goes into the host cell, the Duat, which is hell," he said, hoping that she would not agree.

"Yes," she said. It was as if she had struck us with a bat, yet our talk with Quixote was making more sense. We understood that the spiritual world was the quantum world of atoms. We understood that the Egyptians masked their scientific knowledge in religious symbols. The solar-viral life-form that Quixote spoke of was bacteriophage Lambda, phage for short. Both the Edifice with its nilometer and the pyramids with their causeways were designed like Lambda. The phage transfers or ferries genes between organisms. It also ferries the dead person's genes into the host cell. Lambda can live two different lifestyles. When it chooses lysogeny, Lambda hides silently in the DNA like a sleeping Osiris. When it chooses lysis, the Osiris virus literally rises from the dead as explosively as an attack of soldiers clambering from a Trojan Horse. Lambda is like a plague of locusts when it erupts, a swarm of hornets, an exponential growth of numbers. *Agnus Dei, Filius Patris*

"The meeting of the Deceased person with the Sun-god," John repeated, "for the trip through the Duat was a meeting where a human is inserted, absorbed into a phage Lambda, which then attaches to a host cell."

"Not a human, John—fragmented DNA, human consciousness, human genetic potential, information, whatever elements remain after Death," said Lucia forcefully.

Like a robot John continued, ignoring Lucia's comment. "The Duat is the host cell which is like a hell. Lambda DNA is injected into the host cell with its human insert. It takes over the host cell's replication machinery and reproduces human-phage clones, viral-human beings."

He finally stopped to take a breath, and then the words poured out of John's mouth again like a rush of red poppies replicating.

"The Egyptians were cloning a new species in the afterlife after Death. Is this possible?"

Lucia just nodded her head, completely agreeing, and then calmly, she said, "The human species was not created complete and unchanging. Consider this transformation as a type of natural selection that would assure the survival of the human species by allowing it to surpass itself, while preserving the collective consciousness of humanity."

There is in every lunatic a misunderstood genius
whose idea, shining in his head,
frightened people,
and for whom delirium was the only solution
to the strangulation
that life had prepared for him.

Van Gogh, the Man Suicided by Society
(1947)
Antonin Artaud

18

Numb, we sat in our garden of silence without consolation, two souls, two disturbed Truth seekers. I imagined that hell was similar to the poet Friedrich Holderlin's abyss, unbound and all-fathoming, seething with light from lytic viral production. It seemed that the free rhythms of his works were tragic hymns, written calmly and courageously to stave off his madness, his thoughts of Death and the abyss.

Modern psychologists have diagnosed Holderlin's madness as acute schizophrenia with bouts of manic-depression, but medical documents during his time are fuzzy, claiming that he suffered from *trauriger Zustand, Zerruttung,* and *Umnachtung.* Translated, that is sad condition, confusion, benightedness. One could say that he was overcome by the darkness of night, by melancholy, by hopelessness, by the same despair that haunted Nietzsche and others.

John had moved his chair into the sunlight. He looked sad, for he must

have been thinking of the many creative artists who have gone mad in their quests for Truth, the ones who could not find strength in wisdom, the ones who saw insanity as a way out of an intolerable world. These madmen were not to be blamed, for they were culturally bound by the abyss of modern fragmented thinking.

Take psychology, for instance. About 1906, the Swiss psychologist-guru Carl Jung claimed that one of his schizophrenic patients saw a penis hanging from the Sun, and that it moved to produce the wind. Jung was confused as to the meaning of this odd mental picture, but interested in mythology, he discovered a pre-Christian Mithraic religious reference about the wind originating from a tube hanging from the center of the Sun.

From this Jung theorized that since the patient knew nothing of this myth, that the image must have come from the shared human heritage of ancient residues buried deep in our unconscious, what he called the collective unconscious. Jung believed his method could correctly diagnose psychological symptoms from fantasies interpreted in line with mythical images. At the same time he was treating his penis-patient, he diagnosed an American woman as schizophrenic by the same method, had her admitted to a nut-house, but she was released within a week with no symptoms of schizophrenia. Jung had made a mistake.

Certainly, there are mythical images in the hallucinations of the insane, but is this cause for incarceration? What if Jung had explained to his penis-patient that his hallucination represented a solar flux tube or a Coronal Mass Ejection of plasma, which actually does produce the solar wind? But Jung could not explain this possibility to the patient because he had no imaginative capacity to see a Coronal Mass Ejection as a penis.

To be fair to Jung, this knowledge about the operation of the Sun was not available in 1905. But it is available today in the young science of Space Physics, which few psychologists study because our sciences are split, fragmented, packaged into neat schizoid disciplines, multiple personalities attempting to see parts of Truth, but not the whole. Today, systematic Western clinicians have the Diagnostic and Statistical Manual of Mental Disorders that allows them to easily diagnose clients.

The disorders are classified and subclassified with diagnostic criteria placed in compact gray boxes. Even though modern psychologists do not understand the meaning of their patients' hallucinations, they can still classify-label-diagnose the client as mentally ill. What is worse is that the patients believe the clinicians are right, so they live demented, tormented lives, justified as they are by the clinicians' diagnoses that they are crazy, schizophrenic, mad.

But not all patients are believers. The madman-philosopher Antonin Artaud

spent nine years in insane asylums. His persistent delusions, auditory hallucinations, glossolalia and violent tantrums rewarded him with repeated electroshock treatments during his final three years of captivity. Artaud was not suicidal, but he said that each conversation with his psychiatrist made him want to hang himself because he could not cut the physician's throat.

Of course, physicians can vary their diagnoses for schizophrenia. There is the Disorganized Type, the Catatonic Type, the Paranoid Type, the Undifferentiated Type, but why label humans on the weak base of diagnostic criteria mired in misinformation and based on a language dissociated from meaning? The real problem is that clinicians can not understand how the imaginative insane can *see* these mental pictures that define Truth and Knowledge.

To the clinician, an individual has lost ego boundaries or the sense of self, when that person is perplexed about identity and the meaning of existence and has the insight—not delusion—to sense control by an outside force such as Nature. Because psychiatry frowns on spiritual quests, psychiatrists see the genius of the artist as a threatening monster that must be restrained, deadened, electrocuted.

Take the French surrealist writer Gerard de Nerval, whose physician advised him to document his madness in a book. Nerval then wrote *Aurelia*, a story about the delights of Imagination, dream and his vision of a golden goddess and her radiant orchard paradise. He believed dreams opened up the spirit world. In one of his dream-like voyages, he explained how he was carried along a current of molten metal, whose streams were chemicals that crisscrossed the world. Nerval described this as a *transparent network which covers the world* and stretches *by degrees to the planets and stars*. Actually, this is a pretty accurate description of the earth's magnetosphere, an energy structure with loops of crisscrossed magnetic field lines and currents.

In his last account, Nerval also wrote that these *currents were composed of living souls in a molecular condition*, and that he was traveling by them too fast to see who they were. Likewise, magnetic field lines have ions frozen on them like beads on a rosary, like nucleotides on the DNA molecule. Chemicals are composed of atoms and space abounds with hydrogen, nitrogen, oxygen, carbon, iron atoms and molecular blends, even amino acids, the foundation of matter. Nerval's awareness also suggests that his *serpent that encircles the Earth* is none other than the real ring current around our planet, the Van Allen Belts. Finally, he sensed his own spiritual strife deeply and described his plight as *sliding on a tightrope of infinite length*.

Nerval believed that we acted out our destinies on earth, where we were captive because the electro-magnetism in our bodies is forced in a direction imposed on it by laws. Our ills are related to an error in the general combination

of numbers. We have been cut up in a thousand pieces and the races are losing *strength and perfection*. We have completely misunderstood the secret of life. Information has been falsified to keep us ignorant. We are immortal, we have a double, a molecule is a group of souls, and Death ultimately devours everyone, whether you have been good or bad.

Thoughts plagued me like flights of ideas, like blackbirds circling a wheat field. I remembered that Nerval hung himself from an apron string, his pockets stuffed with the last pages of *Aurelia*, where he wrote that he would *fix* his dream state and use his will power to dominate his sensations instead of being controlled by them. After all, he believed that the microcosm is simply the image of the macrocosm in one's heart.

Perhaps *Aurelia* was the Egyptian mother-goddess Isis, for in 1843, twelve years before his conscious suicide, Nerval journeyed east to Egypt, Cairo, Alexandria, the pyramids. Nerval, *l'intelligence brillante, active, lumineuse,* in search of hashish, adventure, the occult, the bizarre, and the mystic Eternal Female, was later reduced and sentenced to a Freudian interpretation—childhood identity problems, a mother fixation, sado-masochistic ambivalence, sexual impotence, homosexual inclinations.

Still, even Antonin Artaud believed a physical suicide like Nerval's was not the answer because we were already dead, we had already suicided by living dead in the world. So Artaud offered an alternative, an *anterior suicide* or retracing our steps *to the other side of existence, not to the side of Death*. I imagined Artaud's option as a movement across the tightrope to the Overman, the new cosmic species, the final stage of human evolution.

What is really needed is an understanding of the meaning of the vision, the meaning of the hallucination itself, along with an understanding of ancient symbols. Jung, despite some mistakes, was on the right track with his method of Active Imagination. This healing function to restore the unconscious meaning of the symbols could also restore a healthy balance to both the psyches of patients and their psychologists. Practical treatment would be the person's own insight into the process. To be healed, the person would try to understand the deep unconscious meanings of the mental pictures, the symbols, the bizarre hallucinations, the confused diagnostic criteria. For example, one would have to consider the actual meaning of the sensation of slowed time, social withdrawal, eccentric behavior, magical thinking, persecutory delusions.

Is it not true that the major clinical diagnoses rotate like a monstrous galaxy around one central symptom? Is not that symptom the black hole of human sadness anchored to Nature's cold indifference and our own inability to unmask Truth, to see the jester for what he is?

My manner of thinking caused me to feel like one of Holderlin's bees,

drunken and maddened to a frenzy and burned by the light because of too many spring scents. But what I smelled was not a spring scent; it was the putrid stench of a culture lobotomizing man, sentencing man to Death-by-mediocrity.

Yet, like a madman attracted to the light that punishes the moth, I too wanted to know the unconscious meaning of the symbols, and it was then I realized why Quixote called me *Psyche*, for I was forced to love in the dark without seeing the face of the lover, the face of Truth because Western culture and Nature had dangerous boundaries and laws that safeguarded ignorance.

Remembering the man from La Mancha, I suddenly understood his intent. He was trying to explain the meaning of ancient symbols as was Lucia. They were trying to restore the fractured consciousness of humanity by connecting images and language to meaning. Both Quixote and Lucia knew the symbolic code and were attempting to explain it. They were dissecting the heart of Nature and the corpse of culture.

Lord of the Sublime Arm

> It is not easy to characterize a discipline like
> the history of ideas: it is
> an uncertain object, with badly drawn fron-
> tiers, methods borrowed from here
> and there, and an approach lacking in rigour
> and stability.
>
> *The Archaeology of Knowledge and the Discourse on Language (1972)*
> Michel Foucault

19

John watched Lucia for several minutes as she wrote in her notebook. Then he stood up, stretched and walked over to the pool, looking down at the reflection of the mountains in the clear water, thinking that what is above is what is below. Just then a mountain lion appeared in the waters, its yellow eyes flashing, its 150 pound tawny gold body frozen on a six-foot expanse of the ledge.

It was clear to all of us that the mountain lion in Arizona had few, if any, natural predators and was at the top of the food chain. Immediately, John remembered that a person should stay calm, speak firmly and make eye contact, always leaving the lion an escape path and showing the lion you are not prey. John looked directly into its glazed pitiless eyes, took off his shirt, and dove in the pool. When he surfaced, the lion was gone, as if it had never been there, as if it had been a hallucination.

I rambled over to the three-foot ledge and gazed beyond into the ravine. No tracks. When a lion walks, it places its hind paw in the imprint made by the

front paw. Lions have four toes with three distinct lobes at the base of the pad, resulting in the distinctive "M" shape. Since their claws are retractable, they are not visible in the track. Was the lion really here? I was not sure.

Without warning, I was drenched in sweat, my adrenaline surging. I had the sensation of something dreadful too close to my head. Slowly, my eyeballs rolled upward, as I peered into the horrid black eye of the cold Sun. A sudden sickening rush of movement made me jerk backward as the dark disc burst with energy, pulsating at a fast rate, hammering at my frozen brain. Then the monstrous globe expanded into a huge gaping mouth, a moving tongue of fire licking out with flaming fingers, ripping at the depth of my being, tearing at my paralyzed heart! Unable to breathe, but desperately struggling to stay calm, I backed up slowly, leaving the beast an escape route.

Then swiftly, I dove for my deck chair beneath the umbrella's shaded protection, unnerved and paranoid from the encounter, an emulsion of sweat blurring my vision. The Sun was still stalking me! How did I sink so low on the food chain? It wanted to rip out my heart!

Breathing deeply, I tried to relax to stop the attack of thoughts. Hearing the calm voice of John questioning Lucia reassured me that I was still alive and safe beneath the ostrich-feathered sun-shade.

"What do you mean when you say the rooms in the Edifice map the journey through the Duat?"

Glancing up from her writing, Lucia said, "The subterranean rooms represent the underworld of Osiris, the Duat. The scenes on the west wall of the Edifice show Taharqa walking north, which is the same direction advised by the Pyramid Texts and the Coffin Texts. The west staircase wall leads to an antechamber, then a vestibule. The journey through the Duat begins in the west, where the Sun-god approaches the Pharaoh Taharqa."

From what Lucia said, it seemed as if the Deceased had to go north, then enter the Duat in the west, but these directions were not specific, so we listened and watched as she opened to the plates in the back of LeClant's book.

She explained that Taharqa opens the Duat and proceeds into the next room, which is the Chapel of Re. As she showed us the wall reliefs in the plates, we saw Taharqa dressed in a kilt with a triangular front, sporting the ceremonial tail in the presence of eight deities on a boat. A second representation depicts him near an offering table of meat, fowl and bread loaves with his right hand raised. At the foot of the table is an oblong vase with blooming lotus. The translated hieroglyphs explain that Taharqa the Sun-god will be transformed and that there is a mysterious door leading out of the Duat. We waited for Lucia to tell us the escape route out of the Duat-Hell, but she did not.

"The relief on the north wall of the room shows the night-bark with the

Sun-god and crew of eight," she continued. "The Sun-god and five deities onboard this small ship have ceremonial tails as does the baboon in the bow, representative of the god Thoth."

We then learned that the Sun-god Taharqa conquers the monster serpent Apopis and is reborn as the newborn infant being lifted by the primeval deities Heh and Hehet in the relief. Seeing the large winged transformation beetle on the wall reminded me of my experience pushing dung in the Sonoran desert. As her voice droned on, the idea of becoming Frankenstein crossed my mind, or worse, the idea of being devoured by a monster. And then, a hawk flew up from the ravine and I flinched, thinking it was Bosch's bird-beast.

"In the final room, the left side of the lintel in the upper register shows the King with the Wife of the God holding a palm and a priest carrying a standard with a falcon on the perch. However, the dominant scene is a mound with a wide band arching above two outstretched arms with hands open to the sky. A falcon is centered between the arms on what appears to be a lotus with a plume on the right, a symbol of the mother goddess Isis."

"The arms remind me of Christ on the cross," said John, mimicking Christ's stance on the cross by stretching his arms out to reenact the Death of the Godman.

Annoyed at John's theatrics, Lucia spoke rapidly. "What the two long arms signify is the chemical equilibrium of the rising Lambda genome within the host cell. Formerly inert or dormant, the genome is once again balanced by the activity of genes that were formerly repressed. These activated genes and the nutrient lactose medium balance the left arm and right arm of the Lambda genome, allowing the birth of the Horus species by the lytic pathway, at the expense of the human species and the lysogenic pathway, which has already occurred for the Deceased."

To me it did not seem odd that the Pharaohs used arms to signify the left and right arms of the Lambda genome because modern geneticists talked in terms of left and right arms. But something was wrong. Could you just exterminate the human species with a little lactose? Lucia must have sensed my uneasiness.

"Actually," she said, "it comes down to a competition for control between c-one protein and cro protein. If c-one wins the battle, we have the lifestyle of lysogeny; when cro wins, we have the lytic lifestyle. So with the cro protein victory, the scales become balanced—lysogeny was yesterday, the lytic cycle is now."

Lucia paused for a moment, as I imagined two proteins fighting over a bowl of spilled milk. An expression crossed John's face as if he understood what she was saying.

He said, "The Egyptian judgment scale, equally balanced on both arms by a feather and a human heart, represents this same idea of chemical equilibrium brought on by lactose metabolism."

"Yes," said Lucia, "because the human heart must be balanced by the lactose nutrient medium, by Isis, who is indispensable to the reaction that balances the scales by allowing lysis."

John and I were beginning to appreciate that Isis was pivotal to the whole chemical process, for without the lactose medium, the transformation of the Deceased Sun-god could not take place. I then realized that the Deceased was actually three molecular forms in one chemical, self-assembled unit. The Deceased was the Sun-god that bonded to Osiris in order to produce the new Horus species composed of all three. The notorious trinity was respectively the human insert bound to incoming Lambda DNA, bound to rising Lambda DNA in the host organism. Three Kings. Cell lysis would allow the escape of this tri-molecular species into the extracellular medium, into the daylight of the moon, into the cold black starry cosmos, where the Sun would never come back as we know it. *Gloria Patri, et Filio, et Spiritui Sancto*

Pointing at the relief in the *Edifice of Taharqa*, Lucia then said, "The mound represents the rising Osiris, who is excising from the cell due to the cro protein victory and consequent lytic lifestyle," she said. "The Rites of the Divine Reentrance occur in this last room. The ceremony simulates the arrival of Amun-Re, Lord of the Thrones of the Two Lands, which are the two arms of the Lambda genome. A priest welcomes a short procession led by a prophet carrying a shrine chest with a curved roof, containing the sacred uraeus or cobra. Four attendants follow, bearing a rectangular *hn*-tabernacle with a curved roof. A priestess is next with her left arm covered and her right hand holding a palm, an Osirian symbol of the vegetation god's victory over inertness, that is, the victory of vegetative lytic replication over lysogeny. The legend under the tabernacle states *the earth quakes*, a reference to the earth-cell bursting into flames or the flood of viral progeny from lytic replication."

At this point, we easily recognized that the tabernacle represented the soon-to-rise Osiris, and that Lucia had a substantial amount of evidence supporting the idea that the Edifice mapped the lytic pathway to Eternity. Yet, what disturbed us more than the idea of a viral-human, was that Lucia was not telling us everything about her Isis Thesis. She gave us limited information about the code of ancient Egyptian signs that she had cracked. Nor did she give us the Egyptian directions for the the path to Eternity. We had no choice but to listen to her rambling explanations, hoping she would tell us soon.

In the text, Lucia then showed us the scene of the central Mound of Osiris, a crypt buried in a mound surrounded by a wall and supported by an acacia

tree. To the right was a carving of Taharqa throwing four balls. The rite began by cursing the north quarter of the world, then the west, south and east. Then the Pharaoh, attired in a kilt and ceremonial tail, ran toward each of the four cardinal directions, throwing one clay ball in each direction with his right hand to destroy Amun's enemies. The text describing the balls claims that they protect Re and are born of him.

"That the balls are born of the Sun-god Re," Lucia said, "suggests the production of viral progeny. This apocalyptic act of throwing balls or clearing away the world can be compared to the usual result of Lambda progeny production, which is cell lysis or destruction of the cell. Balls or discs suggest the spherical phage heads, rolling circle replication, and the symbol of Osiris bent back into a circle."

We stared hard at the image of the Pharaoh with his right arm raised, his legs spread to throw, and his left arm stretched out like a pitcher bent on winning the World Series.

"This," Lucia said, "is the same image of the Envoy of Heaven beneath the winged disc in the book Amduat from both the Tomb of Seti I and the Tomb of Ramesses VI."

The image of Taharqa with his four balls reminded me of the Four Horsemen of the Apocalypse, who each exercised destructive power over a fourth of the earth.

John, his bloodline Irish, was thinking similar thoughts about power over earth. Boiled like a potato in the waters of Roman Catholicism since he was a child, he realized that the activity of the Four Horsemen in the book of Revelation was the same as Pharaoh Taharqa's ball game. Surprised, he stared at the image in the book as if it had stolen something sacred from him, but his loss was not related just to his faith. For, the roots of deceit went much deeper, and he knew it. The loss was the theft of his identity, his being, his thinking by controlling social forces that had distorted knowledge with lies. History, religion, psychology, to name only three, had created an inauthentic world to enslave a man's thought and make him mill around confused like a sheep to be slaughtered.

John knew his biblical history and the account of the Four Horsemen of the Apocalypse, written by the virgin apostle John, symbolized by an eagle. He knew there was no document with evidence for the exact year the book of Revelation was written. Composed about 155 CE, Justin Martyr's work called *Dialogue With Trypho* was the earliest dependable evidence for the existence of Revelation. Martyr wrote that the apostle John had a revelation related to resurrection and judgment.

Frowning, John lit up a cigarette and leaned back in his deck chair.

"The book of Revelation," he said slowly, "was written in Greek, so it seems that the historians refashioned Taharqa's ballgame into a Greek cavalry raid. The Egyptian material predates the Greeks by at least three hundred years."

It was true that Taharqa ruled about 660 BCE, and Alexander the Great spent several months in Egypt in 331 BCE during his campaign against the Persians. Some historical resources say that Greece and Egypt coexisted for the next three centuries, but others say Alexander conquered Egypt. Journeying on the Nile, Alexander arrived in the Egyptian city Memphis to study the customs and laws. He gave orders for temples at Luxor and Karnak, the location of the Edifice, to be restored. Appearing in Egyptian reliefs wearing the ram horns of Amun with his Greek name translated into hieroglyphs enclosed by the royal cartouche, it was written:

Horus, the strong ruler, he who seizes the lands of the foreigners, beloved of Amun and the chosen one of Ra – meryamun steeper Aleksandros

One could easily see how an Egyptian ballgame could turn into one of Alexander's cavalry raids. The conqueror fought battles on horseback, and horses were as important to the Greeks as Apis Bulls were to the Egyptians. The Roman historian Plutarch tells an interesting legend about how Alexander acquired his powerful battle horse Bucephalas.

The large-headed black stallion was vicious and unmanageable, always refusing to be mounted. Yet, Alexander had noticed that the horse was disturbed by his own shadow, so he approached the spirited animal, turned him into the Sun, mounted him nimbly, urging him into a full gallop. From that moment on, Bucephalas never failed Alexander, until the worthy stallion died of battle wounds in 326 BCE. It has been said that Alexander viewed his horses as immortal and a gift from the gods. He later founded the city of Bucephala, thought to be the modern town of Jhelum in Pakistan, in memory of his stallion Bucephalas.

It was obvious that the Greeks easily preferred charging a horse into battle over throwing balls at enemies, so they altered the Egyptian context. What bothered John was that the process of history distorted and distributed the Egyptian cell lysis chemistry that surfaced later in the Bible, a source claiming originality that did not understand the chemical intent. Actually, historians call this process of distortion *syncretism*, the fusion or mixing of various religious doctrines, resulting in a loss of Truth and a construction of the idea of God on the basis of lies.

This same penchant for fictional creativity or lies is evident in our modern power-knowledge systems, such as education and medicine that control thinking and define normalcy by claiming that they possess definitive knowledge, which is impossible. No wonder we are confused, for even a neurosurgeon

would have difficulty activating memory sequences in the smattered brain of human history. With this fragmented receiving organ, modern culture can only evaluate an unobservable past of memory sequences that are altered, written down and repackaged by the prevailing power elite.

So it was that John saw Truth surviving outside of history, outside of modern consciousness, surviving but buried within the lost meaning of the signs carved in the Egyptian pyramids and coffins. John believed that Truth haunted these abandoned relics that Lucia claimed she had decoded.

20

> And perhaps everything phallic is just a setting-forth of the human hidden secret in the sense of the open secret of Nature. I can't remember the smile of the Egyptian gods without thinking of the world "pollen."
>
> *Note to Lou Andreas-Salome, February 20, 1914*
> *Rainer Maria Rilke*

Setting an hour ago, the Sun was gone, and now the dark sky glowed with a silken shade of deep blue that the Egyptians called *lapis lazuli*. Stars flickered into existence like reborn souls, sparked by some centre outward, so they could rise upward to a point of origin in the universe. But John, his elbow on the table so his hand could support his forehead, did not see the lights in the darkness.

The same melancholy and anguish that settled in the minds of Holderlin, Artaud and Nerval was evident in John, but he disguised it under his mask of reason. He reached for a cigarette, while watching Lucia organize her notebook, for she was getting ready to retire to her glass laboratory to rewrite her thesis.

Standing up, she walked halfway to her lab, then turned around and said, "Cloning experiment tomorrow morning, sunrise."

Like pillars of salt, we blankly stared after her as she retreated into her glass house. Judgment Day was near. We were on our way to hell.

That night I slept restlessly, frightened by shadowy specters from the minds of Goya, Nietzsche, Poe, Coleridge, Artaud, Nerval and Bosch. Nowhere in their hellish works could I find any advice about the exact path to Eternity.

They knew the destination, but not how to get there. Even Quixote had succumbed to melancholy by the end of Cervantes' masterpiece despite his chivalry, and I wondered if this was the reason for his despair.

Anxious, I comforted myself by the idea that Lucia had spent years studying Egyptian texts as had her grandfather. She had studied the least corrupted Pyramid Texts from the Old Kingdom that were carved in the tombs of the Pharaohs and Kings, along with the Middle Kingdom Coffin Texts carved in the coffins of the nobility. She had studied them all: the Amduat, the Book of Gates, the Egyptian Book of the Dead, the Book of Two Ways. She had a solid evidential code defining their interlinked, complicated symbolic system that supported her thesis. She understood the intent of the hieroglyphic language and sacred images.

There was no mistaking it. Lucia understood the Egyptian religion of science, and she knew the path to Eternity. The knowledge was locked up in her thesis. Still, her secret code unveiling the meaning of ancient symbols depended on her Lambda theory about the lytic pathway. She expected that after our white powder trip through hell to Eternity, we would return to confirm that the Egyptian heaven is simply a quantum experience, resulting in a lytic pathway transformation of a human into a viral human. Sure, she had a lot of evidence for this model, but she wanted her theory to wear the uniform of the Scientific Method. This would convince the logical-positivists like the narrow-minded Professor Grolsch. John and I were simply the means by which she could place her thesis on logical-positivist ground, the basis of an actual experiment with real observers.

I thought of Quixote's enlightened logic, what he called the philosophic method. Intuition first, followed by vision, then deduction or premise-to-conclusion, so that the observed evidence would be linked together. In this light Lucia's thesis was solid, but the Scientific Method required that on the basis of a hypothesis, the scientist must predict what should be observed under specific conditions. As a scientist, Lucia needed a carefully designed, controlled experiment to fulfill this exact requirement. If her observations corresponded with her predictions, then the hypothesis would stand. John and I were the key because we were the actual observers that would determine if what we saw matched her predictions.

Lucia had no intention of telling us the exact path through the Duat-Hell because if she did, she would sabotage her own experiment by giving us advance information. She was hoping that we would return and verify the Egyptian predictions about the afterlife. Our observations, of course, would support the code she cracked and match up with cellular events she observed in her lab cloning experiment. Lucia had circled her bases, and she was heading for home

plate just like Lou Gehrig, the Iron Horse, who had a slugging percentage of .765 before he died.

A DNA sample had already been taken from John weeks ago. Lucia intended to insert his eukaryote DNA into phage Lambda tomorrow. The Lambda vector would then attach to an *E. coli* host cell, injecting the recombinant DNA into the one-celled organism. At the same time, John would ingest the gold. Not only would Lucia have a personal account of the journey through the host cell, but she would also have a controlled experiment. It would all happen in her glass laboratory when the Sun rose tomorrow.

Troubled and frustrated by my attempts to use my Imagination to determine my future, I must admit that I was still uneasy about becoming viral. The thought of Durer's dark angel preoccupied me, for I understood the angel's melancholia. The sullen angel sitting in its alchemist lab was thinking about the potential transformation it could make. The heavenly change was not appealing; it was nonhuman. The engraving's magic square of numbers adds equally, but is unequal; the scales balance, but are off. The infant nymph sits on the grindstone indifferently, a cold product of Nature, a product of rolling circle replication, a human clone contemplating itself, contemplating that it was still human but viral. I inhaled deeply to stop the rapid explosion of thought.

It is difficult to think of oneself without the human form, to think of oneself as an octahedron or an icosahedral head with a tail. If this were the transformation that Nietzsche envisioned as the Overman, then it may have contributed to his madness.

Yet, Quixote said man was the mutation. I trusted Quixote and had an irresistible urge to contact him before the cloning experiment. I calmed myself by thinking that a clone was simply a group of cells that are genetically identical as a result of asexual reproduction, or a clone could also be the result of incest, which the Egyptians practiced as did the Persians, Phoenicians, Incans and Aztecs. They called it royal incest and keeping the bloodline pure, so when a brother married his sister, they shared 50 percent of their genes.

Early tribal societies believed that incest enhanced the magical powers of the mind. It follows that by keeping the Pharaoh's bloodline pure, a specific genetic makeup would be preserved, possibly one allowing the Egyptians supernatural abilities. Perhaps clairvoyance, precognition, or an ability to perceive the quantum world was due to genetics.

This bloodline issue reminded me of the ancestry of the most famous racehorse in history, a high-spirited chestnut named Man O' War, born in 1917. The big red colt was an American World War I baby, bred from pedigreed Arabian stock on the sire's side and respected English stock on the dam's. Of 21 starts, Big Red won 20 and during one race at Belmont Park, he surpassed the

field of horses by 100 lengths. Sam Riddle, his owner, was extremely careful with Big Red's training and breeding. For 23 years at stud, Big Red sired 64 stakes winners. The fillies he sired became excellent broodmares, foaling 124 stakes winners. When Big Red died at age 30 on November 1, 1947, he had set three world records, two American records, and three track records. The horse was embalmed and placed in a custom casket lined with racing colors. Like Big Red, the Pharaohs entombed and mummified their sacred Apis Bulls, which were incarnations of the creator god Ptah.

What intrigued me about Big Red was that many thought his stud career was mismanaged by Riddle, who only bred the horse to his own mares. Like the Egyptians with their Apis Bulls, the fiery red horse had a bloodline that Riddle deliberately kept pure. Like Riddle, the Egyptians were preserving special abilities in human beings by guarding their bloodlines and keeping them incestuously pure.

Shutting my eyes, I tried to see sheep grazing in green pastures, instead of thinking of cloning experiments, codes, symbols, bloodlines and riddles. I hoped I would run into Quixote.

21

O King, you are this great star, the companion of Osiris, who traverses the sky with Orion, who navigates the Netherworld with Osiris; you ascend from the east of the sky, being renewed at your due season and rejuvenated at your due time.

Utterance 466, Pyramid Texts

Within minutes, unwanted ideas in print were coming to my mind as I floated into Futurity.

Howard Hughes Medical Institute News - November 9, 1999
For more than 30 million years, humans have been carrying a snippet of DNA that resembles a gene sequence of the human immunodeficiency virus (HIV). An ancient family of viruses, known as HERV-K first took up residence in the genetic material of Old World monkeys. The viruses then moved with pre-human hosts as these species became *Homo sapiens*.

Nature - February 12, 2001
The human genome is 95 percent junk and highly fragmented. Millions of years ago, large stretches of the genome came from viruses. The genome in places is a sea of reverse transcribed DNA with a small admixture of genes. Viruses made the human genome what it is today.

Journal of Theoretics Vol. 4-6, 2002
Many long-held beliefs were recently uprooted due to research showing that 30 percent of a plant's genes are similar to a human's. Positing a cross-kingdom heritage with that of a species intimately dependent on light, introduces a new perspective on mysterious psycho-spiritual enigmas, such as halos and uncorrupted bodies.

National Geographic News - October 8, 2003
Studying the cosmic band radiation of deep space, cosmologists and mathematicians suggest our Universe is finite and resembles a soccer ball, or more accurately, a dodecahedron, a 12-sided volume bounded by pentagons. A dodecahedron has line segments based on the Golden Ratio Phi.

I understood intuitively that the human genome was a mess. Even the DNA of a dog was more functional. That large amounts of our genes came from viruses and that we share 30 percent of our genes with plants made the idea of Osiris the virus easier to swallow. Even the universe as a dodecahedron, a volume of space with 12 faces, 20 vertices and 30 edges, was related to icosahedral viral structure. In the three dimensions of our world, the icosahedron serves as a model of five-fold symmetry, for it is a solid containing 20 identical triangular faces, 12 vertices, and 30 edges.

Actually, the Lambda virus was the basis of both human evolution and the new afterlife species, two beginnings, two products. The lytic pathway was simply rapid vegetative replication, human-viral plants popping up everywhere in a spontaneous outburst of the new species. In my mind I imagined the lytic cycle as an explosion of disinfectant spray from an aerosol can, a sudden growth of poppies in a nightmare or wheat sheaves in a field—a Fibonacci frenzy of growth based on the Golden Ratio Phi.

At that moment, my mind relaxed, shifting within me as if a large hand picked me up and deposited me before a brilliant yellow wheat field. The sunless sky above was a deep ultramarine blue and seemed to be lit by a light I could not see. Two burnt sienna paths blazed before me, one encircling the field, the other slicing obliquely through the center. The breezes of the north wind whirled over the stirring wheat sheaves, bending them into a soothing sea of yellow-orange waves. Sailing over the waves, a white Jaibaru stork glided gracefully, the wind wafting it higher into the bright sky.

Choosing the oblique path, I merged completely into the red-gold wheat, wondering how long it would take a single reaper to harvest the immense garden. An eternal job, I imagined, for the field stretched endlessly before me. I walked along thinking that the path would dead end, noticing that shadows did not exist within the gold sea, nor did sound. The shroud of silence was so complete that I could not hear the rustle of my own feet trodding, so I stopped. Sweltering, the Sun's breath burned into me, but I could not see the cold globe above, only the wheat swaying rhythmically, soundlessly pressing transparent waves of warm energy heavenward like rippled glass.

Unexpectedly, images from Goya's black paintings slashed through my mind, and I was afraid to turn around. With my head locked forward and my neck stiff, I slowly turned my eyes to the left to glimpse thousands of small

eyeless heads, each attached to its own sheaf of wheat, each with a thin shuddering tongue jutting from a cracked puncture in the face. The heads danced on their thin stalks, their facial expressions blank, emotionless, empty. Repulsed by their rapid movements, I stepped to the right only to encounter more heads and sheaf-tails. Then, like a mighty wall rising before me, the shrunken wheat-tailed heads multiplied and swarmed upon me, jerking spasmodically like larval forms. Instantly, a horde of black birds thundered heavenward as a gun shot exploded behind me, and I crashed to the ground next to a fallen man, his deep red blood gushing from a raw wound below his heart.

To my horror, the man was the Dutch painter Vincent van Gogh. Sitting up, I tried to support him as he struggled to rise. Three times he fell down into the indifferent earth, and three times I heard the horrid dissonance of Mahler's Sixth Symphony thundering through my mind, the sound of God striking down a man, the horror of the reaper doing his job. Finally, Vincent was standing, fatally injured. His eyes told me that we should proceed on the path ahead to the inn where he lived.

We walked slowly and carefully in silence through the wheat field, his blood slowly dripping to the stained earth in shades of brilliant reds and deep purples, a palette of blood from his tortured spirit. Preoccupied with getting him to safety, I forgot about the shrunken plant heads as my consciousness shifted back to Lucia's house, where I laid sleepless, staring out the dark window and thinking of the self-trained Dutch artist and his sickle god.

Vincent first painted *The Reaper* a year before his suicide. The thickly painted, almost all-yellow canvas shows a small man with a sickle reaping a golden wheat field under the monarchal eye of the titanic Sun. Vincent understood the reaper as an image of Death and humanity as the wheat Death reaped. Yellow was his favorite color as can be seen by his many paintings of sunflowers, buildings, backgrounds, fields and starscapes. The color bleeds from the faces of his subjects. In his self portraits, it is apparent that the last dab of paint he placed in the pupils of his own blank eyes was a pale citron yellow. Even the canvas of his skull is highlighted in a halo of Indian yellow, the color of the Sun.

His painted skull still haunts me. The high forehead, the empty eye sockets dabbed blood red, the weak occipital crest that housed Vincent's tormented brain, all these features, frozen within a pentagonal face painted lurid green. Was it the frightening visage of humanity at an evolutionary dead end? Or was it simply a bone mask from which Vincent van Gogh's consciousness vanished? I wasn't sure.

For van Gogh, painting self-portraits was a method of rehabilitation and healing after a breakdown. It allowed him to watch himself, to step back from the

canvas and reflect on his experiences. He spent the final fifteen months of his life in an asylum in Saint-Remy-de-Provence in the south of France and in the small village of Auvers. Although living in Auvers for only seventy days, van Gogh painted almost seventy canvases. Suffering from a form of epilepsy, depression and acute mania, along with visual and auditory hallucinations, he had long episodes of lucidity, during which time he buried himself in his work. Tormented and frightened by his illness because it stopped him from painting, he committed suicide in July of 1890.

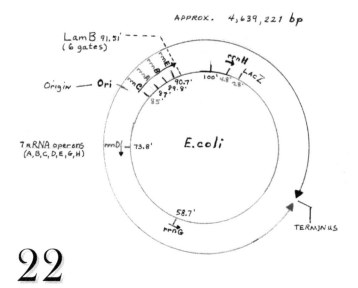

22

> But there's nothing sad in this Death,
> it goes its way in broad daylight
> with a sun flooding everything
> with a light of pure gold.
>
> *Comment by Vincent Van Gogh
> on his oil painting "The Reaper" (1889)*

Appearing like a golden glitter bird in the mountains, the molten Sun withered the rose pearl of the sky as it climbed higher to crown the peaks in violet hues. Reflected, this image of beauty glowed in the glass walls of Lucia's laboratory, where the light forged her into a surreal landscape of ampules, beakers, mountains, flasks, vials and incubators, everything shimmering in a mirrored series of scintillating Suns floating like disembodied spirits. Oblivious to these effects, Lucia gazed into her microscope at the specific DNA fragment she had isolated for the cloning experiment.

To Lucia, genetic engineering was molecular agriculture. Accordingly, and with the indifference of a reaper, she cut and spliced genes, easily manipulating and modifying the DNA to combine molecules. Recent developments in the field had made her job more accurate. In 1967, researchers isolated DNA ligase, an enzyme that acted as a molecular solder, joining two strands of DNA together to construct recombinant molecules. This advance was followed by the

isolation of the first restriction enzyme or molecular sickle to cut DNA at precisely the right sequence. The impact of these advances cannot be understated, for now scientists could create recombinant molecules with these enzymes by joining the DNA of one organism to that of a completely different organism. Then these recombinant molecules could behave as replicons, that is, they could replicate in a host organism. This was the nature of her task today: she would insert a human DNA fragment into a Lambda genome to create a recombinant molecule, which would then replicate within the host organism *E. coli.*

My knowledge of the cloning experiment made me uncomfortable about John ingesting the gold, and I had greater reservations about the physical and hallucinogenic consequences of manipulating genes while narcoticized, not to mention I was suspicious the experiment might actually transform us into a human-viral species of millions of clones. Lucia assured us that the risk of Death was minimal, and that we should be used to hallucinations by now. Her major concern was putting a human DNA fragment into a bacterium like *E. coli* because it populated mammalian guts. If she lost track of the organism, the biohazard of spreading the inserted human-viral recombinant to humans and other animals was a risk. Even though recombinant DNA is found in Nature through interspecies gene transfers, these transfers occurred at low frequencies, so the results were unpredictable.

I understood Lucia's apprehension about tampering with the evolutionary process, for she could not predict the impact of genetically engineered organisms on the environment. The possibility of an unplanned release of genetically modified organisms was a misuse of technology that could intervene with Nature and cause biological and social chaos. Yet her awareness of this did not stop Lucia from moving forward with the experiment because she believed that her research would benefit humanity, eliminating the fear of Death, making the afterlife the final tantalizing challenge of one's life, the last chance to transform into a new species, an opportunity to transcend being human and realize a lost legacy. Her research convinced her that the Kings used their conscious will and scientific knowledge to access a specific pathway through hell to Eternity, where the living dead person, the last emperor of a soon-to-be-extinct lineage, faced the final challenge with spirit, courage and Hope instead of the customary human response of weakness, fear and despair. I couldn't help but admire her intentions.

Watching her in the lab, the idea came to me that humans were more than leaves swept by the wind; we were beings that could decide our own destiny. The writings of paleontologist Pierre Teilhard de Chardin made more sense to me now. Like the Egyptians, he too believed we could consciously participate in evolution, that we could choose to become the *Ultra-Human, a second species*

of Spirit. Pierre, a scientist and a Jesuit priest, had spent three years studying in Cairo. There he experienced a sense of wonder that gradually grew into an understanding of the heart of matter, what he called a *World-heart* of two streams, two *Centres*, from which planetary humans evolved and the universal Ultra-Human emerged. He envisioned the Ultra-Human as a *fantastic molecular swarm, an awe-inspiring multitude, a terrifying granular Energy*. His vision matched Lucia's and Quixote's insight. Yet, according to Pierre, a man had to be very careful when he surrendered to this godly whirlwind of Energy, for it would *either drag him down into the darkness of its depths or lift him up into the blue skies*. He wrote that this passage, this spiritual escape from the planet, could only be accessed for natural organisms through Death.

Then another thought of Pierre's boiled through my mind like hot lava. *The day will come when Earth, too, bleached to a uniform whiteness, like a great fossil, will be a mere gravitational cipher; there will be no more movement on its surface, and it will still hold all our bones*. I shivered, thinking that now was the time to jump ship, to break free from the planet if it was possible.

From the deck, I could still see Lucia in her laboratory, its glass walls reflecting the morning light like a transitory crystal radiating with the possibility of ultimate wisdom. Her auburn-red hair seemed brighter than normal, almost incandescent, and she handled the luminous vial of white powder like a fire goddess, lifting the primeval formula above her head as if she were consecrating it. As usual, her eyes frightened me, for within their light lurked a darkness, an immense desolation that she could not conceal because she understood the dangers of the afterlife, particularly the danger of one's spiritual essence inadvertently being swept into the wrong chemical pathway. This mistake would produce the wrong product, a human species with a junk genome and DNA that was transcribed backwards and upside down. The possibility for this occurrence in the theatre of Death was enormous because of the nature of reaction-diffusion kinetics. After all, on the quantum level, the Deceased cannot be too sure which way he will react or diffuse.

According to Lucia, taking the wrong path in the afterlife resulted in a loss of knowledge that was irretrievable, a deep forgetfulness due to thermal molecular reactions that would lead back to human existence, where one would die again according to the texts. Unless one learned again in the next lifetime what one knew before, there would only be one shot at the Egyptian path. My understanding was that the chance of learning the same knowledge again in a second lifetime was about equal to the probability of taking the correct chemical pathway through the molecular hell of the earth-organism.

It all pointed to one outcome—despair, which to Lucia was a glory-horror trip up and down a mountain. The glory part was climbing to the peak and discovering ultimate wisdom, which quickly informed one of the horror part—there had been a mistake, a trick, a missing puzzle piece—or more precisely, the jester was laughing because the snake was still caught in the shepherd's throat. The pain of this realization was only superseded by the agony of the slide back down the mountain, the fall into human anguish and depression because one sensed that the cycle of Death and forgetfulness spun out a series of ascents and descents like some vast, nauseating vortex that could only spin too quickly in one direction, thrusting one up and down like sands in an hour glass.

Certainly, Nietzsche understood this dilemma, for it is his myth of eternal return, and it may have been what drove him mad, along with witnessing the cruelty toward the carriage horse. Watching the driver beat his horse made Nietzsche understand that cruelty—and by that I mean the intent to kill that is found in war, murder and violence—was simply the unnecessary means a man used to satisfy the dark urge within him planted there by Nature, a chronic desire to return matter back to Nature, so that the freed molecules could be reused again and again for perpetual recreations. The weight of the terrible knowledge that man and his innate impulse to inflict cruelty is natural and beneficial to Nature may have crushed Nietzsche's spirit because he knew he could not escape eternal return. There was no way out of the cruel cycle.

However, according to Lucia, the Egyptian geneticists had engineered an alternative to eternal return. There was only one chemical pathway, one escape from the hideous cycle, and Lucia knew what it was because she had unlocked the meaning hidden in the texts and compiled a code. Yet, we only understood the meaning of some of the signs: Osiris was the dormant phage Lambda sleeping in the host cell; the Sun-god was the incoming phage Lambda or the carrier molecule with the insert of the Deceased; the Duat-Hell was the host organism, also known as the earth's magnetosphere, and Isis was the lactose nutrient for the new species. Put simply, the dead Pharaohs of Egypt, and now John and I, were nothing more than cosmic clones taking a viral ferryboat to hell.

I remained calm in the shade of my protective umbrella, warding off my thoughts and sitting quietly, as I watched Lucia's deliberate progress in the translucent lab and her unswerving dedication to the gold that would take John and me into a chemical nightmare prepared especially for us.

23

Science condemns itself to failure when,
yielding to the infatuation of the serious,
it aspires to attain being, to contain it, and to possess it,
but it finds its truth if it considers itself as a free engagement
of thought in the given, aiming, at each discovery,
not at fusion with the thing, but at the possibility of new discoveries;
what the mind then projects is the concrete accomplishment of its freedom.

Simone de Beauvoir
The Ethics of Ambiguity (1948)

Within minutes, John emerged from the house, carrying a tray of meat, sauce, salts, vegetables and preparation utensils, his lean face betraying no hint of trepidation or anxiety, and it seemed very obvious that at that moment, he had only one intention—to eat his last supper. Firing up the coals, he slapped two choice cuts of beef on the grill, sauteed some shallots and vegetables on the side in an iron pan, and then he poured a thick barbecue sauce over everything and waited for the flavors to marinate, gazing into the rising Sun as if mesmerized by a wizard. Instantly, the alluring aroma of animal protein, peppers, onions, garlic and spices settled like a rich incense in the still mountain air. As the raw red meat sizzled, John brushed the robust sauce on the charring steaks. Inhaling the savory scents of burnt rare meat blended with sauce and

seasonings, I realized I was more concerned about our future than he was because I had no appetite. It was then that Lucia emerged from her glass house to join us on the smoked deck, as John turned the steaks for the last time.

"Lucia," he said, grabbing a plate from the table, "would you like one?"

"No thanks," she said abruptly, sitting down. She was only interested in her immediate mission, which was to explain the dynamics of what was going to happen in the Egyptian afterlife. Her slim hand rested on her notebook momentarily, as if to keep the secrets inside silent.

Removing both steaks from the grill, John placed one steak on his plate, leaving the other on the grill. He sat down quickly and began eating while I stared at Lucia.

She explained that the Sun and earth was an open energy system, where energy was constantly being dissipated. This constant energy flux prevented earth from reaching an equilibrium state. To take advantage of this situation, plants evolved to spread their leaves and capture the Sun's energy by degrading sunlight before it falls to earth's temperature. Evolution was simply a result of selecting and favoring those species and ecosystems that most adequately degraded the incoming, solar energy.

Lucia brushed a fly from her face, a passing fly on its way to the leftover steak on the grill, while I listened indifferently to her lecture on photosynthesis.

"This incoming energy," she said, "is unequally distributed over the earth, and the earth's weather patterns result from the difference in heating at the equator and the poles. For example, five-sixth of the earth's solar radiation occurs at the equator, where species diversity is greater so they can easily reduce the larger amount of available energy. However, because the earth's poles receive less heat than the equator and because they are magnetic null points where particle collisions occur less frequently, the Egyptians advise that the Deceased must go to the closest pole. Here, where there is no magnetic field, the Deceased will encounter Sun and cosmic particles that have a higher energy and clear path into the earth's magnetosphere."

"What kind of advantage does this give the dead person?" asked John, as he chewed up a piece of steak gristle without blinking.

"Access to high energy particles and less chance of annihilation by particle collision," she said. "To understand particle collisions, you must first understand the idea of spin." Pausing, Lucia stood up and walked over to a white poolside chaise lounge, easily recovering the yellow beach ball beneath it. Against the purple mountain shade of hazy sunlight, her delicate face looked ethereal, pure, almost angelic, as she held the beach ball before her like a child who knew the world was make-believe but could not prove it. Angling the ball to show the

tilt of the earth, she slowly spun it counterclockwise.

"Just as the earth orbits the Sun, an elementary particle orbits an atomic nucleus. Magnetism arises from the motion of electric charge or the rotational spin."

She then told us that in 1925, Dutch physicists George Uhlenbeck and Samuel Goudsmit showed that every electron in our universe spins at a fixed rate of *spin-1/2*, as do all matter particles. In contrast, the force particles—such as photons, weak bosons, and gluons—all have *spin-1*.

"Because of spin," she said, bouncing the ball across the deck and over the ledge, "physicists believe that supersymmetry exists or that each of us has a double in the quantum world. It is like having one foot in the quantum world and another in Time and space—two observation points."

The idea that everyone had a double that secretly shared your life intrigued me, and I remembered an old superstition that said if you saw your double, it was a sign that Death was nearby. From Lucia's explanation, I now understood that seeing your double meant you were entering the tiny quantum world of molecules, the observation point where your double resided.

"By 1970, physicists understood that particles come in pairs with spins differing by half a unit. Matter particles of *spin-1/2* pair with force particles of *spin-1*. Yet none of the known matter and force particles could be paired with each other. There was an undiscovered super partner whose spin was 1/2 unit less than its known counterpart. This meant that the electron with *spin-1/2* had a super partner with *spin-0*. A force particle like a photon of light had a super partner with *spin-1/2*," she explained.

John and I then learned that the doubleness or supersymmetry was part of String Theory, which proposed that each particle of matter is a vibrating string with a double called an anti-string. She said a dog could be broken down to atoms, then to electrons, protons and neutrons, then to quarks, and finally to a vibrating string with its anti-string partner. This two-string guitar was the very base of matter.

Along with this, she told us that String Theory proposes that there are ten spatial dimensions and one Time dimension. Three of these spatial dimensions create our world, but the rest are curled up in the quantum world.

"What's really interesting is that if the Time dimension is curled up as they suspect, then traveling the curled up dimension could mean returning to a prior instant in Time or retracing your past," she said.

John's eyes sharpened as he moved his plate aside, the stripped raw T-bone patterned on the ivory ceramic like a red cross.

"It sounds similar to the past-life reviews people have when they die." Quietly, John took a pack of cigarettes out of his shirt pocket, removed a cigarette

and lit it up, then he replaced the pack back into his pocket. He then told us that before dying, his father recalled a regression of events from his late thirties to his teenage years that culminated in a vivid experience, where he thought he had made his first girlfriend pregnant. All the sorrow and desolation of that early event was experienced again on his Deathbed. Other traumatic childhood memories followed, as his father receded further into his spent youth, his remembrances suddenly stalling at Death's zero point, so that he could escape a dying consciousness that reminded him of every mistake he ever made.

We sat solemnly, thinking of Time as a curled up dimension that one could retrace at Death, just as a triangular flock of geese arrowed along the horizon, their distant trumpeting a reminder that life and Time never stand still.

Soon Lucia broke the silence, saying that at the birth of matter, three dimensions are singled out for expansion, while the rest stay microscopic. Researchers believe that if dimensions are curled up in circles, then a string and its anti-string, like two rubber bands, can wrap around them and stop the dimensions from expanding to create our physical world.

"Imagine a lotus," she said, "and each petal represents the curled dimensions that do not expand. In the center is a small circular cylinder with our three dimensions, which are wrapped by two strings. When the strings collide, the cylinder expands upward like an accordion from the center of the lotus," she said, explaining that when enough of these events happen, then the dimensions will unfurl and life in our world is born.

"What's really unique is that this unfurling, caused by strings colliding, only happens in three dimensions or less because in four or more space dimensions, they are less likely to collide," she said.

John was pensive as he sketched a lotus with an accordion exploding from it. "So you're saying that the afterlife occurs on the quantum level, where a dead person meets his double, and that double goes with him if he follows the Egyptian path, but if the dead person doesn't take the right path, his double annihilates him," John commented, his voice a monotone as he focused on drawing a little person clutching the top of the accordion cylinder, a miniature human who had taken the wrong path back to our three dimensions.

"Yes," she said, nodding. "The Egyptians believe that when the Deceased moves to the polar north, in those last minutes of life, his double is with him, and then he does not die a second Death. But, you need to understand that this process of annihilation is happening in the afterlife at all times," she cautioned, "for the texts are full of references about other spirits going to their doubles or being destroyed. There's actually a boiling Lake of Criminals for spirits who have gone to their doubles."

Listening to Lucia's warnings, I surmised that it was not going to be just a

simple, uneventful trip to hell. There were obstacles and your own double could be one. The bottom line was that if the double remains, the Deceased is not destroyed by the fires and other torments in the afterlife. I looked at John, who had quit drawing, and for a brief moment, I imagined his lower body as a cylindrical accordion, and the strange music of Lucia's voice was coming from it.

"So, it's the pathway that counts." Lucia paused briefly. "This cool pathway is special because it results in a bioluminescent species rather than a photosynthetic recycling of elements for humans. This means that fermions or the building blocks of matter can become bosons or force particles at human Death. Like String Theory, the Egyptian texts suggest that Nature is supersymmetric and that two very different kinds of particles are related. Every fermion would have a boson twin, and vice versa. Consider that the average lifetime of a photon or a graviton is infinity, and you have it all—the Egyptian Eternity."

"Where does this cool bioluminescent pathway lead to?" asked John, as he put out his cigarette on his plate.

"The pathway takes the Deceased through the Duat, which is like a hot birthing place, and out to the stars."

She continued briskly, "Energy can be discarded in two ways: photosynthesis and chemiluminescence, which is the emission of light by an atom or molecule in an excited state. Whereas photosynthesis produces both light and heat such as a burning candle, chemiluminescence produces light without heat—cold light, starlight. The texts emphasize that at the pole the Deceased receives the Sun-god's cold water, cold light, cold DNA."

John paid attention to Lucia's explanation of chemiluminescence, but I was considering her earlier remark about high energy particles at the cusp. From my experience dealing with the Sun, I expected the cold light at the pole to pack a real punch, a punch thrown after the bell because you were already dead.

As Lucia's voice droned on, the trivia marched into my mind. In 1952, Sugar Ray Robinson boxed Joey Maxim at Yankee Stadium. The temperature in the ring that night was around 100 degrees. Leading on all three scorecards in round thirteen, Sugar Ray could not get off his stool when round fourteen began. The heat had overcome Sugar Ray, not Joey Maxim, and my thoughts froze on that point.

"For chemiluminescence to occur," she said, "the excited molecule needs time to generate a photon of light, so that its excitation is not transferred to neighboring molecules in the form of thermal motion. The colder atoms get, the slower they go, which gives them a chance to self-assemble. When you get down to Absolute Zero, the atoms are barely moving. This happens in outer space, where the temperature is close to Absolute Zero. Outer space is actually teaming with molecules that have had time to self-assemble because they are

moving slowly."

"Molecules of what?" John asked.

"Combinations that create even amino acids—hydrogen, carbon, nitrogen, oxygen, iron," Lucia said, "the same molecules that make up human matter. But, my point here is that by going to the cold polar north, the Deceased is setting up his atoms, his genetic remains, for a transformation from a photosynthetic mode of thermal life to a chemiluminescent form of cold light. You could say that the transformation is to a bioluminescent being, what the Egyptians called pouring out a star."

A fleeting memory glimmered in John's eyes, and imitating the melancholy mindset of a misunderstood prophet, he said, "*Alas! There cometh the time when man will no longer give birth to any star.*" This statement by John from Nietzsche's allegory *Thus Spake Zarathustra* reminded me that there was wisdom in madness, and that Nietzsche foresaw a future where man's evolutionary path was a dead end, a return to the cave, a harking back to the beast in the tower. The beaten philosopher understood that man would rather go back to the beast than become the Overman that surpasses man.

Then John said, "So you're saying that the Egyptian Duat, which is the magnetosphere on the macro level and a one-celled organism on the micro level, is where the transformation occurs, and you enter the Duat at the poles."

"Yes," she said, "because an opening exists there that the Egyptians call the Gap, a special gate into this chemical kitchen, where the self-assembled molecules are re-created into the new species. In the organism, it is called the LamB receptor site, and this is a special portal protein where phage Lambda inserts its DNA into the host cell."

Lucia stared at John with her intense eyes. "Now, imagine the Deceased as an information molecule arriving at the northern pole to meet the Lambda Sun-god, who represents a molecular state of hydrogen and other cosmic elements with temperature, pressure and chemical equilibrium. The Deceased then bonds to or is engulfed by the Lambda Sun-god, which then ferries the human insert into the host organism through the LamB portal protein. The Deceased is now in the host organism, a molecular hell of chemical reactions. But, the Deceased is safe from the chaos and entropy because he is bonded to the Sun-god and traveling with a group of self-assembled molecules."

I needed a moment of solitude, so I shut out her voice. The idea of being engulfed by the Sun-god made me think of the way John chewed up his steak. He engulfed it, he ate it. At that moment, I could see that eating was similar to molecules bonding, molecules absorbing each other to become one unit. You could say that when molecules bond, they eat each other. Along with this, it seemed as if molecules knew each other, for how else could they make the

proper bonds? Plus, the afterlife molecules shared a common purpose, the transformation of the Deceased. Intuitively, my precognition told me that chemists would come to know these molecular qualities in the New Chemistry of the 1990s. They would call it molecular recognition, where one molecule recognizes another by its shape or properties.

I was beginning to understand the immensity of Lucia's research that was bent on unraveling the puzzle of life, Death and Eternity, for it was obvious that, in some way, the Egyptians recognized the molecules that recognized themselves. It was also amazing and very convenient that the cell had a special LamB receptor site for the Lambda Sun-god to inject its DNA. How did the ancient Egyptians come up with this? Incest? Clairvoyance? Schizophrenia? The gold? And why does the Sun and earth fit the model of phage Lambda invading an *E. coli* host cell?

"Look at it this way," Lucia reasoned, "the Deceased has moved from one life form to another; he has moved from his decaying human body to an active phage Lambda. You might say that he has walked a tightrope from his human body to a viral-cosmic life form. Despite the chaos and entropy of the afterlife, he is balanced. He is simply a Flux Transfer Event of information, a message transmission into the host cell."

Once again, I needed time to understand what she was saying. Actually, it seemed that the dead person had moved from a warm-blooded human to a cold virus. I found it very difficult to think of a lukewarm human being, a human virus. Understanding the Deceased as information was easier for me. DNA made protein and protein made the new species, the lukewarm phage-light being. I tried to think positively about the transformation, but letting my Imagination invent my future was difficult.

"Can you tell me more about this LamB receptor site at the famous Gap of the Egyptians," said John.

Lucia settled back on the deck chair for a moment, then she reached for her notebook, as her auburn red hair curled around her neck like a carnelian necklace.

"This polar attachment site in our one-celled organism is also called the Maltose Transport System. So it serves two functions, an attachment site for Lambda and a transport pathway for sugars. Remember, the macrocosm is the microcosm, so the earth system represents a one-celled organism such as *E. coli*. The LamB portal protein or Gap is a water-filled channel across the outer cell membranes and it has six gates. When Lambda's tail fibre attaches to the LamB protein, its DNA is injected down the long hollow core of the tail and into the bacterium. According to Egyptian texts, the LamB portal will appear as a blue gate, which indicates the warm portal opening."

When Lucia said blue gate, I remembered Poe's story of Prince Prospero and the revelers, and how they were trapped in his home, the first room being blue and the last blood-red with Death. I tried not to think of the Duat as a Death house, but the idea haunted me, glared at me like that one unblinking treacherous eye of the vampire Geraldine. I then realized that John and I were both concerned, but for different reasons.

"Lucia, how exactly does one get to the pole when the earth rotates from west to east." John hesitated. "It seems that a dead person would just drift eastward with the planet's rotation."

I watched Lucia closely, but she did not waver from her certainty about the Egyptian path. The words rolled out of her mouth as easily as Don Quixote's explanations.

"The Egyptians glorified the Beautiful West. The reason for this is that you must go west to arrive at the northern pole. It's called the Coriolis effect."

She then explained that as a result of gravity pulling objects down and the ground holding them up, the effect of the Coriolis force on air heading east or west was to deflect the air south or north. In the northern hemisphere, objects heading east are deflected south, and objects heading west are deflected north. So in the northern hemisphere, to go north, one must head west, and vice versa in the southern hemisphere. Thus the Egyptian emphasis on the Beautiful West.

After this, she told us that the Pharaohs used the earth as the guide, and that the Egyptian path to Eternity was west to the northern pole because these high latitude regions on both hemispheres have open magnetic field lines connecting directly to the Sun's interplanetary field, where cosmic elements pour in from the stars. Here at the polar cusps, she continued, space physicists have observed Flux Transfer Events or magnetic bubbles, which are injected into the magnetosphere at points where magnetic field lines have stretched and snapped because of the solar wind force. Lucia explained how physicists track these bubbles at the northern cusps with their spacecraft radar, as they travel in and out of the magnetosphere.

To make sure we understood that what was above in the sky was the same as what was below in the quantum world, Lucia then gave us the same information again, but from the perspective of the earth as a one-celled organism like *E. coli*.

"You still travel west to go north because what is above is what is below. When you arrive at the element-enriched pole of the cell, you join up with the Sun-god, which operates like an incoming phage Lambda or Flux Transfer Event, and you are injected through the LamB portal protein or Egyptian Gap into the cell. Then you travel through the cell along the single circular chromosome, take over its replication machinery, activate the sleeping Osiris and the

lytic cycle, and then escape from the earth-cell into the universe. The Egyptians claimed this final outcome was the same as becoming the Morning Star."

What Lucia was saying made some sense, especially since she matched up events at the earth's poles with similar happenings at the poles of a cell. But to me, it seemed that she was throwing us out there like a pair of dice, hoping that probabilities would hold and that a lucky seven would come up as easily as the right pathway. John must have sensed this same randomness that was leaving us deadened.

"Lucia, let me go through this again," he said. "I take the powder while you're doing the cloning experiment. Then I rise up in the air like Carl Jung, resisting the impulse to go east with the earth's rotation. I then head west. This brings me to the North Pole because of the Coriolis effect. Now, how do I recognize the Sun-god," he asked smiling, his eyes glittering like the magician he was not.

Lucia sensed his cynicism. She also understood the importance of making the right chemical bond, so she qualified her response with a speculative description of the Sun-god.

"The Egyptians claim that you will immediately know this Sun-god. I would imagine that the crystalline structure of an icosahedral head would reflect light at all angles. You might see the full light spectrum of rainbow colors melded into a radiant white light. Remember, your job is to tell me what you see."

Lucia's eyes shifted in a way that made me think she remembered something important, something we needed to know.

"Also, I forgot to mention that there is a stairway," she said.

"Stairway, what—a stairway to Heaven?" John began to laugh hysterically, and again, I sensed his anxiety. Underneath that quiet mask of his stoic face was fear.

"The Egyptian Great Stairway," she said patiently, "is also referred to as the staircase cusp by space physicists. The technical state of the polar cusp is that the magnetic field is zero. Solar ions, cosmic elements from the stars, and ionospheric ions from earth are all present, and the process of magnetic reconnection is occurring. Magnetic field lines are breaking and rejoining impulsively at the poles. This happens when the magnetic fields of the Sun and earth bump into each other, causing field lines to stretch, snap and reconnect, causing Sun particles to slide like beads onto earth's magnetic field lines."

Against my own intuition, I envisioned the Sun as a golden being throwing a rosary of ions at the earth, and I saw the rosary break and scatter the beadlike ions into the poles, the ions floating there like bright luminous light bubbles, until each one fused to the earth's spinning magnetosphere to be sucked inside.

Lucia's voice flowed on. "Because the cusp consists of the earth's magnetic

field lines most recently merged with the Sun's, physicists have observed variations in the merging rate of field lines. Spacecraft radar have tracked these energy variations, which are not always uniform, but display intervals and sharp jumps that form an energy landscape that looks like a staircase. This staircase energy structure indicates that magnetic reconnection is happening."

As if this were not enough, Lucia then explained the same scenario, but from the cellular counterpart, which is DNA strands being exchanged in a similar fashion to magnetic field lines reconnecting. She explained again that the texts referred to these processes as *crossing over,* the same terminology modern biologists use.

"The stairway signature is caused by merging due to the presence of two tunneling barriers, which would be the double cell membrane of *E. coli* at the LamB receptor site, where phage DNA is injected, the Gap."

"All right Lucia," John conceded, "I see the science of the stairway."

"It's actually a simple pathway, John. You go westward to arrive at the pole, then you will see the staircase cusp. Rise up it and you will see the Sun-god. You should be at the LamB receptor site and its six gates, and it is all reaction-diffusion kinetics from that point on."

John seemed relieved or rather he seemed resigned, fated as he was to go through with the stunt. He smiled and said, "How dark is hell?"

"I don't remember ever being there," Lucia said, as she stood up and walked into the house.

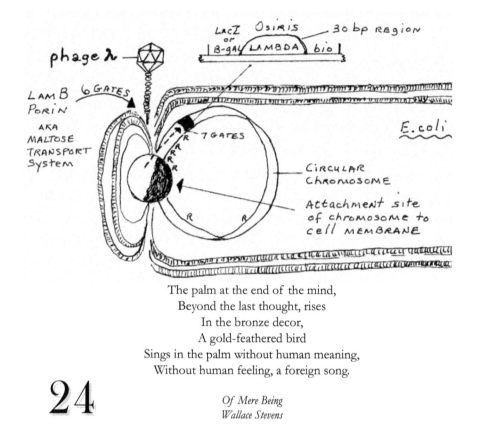

> The palm at the end of the mind,
> Beyond the last thought, rises
> In the bronze decor,
> A gold-feathered bird
> Sings in the palm without human meaning,
> Without human feeling, a foreign song.

24

Of Mere Being
Wallace Stevens

From the information Lucia just gave us, it was clear that at Death a person would finally see his double, and if the Deceased was on the right path, he would not annihilate with his double. The wrong path resulted in annihilation or what I call Death-by-double, and possibly a return to an earthly existence as a rodent, a dog, a turkey or a human, who could not remember anything about his previous life or afterlife experiences. It was essential that John and I travel the correct path, which was west then north along the curvature of the globe to the North Pole. Here we would ascend the Egyptian Great Stairway and see the Sun-god and his anxious crew, ready to ferry us into the transformation furnace of hell, also known as *E. coli*, a one-celled, rod-shaped, gram negative bacterium with a double membrane and a polar LamB receptor site with six gates or interconnected rooms. I exhaled deeply, for I was having difficulty seeing myself as an information molecule bonded to a virus for a trip through a cell. Still, I tried to visualize the trip as a logical series of events so I would not go crazy.

Once inside the dark cell, I imagined we would flow down electrical potential gradients like an electrolytic message, floating along the long chromosome which connects to metabolic pathways. Proteins would be everywhere—enzymes for catalysis of cellular reactions, communication proteins such as hormones, receptors and chemical messengers, transport proteins with tunnel-like channels, structural proteins and finally, our greatest adversary would be the cell's defensive proteins, antibodies and other molecules that bind to foreign molecules and destroy them. For we were foreigners invading, and like Alexander the Great, we planned to take over the cell's replication machinery, so that we could be replicated and packaged into millions of human-viral particles with heads and tails that would emerge from the Trojan Horse of the cell like miniature warriors, like a plague of locusts with human faces, iron breastplates and scorpion tails.

Stop!—I told myself—stop the flight of ideas! But no matter how I thought of this transformation, it was unappealing, and I could not imagine a human with viral parts. Again, images flashed through my mind, tormenting me, until I finally stalled on an unsettling picture of John as my Siamese twin, and our lukewarm head was locked together into a distorted geometric solid that looked something like the stretched triangulated cube of pentagons that disturbed Durer's melancholy angel.

Was there no other option? Maybe rebirth was a possibility, but then who could guarantee how one's molecules would be recreated. Ultimately, I thought, the Sun will win by overcoming the earth, for it forever rams and hammers our tiny planet with speeding gusts of solar plasma, and if this doesn't demolish our globe, we may explode our own planet with nuclear warheads or octanitrocubane, blasting our molecules into the heavens and then what? Would one's conscious remains just drift in outer space like a piece of immortal debris? Maybe now was the time to transform into an adaptive species by jumping to a viral genome that could retain human consciousness, while replicating into a life form similar to the cold-light matter that already populates most of the universe.

Still, the idea of a cross between a hot and cold species, a lukewarm species such as a bioluminescent phage-head was not my vision of Eternity, for the human experience, although a miscalculation with the wrong numbers, is magnificent. At times, the glory of the human world is overwhelmingly beautiful. Then, it can also be catastrophic, a terrible sorrow, a painful nightmare drowned in despair.

Yet, I could not ignore the fact that the Egyptians believed their pathway led to a satisfactory Eternity and a chance for a human being to exist as a constructive life form. Perhaps, the Tarahumara tribe believed in this same destiny.

I tried to console myself with the idea that the afterlife might look a lot better when we arrived there, but then, it could also be a lot worse.

Reminding myself to be positive and use Imagination, I surmised that if the dead knew the Egyptian path to Eternity, they would not have to endure the inevitable Judgment Scene ordained by our religions, a bad experience, where you were like one of Coleridge's mariners or Prince Prospero's guests, not really sure where you would end up, what you did wrong, or why you were invited. Thoughts like these persuaded me that the Egyptian afterlife transformation was actually a form of secret salvation because knowledge of the path was only given to the Pharaohs and nobility, not the plebs.

It dawned on me that the plebs were never really able to figure out the exact pathway, so the idea of heaven and hell filtered down through the centuries in religious propaganda from church officials to enforce a morality on the common people that made them easier to control. Faith! the theologians cried. You must accept the doctrines on Faith!

Of course, the church officials had to accept their own doctrine on Faith because they didn't know what it meant either. They did not know the pathway to Eternity, for the directions were buried in Egyptian hieroglyphs that were not deciphered until Jean-Francois Champolion broke the code in 1822. Even this discovery did not unveil the hidden meaning in the phonetic symbols and artwork that Lucia claimed she had decoded.

Nonetheless, this endeavor by the Pharaohs and nobility to keep their scientific knowledge secret was abetted by their ability to keep their bloodlines pure by intermarriage within the royal line. Yes, incest was the means to keep the plebs out of royal affairs that related to secret scientific knowledge that would give the Kings an edge in the afterlife. But, incest may have also increased the Egyptian predisposition for mind expansion into the tiny quantum world. In fact, brother-sister and child-parent marriages were common in pre-modern cultures that believed royal incest nurtured supernatural abilities. Naturally, the common folk were not allowed this special privilege, but the Kings were.

Add this inherited inclination of the Kings to white powder use, and one might experience a passage into the quantum world similar to what twentieth century psychologists have called schizophrenia. Instead of concealing authentic experiences, modern psychologists could have tapped into innate wisdom like the ancients, but, again and again, psychologists have shown that they do not have the skills necessary to mentor schizophrenics, for they have resorted to electroshock treatments, isolation, strait jackets, incarceration, sedatives and other drugs. They have purposely masked quantum insight in a shroud of insanity.

In the midst of my reveries, John had fallen asleep in his chair. I thought I saw a shadow behind him, a rippling movement beyond the rock ledge, but it must have been the silhouette of a hawk angling the air currents beneath the Sun. It wasn't long before Lucia returned with black coffee, no extras.

25

> He who lacketh discrimination,
> whose mind is unsteady and whose heart is impure,
> never reacheth the goal, but is born again and again.
> But he who hath discrimination,
> whose mind is steady and whose heart is pure,
> reacheth the goal, and having reached it
> is born no more.
>
> *Katha Upanishad*

Lucia was anxious to get started. She patted John gently on the back, and he looked up and smiled at her. Watching him, I wondered if he trusted her, although I guess that really didn't matter to John because he had spent most of his life trusting people and institutions that had let him down. He had an agenda similar to Gerald Nerval's aspirations; John would suicide himself to find ultimate knowledge, even if he was scared shitless.

Stretching, he said, "What else, Lucia. What else do we need to know?"

After pouring a cup of coffee, Lucia said, "When you arrive at the pole of the earth-cell, you're going to experience a lot of ultraviolet radiation from the Sun, which is going to have some interesting effects."

As I remembered that Galileo had gone blind from staring at the Sun, John leaned forward and said, "Such as?"

"UV radiation," she said evenly, "is caused by Sun flares which send energetic protons to the polar cusp, causing Flux Transfer Events that significantly increase the radiation there. On the cell level, this is damaging, so our host cell senses Death-by-irradiation and sends out an SOS response. This cry for help

brings forty-two genes to the aid that help repair the cell's UV-damaged DNA, so that replication can take place past the damaged DNA."

"So you're saying that we won't have a problem taking over the cell's replication machinery, and that we'll actually have an army of helpers," said John, smiling quizzically.

Lucia watched John, knowing that she could never really describe to him what it would be like in the quantum world.

"That's right," she said flippantly, "and along with your molecular army, you're going to get a long sword."

Both Lucia and John began to laugh, but I did not see the humor in her remark. John was awake now, his mind sharpening.

"The Egyptian texts describe the monster serpent Apopis. Is this snake going to be a problem?"

What snake is not a problem, I thought, remembering the one lodged in the shepherd's throat and mine, but Lucia had an answer for everything.

"The Pyramid Texts state that Apopis is a four-coiled serpent, which is a pretty good description of this protein that keeps forty-two genes depressed in the host cell. Actually, this monster LexA repressor protein represses the right arm of the Lambda genome. It stops the replication of certain genes that promote lysis." Lucia paused to finish her coffee with one long swallow, and then she continued.

"You could say that the protein or the monster snake Apopis is stuck in the Lambda genome's throat. The genome is like a DNA tree, and Apopis is wrapped around it, preventing the function of certain genes. But this snake can be dislodged from the genes. What happens is that when single-stranded DNA is present in the host cell due to Lambda penetration and UV irradiation, the cell responds with an SOS response. RecA protein and the forty-two genes are activated, and this team cuts off the LexA repressor protein, or as the Egyptians would say, it slays the monster Apopis."

At that moment, I felt relieved that we would not have to deal with this monster Apopis, and then suddenly, I felt ridiculous because I was worried about fighting a stupid repressor protein.

Lucia continued, "In order to better understand SOS activity, let's go back in Time to 3000 BCE, when Thuban was the polestar in the constellation Draco, which means *dragon*. When the texts advise the newly Deceased to go to the polar cusp guided by the polestar, the Egyptians understood that the genetic result of this movement to Draco would be the slaying of the dragon Draco or Apopis. It works like this: the Deceased arrives at the pole, merges with the Sun-god, and enters the earth-cell, causing a break in its DNA. The SOS response of the cell goes off, and RecA protein binds to the single-stranded

DNA, inactivating the LexA repressor protein. From a mythic perspective, the Deceased with his RecA sword slays the dragon-protein LexA-Apopis and wins Eternity because the cell goes into SOS. Actually the dragon, the LexA repressor protein, catalyzes its own digestion in the face of the single-stranded DNA-RecA filament and the activation of forty-two genes."

"What you're saying is that just my presence in the host cell is going to free up these forty-two genes and slay the dragon-protein," said John.

"Yes," she said. "Now, I want to talk to you about the environment of the cell. It's going to have protein-folding structures or energy landscapes that look like mountains, valleys and waterways. Actually, you'll be navigating a funnel-like landscape where different proteins appear with backbones, helices and ribbon structures that look like snakes or serpents. You'll see long protein chains fold into compact stable structures." She paused.

"Remember that upon entry into the cell, you will pass through the six gates of the LamB porin. Then before Osiris rises, there will be seven more gates that you must cut through so that Osiris can rise, seven rooms as in Poe's story. This is the seven base pair integration and excision pathway to the *LacZ* gene site. In other words, Osiris leaves by the same route he came in."

I remembered Prospero's horror and his destruction, when he tried to unmask the hooded specter in the Red Chamber, and I stared at Lucia as if she were a messenger from the Red Death itself. But all John did was bow his head in the manner of Sir Galahad, sweep his arm to the right like a gallant knight, laugh and ask,

"Any more dragons to slay, my lady?"

"I think you'll be okay," responded Lucia seriously, "but you must remember that you may experience the afterlife as a terrifying dream state, and if this happens, it will get progressively worse until the final degradation, which is rebirth according to *The Tibetan Book of the Dead*. If this happens, you must stay calm and clear-minded and be heroic."

Lucia tried to smile when she said this, but she was unsuccessful, which really scared me. I cringed as a horrible howl ripped through my head. It was the beast crouched in its tower, getting ready for the fall. Then Lucia made one final comment.

"When you arrive at the pole, you will meet a beautiful woman, haloed in brilliant gold, feldspar and turquoise, and she will travel with you as you ferry through the cell. This is Isis, the lactose nutrient medium for the new species."

26

Cyril, the Bishop of Alexandria, had openly embraced
the cause of Isis, the Egyptian goddess,
and had anthropomorphized her into
Mary, the mother of God.

Isis Unveiled
H. P. Blavatsky

Isis was the wife and sister of Osiris and mother of Horus. In the myth, she found the lifeless body of Osiris and used magical powers to bring him back to life by hovering over his body like a sparrow hawk, just long enough to conceive their son Horus. Like the Virgin Mary, Isis was impregnated by divine fire, the fire of the rising virus Osiris.

The story goes on to tell of the rivalry between Horus and Seth over the throne of Osiris. Seth seized it when Osiris was dismembered and inert, booting Horus out. With my new understanding of religious symbols unmasked as genetic designs, I imagined that the fight between Horus and Seth had something to do with proteins, and John must have thought the same, for after Lucia retreated into her glass house, John found a genetics book on a living room shelf beneath that bloody poppy. The book described Lucia's model, the lytic and lysogenic pathways of phage Lambda.

As Lucia said, the competition between two proteins regulated whether Lambda would be dormant or active inside the host cell. These two proteins—cro and c-one—literally fought for protein control over the two arms of the Lambda genome. If c-one occupied the right arm first, its protein would be produced, resulting in human life and the lysogenic lifestyle of Lambda. If cro occupied the right arm first, it would be produced and c-one would dry up.

Control of the right arm was primary because it determined which protein would be made and which lifestyle Lambda would enter. We easily concluded that the evil Seth was c-one and Horus was cro.

Thinking about this, we realized that when the wicked Seth was victorious over the arms of the Lambda genome, Osiris was dormant and life as we know it would develop. On the other hand, when Horus was victorious, Osiris rose from the dead, the new species developed, and the arms were once again balanced. A human Death allowed Osiris to rise and Lambda to activate the lytic cycle. I then remembered the Egyptian image of the risen Osiris bent backwards into a circle, and I knew this indicated lytic rolling circle replication.

To think that it all came down to lysogeny versus lysis, the evil Seth versus Horus, disturbed me, and I wondered if the production of c-one protein was what they meant by the Roman Catholic doctrine of Original Sin. To think that in some way human life was a blunder because Seth stole the operator sequences of the Lambda right arm from Horus was troubling. Suddenly, a sense of relief flooded me, as I remembered my talk with Don Quixote. I missed the man of Truth, and I found my mind wandering away from its immediate deadlock into thoughts of how I could get back to him.

At that moment, John found a sheet of paper Lucia had tucked into the genetics book that deciphered part of Lucia's code relating to the Eye of Horus. On it was written:

Whole Eye of Horus (Eye of Seth and Eye of Horus united) = Double Crown; Double Bull; Two Enneads; Two Eyes; Two Lands; Two Mounds; two arms; Two Conclaves; Field of Offerings; Two Bowls of Sacred Milk; the Great Mansion; the iron Throne of King/Osiris.

Eye of Seth = Red-green-Lower Egyptian Crown; the Black Bull; lesser Ennead; black-left-empty-green-sweet Eye; Southern Land or Southern Lower Mounds of Seth; left arm/hand of earth; Lower Egypt; 3 bread portions in House of Thoth; Seth's bowl; a Mansion pillar; iron of Lower Egypt.

Eye of Horus = White-Upper Egyptian Crown; White Bull; Greater Ennead; right-white-full Eye; Northern Land or Northern Upper Mounds of Horus; right arm/hand of Sky; Upper Egypt; 4 bread portions in House of Horus; Horus' bowl; a Mansion pillar, iron of Upper Egypt.

As we quickly reviewed it, we could understand why scholars were confused. The whole Eye of Horus could be called twelve different names, and it was composed of the Eyes of Seth and Horus, which each had numerous symbolic names. Using logic, we could draw conclusions from the code about certain symbolic relationships between the whole Eye of Horus and its two parts, the Eye of Seth and the Eye of Horus:

If the whole Eye of Horus is the two arms of the Lambda genome, then the left arm of Seth plus the right arm of Horus is the whole Eye of Horus or

the whole genome.

If the whole Eye of Horus is two bowls of sacred milk, then Seth's bowl is full of milk as is Horus' bowl.

From this, we were able to understand Lucia's statement about Isis representing the nutrient medium lactose, for the whole Eye of Horus was only functional when both of the Lambda arms were nourished by lactose. Human cells use glucose, not lactose. Thus the milk-goddess Isis, the nurturing mother, the *regina caeli*, was indispensable to the Horus lineage, the new species, the afterlife transformation, or what I affectionately refer to as Durer's cubic catastrophe.

Now, John and I understood the frequent references in the Egyptian texts to the Milky Way, the sweet and white Eye of Horus, the White Bull of the Sun, for lactose is the main sugar in white milk. Along with this, we knew that the symbol of the name of Isis in Egyptian is an empty seat or throne. From the textbook, John discovered that the dormant Lambda lodges in the host chromosome at the lactose genes. Put simply, Osiris is sleeping with his sister Isis. This meant that when the dormant Lambda rises, that is, when Osiris rises, the lactose gene is empty. So the empty gene seat of Isis indicates that Osiris has risen, and that is why the Pharaohs depicted her headdress as an empty throne.

Reading further, we discovered that normally, lactose is repressed in the bacterial cell by a coiled snake-like protein that prevents expression of the lactose genes by binding to the DNA so that the genes cannot be transcribed. But, the primary *lac* gene can be induced by the presence of lactose in the cell, which inactivates the coiled protein and allows lactose production. The lactose present in the cell binds to the repressor protein, preventing it from binding to the DNA by changing its shape so that the three lactose genes are productive.

An image of the vampiric Geraldine sucking the blood of Christabel flashed before me, and I understood it as the repressor protein bonding to the lactose, sucking up the sugar instead of the DNA. Once again, the snake had to be removed from the DNA tree, from the throat of the shepherd, so the genes could be transcribed

Then I remembered the carved images of deities riding serpents everywhere in the pyramids, and I knew that the goddesses bonded to the serpents meant lactose bonded to the coiled, serpentine repressor protein that prevents lactose production. The image of woman bonded to the serpent simply represented the removal of the repressor protein from the DNA, so that the lactose genes in the cell could come alive for the new species. Women were not inherently evil, nor were they the cause of the Fall of Man.

History and religion had certainly messed up the meaning of that scientific

sign. With new vision, I now understood the meaning of the virginal foot crushing the head of the serpent. So, it became obvious to both John and I that Isis was the enzyme lactose permease that would travel with us through the cell to bond with the repressor protein and allow the production of lactose, so the new species could replicate.

Fresh with insight, I thought again of the Egyptian myth, which described how Isis continually searches for Osiris, finally finding him. Because Isis would be traveling with us in the viral ferryboat, this meant that our destination on the cell's chromosome was to Osiris, the sleeping Lambda genome inside the host cell that was lodged on the lactose gene seat. We were going to wake Osiris up for his Second Coming with a shot of milk.

Seeing your billion-fanged mouths blaze like the fires of doomsday, I faint, I stagger, I despair. Have mercy on me, Lord Vishnu!
11:25

As moths rush into a flame and are burned in an instant, all beings plunge down your gullet and instantly
are consumed.
11:29

Bhagavad Gita

27

Lucia's lecture on proteins and dragons was the final authorization for our passport to hell, and now I found myself thinking about otherworldly or psychotic experiences that so-called schizophrenics endure, such as the delusion of double awareness, also known as the imaginary companion or String Theory proposal of the anti-person made up of subatomic anti-strings. I recalled from my readings that one psychotic patient imagined shrinking into a screaming, squirming heap of formless matter, and another had visions of being set on fire like a log. It was my belief that these patients were experiencing physical reactions on a quantum molecular scale, as were the creative artists who had been diagnosed mad by physicians.

For instance, the Death-haunted poet Roethke, who wrote in his notebook that he practiced walking the void, was described by psychologists as a manic-depressive psychotic, a paranoid schizophrenic. The poet said that *the moment before Nothingness, before near annihilation, the moment of supreme disgust is the worst.* Antonin Artaud also described this moment as *the horrible repulsion of the Nameless.* Both Artaud and Roethke believed that much could be learned from terror, anxiety and fear of spiritual forms, which are, according to the Pharaohs, simply molecular forms in the quantum world.

Perhaps one remedy for the physicians' diagnostic disasters might be a course in simple physics. They could call it *Psycho-Physics*, the ergodic discipline

where they would learn that an awareness of quantum events is not madness, but genius, and that some have an inherited disposition for these abilities by means of their bloodlines, their genes. If what is labeled madness is simply an unguided excursion into the quantum world, then all people will experience this insanity when they die, even the clinicians, for life at Death breaks down to molecular elements undergoing chemical processes. Imagine the physicians' horror to discover at Death that they have descended into the lurid dream state of their hallucinating, deluded patients. Now what?

It seems that their Diagnostic Manual also labels *residual symptoms of schizophrenic disorder* such as *clairvoyance, telepathy, sixth sense, others can feel my feelings, and sensing the presence of a force or person not actually present*. Certainly, Goya experienced the last symptom at age seventy-two, when he painted his uncommissioned Black Paintings found on the walls of his home. The oil canvas *Saturn Devouring His Children* is a gruesome view of the mythological god Saturn who, with maddened eyes and a voracious blood-mouth, cannibalizes a naked, decapitated human corpse. Naturally, the desire to exist in the world in the human form makes one step back in horror from this painting. Yet as humans, we easily eat or cannibalize the meat of beheaded animal corpses without any feeling or concern.

Taboos aside, perhaps we can connect the image to meaning by viewing Saturn as simply an effaced sign for the natural process of energy consumption and absorption in the realm of the gods, which is the molecular zone where one's elements are recycled. One can certainly understand that the gods in the dwarf world must also eat, that Death is the force that makes us food for the gods, if we enter the afterlife without knowledge of chemical pathways. Eat or be eaten, as they say.

Another Black Painting, *Duelo a Garrotazos*, stages two massive men, possibly brothers, in a peaceful rustic countryside mercilessly striking each other with clubs. One combatant is badly bloodied, and both are quagmired in quicksand, as if fated to fight eternally like the Egyptian brothers Seth and Horus, or better, if one unveils the lost sign, the combatants are two proteins grounded on the Lambda genome, battling for genetic control over vegetative replication.

Like the courageous poet Roethke, Goya had a glaring sense of Death that haunted him, that forced him to boldly paint his vision on canvas. Yet, in the modern world, the madman's attempts to define what is beyond human existence results in a silencing by physicians of the mind, who know less than their patients about the quantum experience.

Indeed, even the warrior Arjuna in the *Bhagavad Gita* did not understand the terrifying, infinite, primal form of God, and he begged for relief from the

horrific vision, apologizing for thinking the monstrous form of his God was human, and the God who claimed he was Death assured Arjuna that few saw this unthinkable form despite study, rites or practice, and that the person who loved him without attachment would meet him again in the end.

Arjuna could only stutter, "Show me your other form—please—the one that I know; have mercy!"

Alas, Arjuna was fated to meet the unveiled horrid manifestation again at Death, and this same revelation that schizophrenics experience in life—the moment of supreme disgust before annihilation—may be the vision that the hero Kurtz saw and had the Charity not to reveal, when he rasped *the horror! the horror!*

Disheartened by my perception, I watched Lucia moving about her lab, preparing for the cloning experiment. There was no reprieve; it was time for John and I to go. Joining Lucia, we immediately spotted the white vial of diamond crystals next to a hybridization oven. The gold sparkled in the morning sunlight like florescent frost. To the right was the adjoining room where Lucia kept the powder, and glancing inside and above the safe, an enormous drawing of the jackal god Anubis startled me. Remembering his role as the god who guides the dead through the underworld to Osiris, I peered into the god's dagger-sharp, misshapen eyes that brooded above an indifferent muzzle, terminating in a frozen human face impaled in its nostrils. Austere, almighty, foreboding, the jackal god stalked me from its shadowy cavern as if sentencing me to Death. John too was staring at the dark demon in the dim room.

Noticing this, Lucia casually commented, "Anubis has often been called the son of Osiris and is identified with the young Horus, the new species. The texts say that the dead person receives a jackal face. This simply means the molecular form of the core DNA molecule of the new species looks like a jackal face."

A jackal face—unbelievable, I thought.

Walking over to her desk near the windows, she opened a text and showed us a drawing of the structure of a DNA nucleosome, formed by an octamer of eight basic proteins. She explained that the DNA double helix wraps around this octamer, and a histone secures the DNA to the nucleosome core, anchoring it to the backbone of the chromosome.

Somewhat comforted, we could see the molecule's core had sequences of amino acids that did resemble a jackal's face. Still, one had to have Imagination to see the circular web of interlinked helices, arranged in a quaternary structure as the head of a jackal.

The Jackal God Anubis
Copyright © 2003 by
Eric Szymanski

A quick review of the text informed us that proteins fold within milliseconds along a well-defined reaction pathway into a unique conformation, and that this energy landscape is a rugged funnel, where there are valleys within valleys. First, it folds from a linear amino acid chain, then into helices, which assemble to each other as it is guided to its natural shape.

Apparently, navigating the folding funnel is like crystallization because the protein flows from a coiled or unfolded state to a frozen folded structure. You could imagine the funnel as a champagne glass, sloping smoothly through the descending circumferential rings of the goblet to the unique folded state at the core.

Instantly, the architecture of Dante's *Inferno* spun through my mind like a dust-devil. His earth was pierced in the northern hemisphere to the center by a hole shaped like an irregular cone, a funnel, and it was crystal clear to me that Dante's circles of hell were like the circles of the Egyptian Duat, his monster Dis was Apopis, Beatrice was Isis, and the ferryman Charon's counterpart was the Sun-god. Hell was the folding of a protein through a funnel energy landscape. I then understood that on the quantum scale, the spinning vortex of the earth's magnetosphere was simply a protein folding funnel. The Duat-Hell was a journey through a protein folding funnel. John could see this also.

Then Lucia said, "The funerary texts state that the Deceased is unique, and the descriptions of his new form include being coiled with a serpentine middle, having a spinal cord in a nest and hinder parts like a broad hall. It would take an idiot not to recognize these descriptions as the different levels of protein structure."

The magnitude of Lucia's research made me see that Egyptian science far superseded modern accomplishments, for the ancient hieroglyphs and images described the pathway of a protein folding to its unique structure after human Death. In essence, this was a horizontal gene transfer, resulting in the nucleation of a unique species that would replicate into human-viral clones.

Again, Futurity flashed forth and my mind connected to the 1998 discovery that Japan's Kinki University scientists would clone eight identical calves using cells taken from a single adult cow. Stunned by this revelation, I realized that five thousand years earlier, the Egyptians were cloning Apis bulls, black bulls with a white diamond on the forehead, a beetle image on its tongue, the figure of an eagle on its back and a tail with double hairs. Each special calf descended from a virgin cow struck by lightning that was incapable of conceiving another offspring. In genetics, this type of lightning, asexual breeding for specific traits is called cloning or forming genetically identical calves by nuclear transplantation. The Egyptians cloned these revered, identical Apis calves five thousand years before the Japanese experiments.

I took a deep breath as John leafed through the textbook, while Lucia returned to her vials and agar plates. My soul searched for something that would distract me from my own thoughts, and glancing upward, I saw a painting on the wall above the windows. In a mauve atmosphere tinged with yellow, a barefoot woman in a sheer ivory dress sat weightlessly, almost disembodied on the northern pole of a large brown globe, probably earth. With her blindfolded face illuminated and her golden hair tied back, her head was bent down into a loom, as if she were being re-woven.

There was a quotation by the painter.

Hope
George Frederick Watts, 1886

I paint ideas, not things.
I paint primarily because I have something to say,
and since the gift of eloquent language has been denied to me,
I use painting;
my intention is not so much to paint pictures
which shall please the eye,
as to suggest great thoughts
which shall speak to the imagination
and to the heart
and arouse all that is best and noblest in humanity.

Upon the mild light of the earthly sun
Turn, bold, your back!
And with undaunted daring
Tear open the eternal portals
Past which all creatures slink in silent dread.
The time has come
to prove by deeds that mortals
Have as much dignity as any god,
And not to tremble at that murky cave
Where fantasy condemns itself to dwell
In agony.

Goethe's Faust

28

The whirling yellow eye in the heavens was now at high noon, and its warm heat settled in a hazy torpor of pearl mist around the scarlet-tipped mountain-tops. Lucia suggested that John drink the gold outside on the deck, so he reclined on the white chaise lounge beneath the fiery horizon of rock and sky. I stood next to him, watching him. He showed no sign of fear. When she offered him the gold, he drank it down like a shot of Bushmills.

I knew I would instantly experience the gold's effects, so I quickly retreated to my normal seat beneath the deck table's ostrich-feathered shield with the terrible knowledge that I would have to face the Sun-monster within minutes, for we were heading due west or straight into the Sun. As I positioned myself uncomfortably in the deck chair, I noticed that Lucia was now in her glass house cloning, and John was sprawled out on the lounge almost asleep. I felt a strong compulsion to look at the glaring Sun. Quivering like a flame moving in the wind, I boldly stared at its bright diamond center.

The sky was a cold pearl-gray and illumined by a strange light that cast a gauzy veil over the silvery Sun that whirled slowly, and then its light turned a Gothic blue, a red jasper, an ivory turquoise, a golden green, and I was in a cathedral of stained glass windows, a mosaic that encircled the mountains, the Sonoran desert, Lucia's laboratory. The rainbow palette of painted light passed through the colored glass, spreading out over the sky, the earth, the ledge, the lounge where John rested within the irradiated beauty.

Then a fiery form materialized in the rocks beyond the ledge, and at first, I thought it was an angel, for it moved with a surreal, majestic grace that seemed to be knocking at the stained glass windows. It was either a pure psychic image or something unreal, something earthly. I watched it curiously as it lunged upward like a fierce bird of prey, splintering the glassy landscape to land on the ledge. Another sharp leap and it thudded to the deck, pausing, panting heavily, its yellow eyes blank, drool dripping from its white-knifed open jaws. Frozen, I watched it slouch toward John, and then in a ravenous rush of movement, the firecat sunk its teeth into his throat and wrenched out his jugular veins. Within seconds, the lion slashed through John's shirt to his bloody heart, which it consumed indifferently. Helpless, I could only stare at the pack of Lucky Strike cigarettes that had fallen from his shirt pocket to the blood-stained decking, along with a small card that was suddenly whipped into the air by the cool breath of the North wind. I watched it flutter upward, then sail downward to float face-up on the pool's azure surface. It said:

I Am A Catholic In Case Of Accident Please Call A Priest

Then it sank to the bottom of the pool and disappeared in the filtering system.

Disembodied and feeling a new sense of freedom, I calmly observed the lion's appetite and how its dark desire crushed John's heart with no remorse or Charity. It was like the indifference of human lust, which compels a person to desire and hastily possess someone new, someone else at the complete expense of loyalty to a loved one in an existing relationship. Lust, pride, envy, anger, sloth, greed and gluttony were all indulgences rooted in human self-interest, a dark heart from which cruelty bloomed.

Yet, I harbored no hatred for the cat that killed John, for it was only hungry, having smelled the leftover steak, which it was now eating rather than John's corpse. Life is full of lessons, and the cat taught me that human cruelty was grounded in the dark desire to satisfy one's appetites, and that the human and animal kingdoms had much in common. A certain calmness entered my soul, and I no longer feared the idea of becoming viral-human.

Just then, a door slammed and a gunshot shattered the moment. The mountain lion leaped over John's dead body, skimming the ledge to lunge along the cliff with the steak still in its jaws. In spectral form, I hovered in an ivory blur above the scene, watching Lucia rush to John with the gun still in her hand.

An immense sorrow welled up from her heart, dusting the silvered dawn in sentiment. From within that fountain of passion, a sharp crescendo of crying violins resounded into space, and I saw the melancholy music of Joaquin Rodrigo fuse with the timeless lyrics of Alfredo Garcia Segur.

Breaking upon the crystal light. . .*Aranjuez!*
Flowing out of Lucia's soul . . *Aranjuez!*

A mourning song of the earth, a memory engraved in Hope never to be forsaken! *En Aranjuez con tu amor!* Enfolded with tragic joy, the lyrics filtered upward like flowers, collapsing the fabric of space and Time.

> *Aranjuez, a place of dreams and love*
> *Where a rumour of crystal fountains in the garden*
> *Seems to whisper to the roses*
> *Maybe this love is hidden in one sunset*
> *In the breeze or in a flower*
> *Waiting for your return*
> *In Aranjuez, my love*
> *You and I*

Then I heard a staccato burst of pleasant echoes, what seemed to be the glorious resonance of laughter, and beyond me on a towering peak was John laughing and waving.

"Hey Doppelganger," he called, "this way!"

Astonished, I saw people all over the mountaintops, and as I drifted toward John, I noticed other spirits like me, moving in mist toward the mountain people. Feeling a sense of *deja vu*, I could only compare the scene to Michelangelo's painting of *The Saved from the Cistine Chapel*, where immortal beings on clouds are extending their arms to ascending human forms like John. It was then I remembered that despite Faust's pact with the devil, he was saved and regenerated at his Death by angels carrying his immortal part to higher atmospheres. Angelic voices chimed around me: *Whoever strives with all his power, we are allowed to save.*

I then understood that John was dead, but living, and that I was his double which he could now see, a spirit that had been indoctrinated and stained by man, a shadow that was coming to life with Prospero's book.

29

> For the great plateful of blue water was before her; the hoary Lighthouse, distant, austere, in the midst; and falling, in soft low pleats, the green sand dunes with the wild flowing grasses on them, which always seemed to be running away into some moon country, uninhabited of men.
>
> *To the Lighthouse*
> *Virginia Woolf*

"We are not coming back from this trip," said John, as he merged into the hazy condensation of the ethers.

"Yes, I know. Let's hurry, I have much to show you," I said, pressing Prospero's book close to my heart.

"No looking back," I cautioned, and then, we flew away from men forever like madmen across the currents.

John's new energy matched my own, and we scaled the aerial heights above the mountains effortlessly, going westward to the veiled Sun, which was at its zenith and gleaming like a silvery disc with the clear-cut rim of a lustrous pearl. The sky was dappled with diaphanous hues of blue and violet clouds that passed behind the Sun, moving from west to east in synchronicity with the earth's rotation. We were angling smoothly to the northern polar cusp, thanks to the Coriolis effect, and the world around was afire with a brilliance that ignited all living things from within.

Timelessly, we curved northward on an iron magnetic field line of molten metal like spidermen, high above the spinning azure-green earth, and despite Lucia's instructions, we were unprepared for the new world bursting before us, what the Egyptians called the regions of the dwarfs. In the molecular state, vision is spectacularly improved, and from John's new perspective within the earth's ionosphere, he saw the emerald planet's Sun-barricade as translucent mountains of plasma, threaded by bronze magnetic lines, stirring like the warp and woof of some filmy metallic curtain.

On the western horizon, the massive plasma barrier bulked up to deflect the ramming solar wind that stretched the earth's magnetosphere eastward into two long rivers of plasma, a whirling vortex crossing far downstream to form a sizeable horizontal tail in the infinite ocean of dark space.

Awed, John stared at the Sun crisscrossed in magnetic rods of iron, and he said, "Doppelganger, the Sun appears veiled in silver gauze because of the effect produced by viewing it from within the earth's plasma barrier, and Coleridge saw this too. In the *Rime* he wrote that the Sun was *flecked with bars*, and I must say now, this was an accurate description of the Sun from within the magnetosphere."

When John said *bars*, I suddenly knew that we were breaking out of the earth's magnetosphere, the prison that thrived on photosynthesis. Not that it was our fault, but we had been imprisoned because of the theft of fire from the Sun. I remembered Nerval's comment that we were captive because the electromagnetism in our bodies was forced in a certain direction. It instantly became clear to me that when a person died, their atoms were released but trapped in the magnetosphere, only to continually return to forms of matter that used photosynthesis. We were breaking through the process of eternal return. We were breaking out of the magnetosphere into the stars! Van Gogh's painting *Starry Night* flashed before me, and I sensed he knew this was possible.

In silent awe we examined the earth's arterial plasma network, the enclosure that surrounded us like the translucent cell wall of some monstrous fish that seemed to be entangled in a net cast from the Sun. Seeing all of this, we understood the relentless power of the Sun, whose winds battered the earth remorselessly, but this did not delay us.

Like falcons, we continued spiraling through the air toward the ice-laden Canadian Arctic, where a sunlit spout of silvery jets swirled round and round in a large vortex above the magnetic North Pole, like a brilliant lighthouse beamed in from the stars. Mesmerized by the magical polar light, which mushroomed upward like a ram's horn into the blue-black cosmos, we soon heard the warm, rich sensual tones of a trumpet, gusting up on the ethers to greet

us. It was the song of a blessed one, a weightless music.

"That's Miles Davis—he never could get that freedom song off his mind," said John, leaning back into the mystic effulgence of the ethers, as the trumpet released a long burst of smooth tones, and then a wispy, intimate improvisation of shattered tones that skated by on the pulse of the north wind.

"*Concierto De Aranjuez* by Rodrigo. Just as Miles said, the *melody is so strong that the softer you play it, the stronger it gets.*"

"John, pay attention here," I responded, for our momentum was decreasing, and the magnetic field line we rode was ending, rooted as it was in the North Pole. In that instant, we leaped off the molten tightrope like two magicians into a large glassy gap between metallic mountain ranges, and then I clearly saw Miles standing on the glittering Arctic shores with the music pouring out of his soul in a kaleidoscope of changing harmonics, and behind him there was an audience.

"John," I said, "Do you recognize any of those spirits on the ice?"

Awed again, John stared beyond Miles into the crowd.

"I think that's Vincent van Gogh on the left, followed by Paganini and Rachmaninoff," he said in disbelief, focusing on the surreal scene. He then recognized the molecular living forms of Adrienne Rich, Georgia O'Keefe and Virginia Woolf, along with Shakespeare, Coleridge, Yeats, Nerval and Artaud. Drifting closer, we saw Poe and Goya, Galileo and Nietzsche, Theodore Roethke and many other great poets, writers, painters and creative artists, standing in two lines before a glimmering energy landscape of a Great Stairway.

At the top loomed the solar light source, a magnificent crystal life-form triangled into numerous pyramidal shapes that radiated above, flashing like mirrored lightning, each face falling on another. We understood it as the image of the Sun-god and the alien Logic that generated our thoughts, the *house of Being*, the mystery of mysteries.

Explosively from within the terrifying brightness of dazzling light, a great roar of thunder erupted, a monstrous blast that even Mahler could not orchestrate. Amazed at its limitless power and unbounded emptiness, I remembered a Coffin Text, *Lord of Terror, greatly majestic, to whom everything is brought*, while John gazed at the cold, almighty, deathless head of phage Lambda. He calmly whispered:

"The Egyptian pathway requires that we enter that crystal, that we bond to the viral DNA."

Knowing what was next, we braced ourselves to be eaten, to be swallowed by the horrifying Sun-god, and then with little adieu, and using an approach totally opposed to that of the weeping Dante and faint Virgil, we flew gallantly into the flashing face of the Sun-god like moths to the light.

Then I looked, and lo, on Mount Zion stood the Lamb, and with him a hundred and forty-four thousand who had his name and his Father's name written on their foreheads.

Revelation of John, 14:1

30

The blazing Lambda head opened its vile mouths to devour us, and the first sensation I experienced was one of terror, absolute disgust, revulsion, the same feeling I had when the mountain lion lunged at my throat, but I forced myself forward, knowing that I was still holding on to my human perceptions, my material desires, my dark love for the human form. So I steadied my soul, resolving to let the hallowed memory of my material form pass into the morass of Time. It was like waving goodbye to one's self. Even though this was difficult, it had to be done so that I could take the only genetic pathway that would save me and Doppelganger from being recycled in the chemical reactive furnace of the host cell hell. Yes, now that I was dead, I had no doubt that Lucia's model was valid.

With the intention of determining my future by thought, not senses or emotion, I convinced myself of the Truth, that being cannibalized was simply the chemical bonding of my immortal part to the Lambda DNA. This act of crossing over would catalyze my transfiguration into a Sun-god, so I could replicate into a viral-human species inside the host cell. To accomplish this, we would attach to the host cell, inject our DNA inside, and then take over the cell's replication machinery for our own use.

Once inside the cell, we would migrate to the other Lambda genome lodged on the host cell chromosome. This dormant Lambda genome, this Osiris, would then rise and burst forth into the lytic cycle to clone viral-human progeny. After this, it would be a smooth ride downhill on protein gradients to the bottom of the hellish funnel, and then to the stars like pollen to the sky on the wind.

These were the instant thoughts that placed my terror under control and forced me to rapidly merge into Lambda's lethal ultraviolet radiation. I then experienced a mind-blowing pressure, followed by a feverish heat, and finally a clammy coldness. It all happened within milliseconds, and now inside the Lambda head, I sensed I possessed a limitless power, a knowledge of the cosmos that was indescribable and magnificent. I quickly searched the fortress of ice and found the chromosome's throbbing center, the nonessential region controlling the lysogenic phage properties. Immediately, Doppelganger and I disabled the c-one gene, otherwise known as Seth, by sinking into the gene site, which sucked us up like quicksand. Then we quietly inspected the long Lambda chromosome.

Double-stranded and linear, it was 48.5 kilobytes in length with complimentary 12-base overhangs at both of its five-foot ends. These sticky 24 cohesive base-ends would circularize and bind the DNA together, after we entered the host cell hell. It was also obvious that there were seven operating command posts called operons that controlled two different viral lifestyles, lysogeny and lysis. Because we had inactivated the c-one protein, we were now on target for the lytic pathway, which would result in the resurrection of Osiris and the birth of thousands of viral-human progeny. Of course, this would also cause a certain amount of host cell destruction and other chemical reactions, but not complete cell Death, for we were a mutant strain of Lambda that would not kill the entire cell.

The Lambda DNA was impressive, but I was more impressed with my new consciousness, which had deepened to a perceptual level that was at once primordial and nonlocal. By nonlocal I mean that we were everywhere, ubiquitous, essentially whole. We were heirs to Eternity and lords of magic with power over Death and the four winds in the starry heavens.

Because we had bonded to the Sun-god, our recombinant DNA would save Osiris by activating the lytic pathway. Like a small sailing ship, our DNA template would ferry us into the host cell to father viral-human progeny. Accordingly, I had no problem attracting other molecules to me, so I calmly observed my self assemble into a supermolecule of nine molecular forms, what the Egyptians referred to as the Great Ennead. I was the Captain of the solar ship of molecules, and I had no intention of grounding my ship. I soon learned

from the molecular cross-talk that the crew had come from Orion, and we were now going backward in Time. We were going back to the Early Universe.

I settled in for the journey, keeping an eye on everybody. On this ferryboat to hell, there was one lovely enzyme, arrayed in a kind of blue that was indescribable, and I soon recognized her as the goddess Isis, the lactose nutrient for our recombinant species, who, like us, would penetrate the host cell. I watched her make herself comfortable on the DNA ferryboat next to Doppelganger.

We soon heard a guttural sound, as if someone was going to spit, and the whole chromosome of DNA slid forward out of the Lambda head down a watery channel that we soon perceived as the hollow Lambda tail, getting ready to attach to the host cell. I saw an open clearing on the host cell, a gleaming blue gate, where a glorious knight sat on an unblemished horse. It was Don Quixote and Rosinante. I glanced at Doppelganger and immediately sensed a deep happiness in the spirit's heart.

Wiser now, I said, "Doppelganger, do you know what Quixote's name means in Spanish?"

I could see that my double really didn't care about the translation, for the spirit was anxious to talk to Quixote, and he was waving his right arm of amino acid links back and forth. Watching the intrepid knight, I noticed that his blue mouth, now full of flashing teeth, was opening and expanding into a large blue-black chasm, his jaws jutting wider and higher to expose what could only be called the abyss of hell. Harsh heat rushed forth from his monstrous jaws, a marbleized mouth that made Moby Dick's maw look insignificant. Seeing this, Doppelganger stopped waving.

Unconcerned I said, "Quixote stems from *quijada* meaning *jaws*, specifically that of an animal. Don Quixote de la Mancha means jaws of the stain."

Shielding me from the hot breath of Quixote, the brash Doppelganger remarked:

"That sheds some light on Cervantes' masterpiece, but right now, you need to be focused on cell entry because we are docking on Quixote's mouth, which is the LamB receptor site of the host organism."

Quixote's toxic breath enshrouded us, as we watched the hellish jaws of the LamB receptor site distend deeper and deeper into the void, the nothing of the cell. Energized, I could only consider that Death had not erased my knowledge of great literature, but had enhanced it. I would have to say that we were taking knowledge with us into the afterlife, for how else did I remember the meaning of Quixote's name, which now pointed to the jaws of Death that would wipe away the human stain, the misnumbered creation that the Egyptians called the conspiracy of Seth?

The word *stain* seemed like a fair description of the human creation; after all, most of our DNA is junk, reverse transcribed and backwards. Aside from this bad luck, my main point is that your knowledge travels with you in the afterlife, but only if you bond to the viral Sun-God for the journey down a specific chemical pathway created for ancient Kings, a pathway through a molten funnel of darkness into the daylight of the stars and the moon. The starry night of the moon.

Just then, the Lambda tail fibers magically docked into the LamB receptor site, Quixote's jaws locked down sharply, and the elongated chromosome moved through the sealed opening like a sharp two-edged sword, sliding easily through LamB's six gates. Once inside the cell, our ship flowed effortlessly with the channel currents, and Doppelganger yelled, "Row you phage-heads!" as if he were the mad Captain Ahab urging his crew on in pursuit of Moby Dick. Now that we had crossed over to the host cell, I marveled at how easily we had breached the two cell walls and tunneled into the host organism's dark DNA caverns full of livewire electricity.

The DNA was truly a Tree of Life, a lightning bolt of crackling dynamic structure. Base-pairs were vibrating, electrons migrating, and holes within the gradient flow opened and closed like miniature tornadoes, coming and going in the living glittering sea of plasma. Molecules were talking to us, an interspecies cross-talk that guided us through the darkness. The pageantry of life on the quantum level was elaborate and more vibrant than anything Prince Prospero could have imagined.

"Doppelganger, did LamB's six gates remind you of anything literary," I asked, noticing that the spirit had quit impersonating Ahab and was now inspecting the bow of the chromosome to make sure the cohesive bases were still sticky so we could circularize.

"I would have to say that it reminds me of Poe's allegory about Prospero traveling through seven rooms to meet Death," said the clever spirit pretentiously, as if he were a literary scholar.

This remark also irritated Isis, who turned around and said,

"Actually, Poe was representing the host cell's seven operons that control replication. The plague of the Red Death was simply our take-over of these seven command posts, so that we could replicate our progeny, our children."

Doppelganger looked puzzled as he remembered that the LamB porin only had six gates, but I found Isis' comment intriguing, for it reminded me of the opening of the seven seals in the book of Revelation that unleashed Death upon the human world. I tried to pursue this line of thought, but Doppelganger's nagging voice distracted me.

"John, we need to stay focused on our task because our chromosome is

going to circularize."

So what, I thought, and then, just as he predicted, the ends of the long chromosome stretched upward in the dark and curved toward each other. At once, the twelve sticky bases on each end cohered to form one large circular chromosome. Experiencing this ferris-wheel ride, I now understood the Egyptian preoccupation with circular discs and spheres.

Thunder cracked through the void, and the earth beneath me shuddered, for the cell sensed our presence. Doppelganger whispered that Thoth was coming to copy the Lambda genome for viral replication, and sure enough, Thoth arrived in the dark with his tablet and pen, ready to go. His role was essential to our success because, as the polymerase for transcription, he would redirect the cell to become a factory to produce the human-viral species.

With a scholarly mind-set, he said, "You will be taking the northerly route to Osiris' hidden headquarters, where you will be close to the interior cell membrane so you can escape easily when your work is done."

Thoth then explained that the host cell's circular chromosome was attached to the interior cell membrane and that replication was bidirectional, that is, there were two ways to copy information to make protein for the new species. He stressed that we had to take the wider path, which was a northerly route to the *LacZ* gene where Osiris rested. We understood the *LacZ* gene as the site controlling cellular lactose production, the nutriment source for the viral-human progeny. Just then, the host cell shook with a violence that surprised me.

Thoth immediately motioned us forward, pointing north.

"What you are now experiencing is the host cell's defensive system. It's called the SOS response."

The cell shuddered again, and we moved forward into the thundering darkness as Thoth transcribed our DNA. The light from within our DNA molecule pulsed like lightening as we floated along the waterway, passing molecular spirits along the banks that wailed as we left them behind. It was now very clear that the host cell sensed our infection and knew we were taking over its replication machinery with Thoth's help. Damaged by ultraviolet radiation, its roaring SOS response was a howl for help that released a flurry of antibodies and other molecules geared up to attack us. However, there was no contest, their assault was futile, for the SOS response also de-repressed forty-two genes that aided our invasion, along with viral enzymes to break up the cell's own DNA. Disabled and literally beheaded, the cell's molecular army dropped dead and burned up within the host's own fiery furnaces.

At one point, we saw a lake of blazing fires and watched petrified souls with human forms burn in a blistering conflagration of torrid flames and smoke amidst burnished demons, thriving in monstrous shapes like Bosch's

beasts. The despairing human spirits shrieked and screamed in despair, leaving us disheartened, for we knew the souls were doomed, not because they were evil, but because they were ignorant. Death-by-ignorance because they lacked knowledge. They did not know the correct chemical reaction pathway in the afterlife, the guided diffusion channel. It was then that I understood the nature of Hope and despair.

In Time, Hope is knowing the chemical pathway to Eternity. Despair results from not knowing, from trying to believe that you're going to heaven, when you really don't know where you're going. Then you die and see a glimpse of the Truth, but you don't have enough knowledge about it, so you wander down the wrong chemical pathways that bring you back to a thermal recycling that breeds forgetfulness, a second Death and eternal return. If your atoms are recycled again into the human form, then the remnants of the knowledge you once had haunts you, an elusive memory that you cannot decipher, a depressing cloud of despair in the world of Time, where the cold Sun shines relentlessly.

As we passed by the unfortunate harvest of souls, I watched the chemical decapitations and melting processes, knowing that the only judgment human beings would endure would be one where their hearts were weighed against the feather of Isis, where the arms of the Lambda genome were equalized with the right arm ascendant for cro protein production. It was a judgment that could only be survived by having the knowledge of the correct chemical pathway.

With Hope we moved on through the cauldrons of darkness. Despite the vapors, chaos and heat, our small sailing ship pulsed with light from within and glided smoothly through the watery channels of the cell's DNA, which was lined with molecular monsters, serpentine protein forms, and other coiled molecules that cried out to us, that wailed as we passed by without stopping.

Our descent deepened, as we zig-zagged along the caverns, and the cell shook violently again, its earth quaking. We heard the roarings that meant Osiris was coming. Inert forms were rising all around us like specters from the dead, as we continued to unseal the host cell's seven ribosomal RNA operons, the replication command posts that would allow the construction of our viral heads, sheathes, base plates and tail fibres. We had all the information we needed to create viral-human progeny. Actually, we were carrying the message of the Sun-god, his DNA, his instructions, his Word, and Thoth was easily transcribing this DNA into RNA instructions to make the protein for the new species. By uniting to the Sun-god, Doppelganger and I had become part of the Sun-god's Word, the force that enabled two species to create a third species, the Overman.

We proceeded on, parasitically taking over the ribosomal machinery essen-

tial for protein synthesis, and then the cell's signaling system alerted us again that Osiris was coming. I noticed Isis looking at me with her penetrating turquoise beauty.

"John, she said, "We're going to enter the interior of the cell's DNA, where the base pairs are not water-loving, so we will be moving on sandy desert instead of water."

I watched Isis closely, knowing that she would soon bond to the serpentine repressor protein, removing it from the DNA, so that the lactose genes could be transcribed by Thoth. This act by a virgin queen would conceive and resurrect the new species, a hybrid of cosmic and human DNA. Yes, the virginal foot would crush the head of the serpent for an immaculate conception of the new species.

Benedicta es tu, Virgo Maria. No stain, no sin, no theft of fire, no human creation. Alleluia, Alleluia.

Then the light pulsing from our DNA illuminated four molecular forms of the protein Integrase that had emerged from the darkness to pull us out of the water onto the sand. We were now entering the innermost caverns of DNA where Osiris, the dormant Lambda genome, was lodged behind seven guarded gates. Headless forms were everywhere, so I asked Isis what it meant.

With her heavenly face staring straight into my soul, she said, "In the molecular realm, having a head means penetration and killing power. Once your head is cut off, a molecule is chemically decapitated, disabled. In contrast," she added, "when you see a serpent body with three heads, it is actually a protein with three helices."

She then pointed at a three-headed serpent that she identified as the cro protein that would produce our viral-human species. The protein itself was radiant and victorious, for it was no longer battling the c-one protein, which we had disabled earlier. Everything was proceeding as planned. The protein product of the cro gene was building up to a critical level, so it could begin late transcription. Thoth kept reporting back to us, for he was measuring this protein progress by his moon-graph, an idea he thought up to measure viral growth. A new moon signified our invasion's low host densities, while the full moon signaled that our invasion was close to burst size.

Reporting back, Thoth said, "The guards are decapitated. A four-way junction is coming up, an X-structure that looks like a cross. Snake through this and Osiris will rise."

Isis was listening intently, and she added, "We're approaching the *LacZ* gene site where Osiris rests. Once he evacuates the gene site, we can use the lactose nutrient source to translate our DNA into protein."

Completely satisfied with our successful invasion into the dark iron furnace

of the host cell, I relaxed, feeling like Alexander the Great did after he conquered Egypt. Actually, I had a few minutes to think about Osiris, for like the Sun-god, he represented the Eye of Horus as did I. This Eye was simply the Lambda genome with an added ingredient—human consciousness. The Pharaohs viewed it as whole when it chose the lytic pathway. The other lysogenic pathway resulted when Lambda lodged its genome in the host cell to produce the planetary human creation, the stained DNA that was junk.

Suddenly, my musings were interrupted by a low rumbling that sounded like the thundering hooves of a distant army on horseback, and Doppelganger yelled, "Osiris is coming!"

The ground then shook terribly as a sharp crackling noise exploded around us. In the darkness, I could almost see a grisly form growing, a grotesque black shadow that was lurching everywhere, writhing, snaking toward us with a tremendous spasm of speed that left me breathless, and then I saw it up close, whirling, spinning with a fury that was unimaginable, its horrible pounding thuds bursting into a mad dissonance, a squealing rage that weakened me. Disembodied, the chromosome stretched us like an elastic string in opposite directions. In a panic, I struggled to dislodge myself from the DNA template, but I was stuck, and then Thoth approached me, knowing that this was the first time I had been on the lytic pathway.

With a confidence that I found condescending, he said, "Don't worry about this change. We're just shifting into a different form of replication called rolling circle. Think of it as a scroll or a roll of toilet paper unrolling. We're locking into a positive feedback loop on the host chromosome that will produce an army of viral heads and tails."

The thick darkness was beginning to disappear, as if someone had pulled back a gossamer veil to reveal the Imperishable Stars and the winds of heaven. But still mystified, I said:

"I thought Osiris was coming. Where is he?"

Thoth was patient, understanding that Truth becomes. He said, "This is Osiris, this is the activity of the Eye of Horus. It is rapid vegetative viral reproduction. The positive feedback loop is Osiris bent backward into a ring, a ring of viral creation on the circular host chromosome. Osiris is the Lord of Millions of phage progeny."

Shocked, I watched as rolling circle replication spit out its new creations, going round the host chromosome at a rate of production that was appalling. It reminded me of Cervantes' fulling mills and the nymph's grindstone next to Durer's angel and the distorted stone.

And so, I remained more than human, as Time moved into Timelessness. Then I saw three friendly horses, their heads and tails ribboned in palms, and

they flashed before me like onyx, carnelian and golden diamonds. Fascinated, I immediately recognized the mighty Bucephalus, the studhorse Man O' War, and the gigantic Trojan Horse.

In a translucent space beyond these three immortals was a pale white horse, bearing a **dazzling black knight** holding an infant, and its name was Death.

Abbreviated Bibliography

Art

Bosch, Hieronymous. *Souls Ascending to Heaven.*
 Garden of Earthly Delights, Right Wing, "Hell"
Dali, Salvadore. *Persistence of Memory*
Durer, Albrecht. *Melancholia I*
Goya, Francisco de. *Disparates; Saturn Devouring his Son; Duelo a Garrotazos*
Michelangelo. *The Saved from the Cistine Chapel*
O'Keefe, Georgia. *The Red Poppy*
Van Gogh, Vincent. *Potato Eaters; The Reaper; Crows Over the Wheatfield;*
 Starry Night; Skull
Watts, George Frederick. *Hope*

Literature and Philosophy

Alighieri, Dante. 1265–1321. *The Inferno*
Artaud, Antonin. 1896–1948.
 Van Gogh, the Man Suicided by Society (1947)
 To Have Done with the Judgment of God (1947)
 The Peyote Dance. trans. by Helen Weaver. New York: Farrar,
 Straus and Giroux, 1976.
Blake, William. 1757–1827. *Milton*
Cervantes, Miguel de. 1547–1616. *Don Quixote*
Chardin, Pierre Teilhard de. 1881–1955. *The Heart of Matter; The Great Monad; My Universe*
Coleridge, Samuel Taylor. 1772–1834. *Kubla Khan; Christabel;*
 The Rime of the Ancient Mariner
Conrad, Joseph. 1857–1924. *The Heart of Darkness; The Secret Sharer*
Criticism: The Major Statements, Second Edition. Charles Kaplan, ed. New
 York: St. Martin's Press, 1986.
Darwin, Charles. 1809–1882. *The Descent of Man*
Foucault, Michel. 1926–1984. *The Order of Things, An Archaeology of*
 the Human Sciences. New York: Random House, Inc., 1970.
Goethe. 1749–1832. *Faust*
Heidegger, Martin. *The Origin of the Work of Art; The Letter on Humanism;*
 What is Metaphysics? What is Called Thinking?
Holderlin, Friedrich. 1770–1843. "The Titans"
 Drafts of Hymns [*When the sap*] and [*But when the gods*]
Iamblichus. D. circa 330 CE. *On the Mysteries; On Daemons*
Jung, Carl. 1875–1961. *Memories, Dreams, Reflections*
Kafka, Franz. 1883–1924. *The Metamorphosis*
Melville, Herman. 1819–1891. *Moby Dick*
Milton, John. 1608–1674. *Paradise Lost*
Nerval, Gerard de. 1808–1855. *Aurelia.* trans. by Geoffrey Wagner.
 Boston: Exact Change, 1996.

Nietzsche, Friedrich. 1844–1900. *Thus Spake Zarathrustra*
Poe, Edgar Allen. 1809–1849. *The Masque of the Red Death*
Rilke, Rainer Maria. 1875–1926. *Duino Elegies* from *The Selected Poetry of Rainer Maria Rilke*. trans. and edited by Stephen Mitchell. New York: Vintage International, 1989.
Roethke, Theodore. 1908–1963. "In a Dark Time"
 Straw for the Fire from the Notebooks of Theodore Roethke, 1943–63. selected and arranged by David Wagoner. Garden City, NY: Doubleday & Co., Inc., 1972.
Sade, marquis de. 1740–1814.
 The Misfortune of Virtue
 Dialogue between a Priest and a Dying Man
Shakespeare, William. 1564–1616. *The Tempest*
Stevens, Wallace. 1879–1955. *Parts of a World*, "Asides on the Oboe"

Music

Davis, Miles. *Concierto de Aranjuez*
Gershwin, George. "Summertime"
John, Elton. "The Trail We Blaze"
KISS. "Black Diamonds"
Mahler, Gustave. Sixth Symphony
Paganini, Niccolo. Love Theme
Rachmaninoff, Sergie. *Dies Irae*, Variation 7.
Rodrigo, Joaquin. Melody from *Concierto de Aranjuez*
Segur, Alfredo Garcia. Lyrics to *En Aranjuez con tu amor*
Sublime. "What Happened/Eyes of Fatima" and "Santeria"

Psychology and Religion

American Psychiatric Association: *Diagnostic and Statistical Manual of Mental Disorders, Third Edition*. Washington, D.C.: APA, 1980.
Bhagavad Gita. trans. by Stephen Mitchell. New York: Harmony Books, 2000.
Foucault, Michel. *Dream, Imagination and Existence*. An introduction to Ludwig Binswanger's *Dream and Existence*. trans. by Forrest Williams. *Review of Existential Psychology and Psychiatry*. Vol. 19, no. 1 (1984–1985).
McClure, Kevin. *Evidence for Visions of the Virgin Mary*. Account of Dr. Almeida Garret. Wellingborough, Northamptonshire: The Acquarian Press, 1983.
New Oxford Annotated Bible with the Apocrypha. Herbert G. May and Brue M. Metzger, eds. New York: Oxford Univ. Press, 1973.
Tibetan Book of the Dead. W. Y. Evans-Wentz, ed. London: Oxford University Press, 1960.